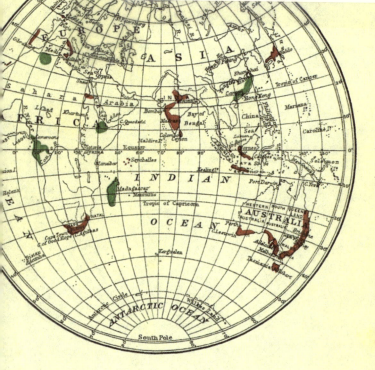

London : Edward Stanford, Ltd., 12, 13, & 14, Long Acre, W.C.

D0301644

OFFICIAL GUIDE

TO THE

NORTH GALLERY.

SIXTH EDITION,

REVISED AND AUGMENTED.

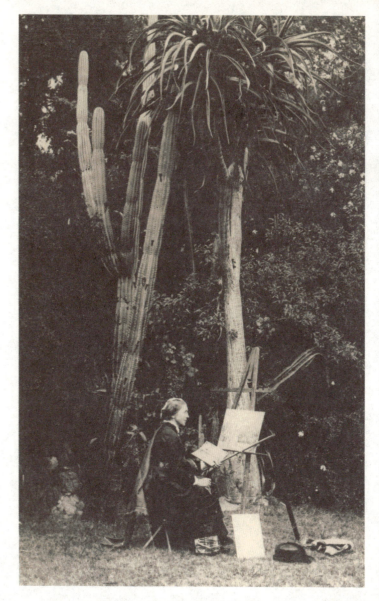

The artist Marianne North at her easel.

ROYAL GARDENS, KEW.

OFFICIAL GUIDE

TO THE

NORTH GALLERY.

SIXTH EDITION,

REVISED AND AUGMENTED.

LONDON:
PRINTED UNDER THE AUTHORITY OF HIS MAJESTY'S
STATIONERY OFFICE,
By DARLING & SON, LTD., BACON STREET. E.

1914.
Price Sixpence.

Kew

PLANTS PEOPLE
POSSIBILITIES

First published by the Royal Gardens, Kew, 1914.

This reprint 2009
Royal Botanic Gardens, Kew,
Richmond, Surrey, TW9 3AB, UK
www.kew.org

ISBN 978-1-84246-424-3

British Library Cataloguing in Publication Data
A catalogue record for this book is available from the British Library

Layout and design: Publishing, Design and Photography, Royal Botanic
Gardens, Kew

Printed by Henry Ling Limited

FSC Mixed Sources
SA-COC-001860
© 1996 FSC A.C.

For information or to purchase all Kew titles please visit
www.kewbooks.com or email publishing@kew.org

Kew's mission is to inspire and deliver science-based plant conservation
worldwide, enhancing the quality of life.

All proceeds go to support Kew's work in saving the world's plants for life.

PREFACE TO THE FIRST EDITION.

THE unique collection of Paintings, of which the following pages contain an instructive Catalogue, is, together with the Gallery in which it is placed, a free gift to the Royal Gardens on the part of the accomplished Lady-artist and traveller whose name the Gallery bears. The pictures were painted by herself, on the spot, in the countries indicated ; and were arranged by herself in the positions which they occupy; and both the preparation and printing of the Catalogue are due to her munificence.

On the beauty of the collection it is unnecessary to dwell, and it is not possible to overrate its interest and instructiveness in connexion with the contents of the Gardens, Plant-houses and Museums of Kew; visitors may, however, be glad to be reminded, that very many of the views here brought together represent vividly and truthfully scenes of astonishing interest and singularity, and objects that are amongst the wonders of the vegetable kingdom ; and that these, though now accessible to travellers and familiar to readers of travels, are already disappearing or are doomed shortly to disappear before the axe and the forest fires, the plough and the flock, of the ever advancing settler or colonist. Such scenes can never be re-newed by nature, nor when once effaced can they be pictured to the mind's eye, except by means of such records as this

(124—11.) Wt. 36033—435/40. 5000. 10/14. D & S. G. 3.

lady has presented to us, and to posterity, which will thus have even more reason than we have to be grateful for her fortitude as a traveller, her talent and industry as an artist, and her liberality and public spirit.

The architect of the building (which may be described as classical, and the principal feature of which is the gallery 50 × 25 ft.) is Jas. Fergusson, Esq., F.R.S., who, actuated by the same generous spirit as his friend the donor, gave the plan and supervised every detail of its construction.

J. D. HOOKER, DIRECTOR.

ROYAL GARDENS, KEW,
June 1, 1882.

BIOGRAPHICAL NOTICE OF MARIANNE NORTH.

Since the publication of the fourth edition of this Guide, the talented painter and generous donor of the collection of pictures which it describes has passed away. Her autobiography ("Recollections of a Happy Life") has been published under the supervision of her sister, Mrs. John Addington Symonds. The following brief sketch has been compiled from this and other sources :—

Marianne North was born at Hastings in 1830, and was the daughter of Mr. Frederick North, of Rougham, in Norfolk, who was for some time M.P. for Hastings. Her mother was the eldest daughter of Sir John Marjoribanks. Music and painting were her natural gifts, and she early developed the great skill in painting flowers that has rendered her name famous.

Frequent travel gave her opportunities for exercising this talent, until it grew into an all-absorbing passion. The years 1865 to 1867 she spent with her father, chiefly in Syria and on the Nile, and a series of sketches made during this period received high praise from competent judges. Mr. North died in 1869, and thereafter his daughter devoted her life to painting. In 1869-70 she travelled and painted in Sicily, but only one of the paintings (361) made in that country is in the collection at Kew. It is interesting, as representing a group of papyrus growing in the River Ciane, the only locality in which it is found wild on the European side of the Mediterranean, where it may possibly have been introduced. There is also only one painting (360) from the Nile regions. It illustrates the remarkable Doum and Date Palms. In 1871 or 1872 Miss North visited North America and the West Indies, and painted assiduously, spending more than two months in solitude in a lonely house amongst the hills of Jamaica. Many of the paintings made on this journey are in the gallery at Kew, and they were the first submitted to botanical scrutiny ; a small selection of them was sent to Sir Joseph Hooker. Her next voyage was to Brazil, where she was received with much

distinction by the Emperor; yet she lived the greater part of the time in a deserted hut in the forest, and her provisions were taken to her from a distance of eight miles by a slave woman, who is commemorated in one of the paintings (56) at Kew. On the return journey Miss North called at Teneriffe. Then followed a trip round the world, with stoppages for work in California, Japan, Borneo, Java, Singapore, and Ceylon, and thence homeward again. The same year she returned to India, visiting the forests of the Himalayas, the chief places of note on the Ganges, and Bombay. During her absence some 500 of her paintings were exhibited at South Kensington.

It was after her return from India that she first conceived the idea of presenting her collection to the nation, and arrangements were made for the erection of a suitable building in Kew Gardens at her expense. At the suggestion of the late Mr. Darwin, and in order to render the collection more nearly representative of the Flora of the world, Miss North next proceeded to Australia, Tasmania, and New Zealand; and the fruits of this long journey are, perhaps, the finest of the collection, very fully illustrating the most striking features of the marvellous Australasian Flora.

In 1881 the gallery was so far advanced that the hanging of the paintings could be taken in hand, but this was a long and toilsome task. The paintings were so numerous that it was necessary to hang them close together, and cover the walls from the dado to the cornice, involving months of labour in adjusting, reducing, painting odd bits here and there, putting in little accessories, touching up, and finishing off generally.

By dint of hard work up to the very day, this unique present to the nation was thrown open to the public on July 9th, 1882. By the end of July the first edition of the catalogue, an impression of 2000, was sold out, and in less than a year another edition of 5000 was sold,—the best evidence that could be had of the popularity of the gift. This was highly gratifying to Miss North, for, much as she disliked flattery, she was keenly sensitive, and awaited the verdict of the impartial public with some anxiety.

No sooner was this work completed than Miss North began to make arrangements to visit South Africa, Madagascar, Mauritius, and the Seychelles; but she was unable to carry out the whole of this programme in consequence of the long intervals between the ships sailing, quarantine arrangements, &c.

As a specimen of her letters, one from South Africa, dated 9th December 1882, shows how bravely she was struggling against breaking health and diminishing strength. It also testifies to the independence of her character, and her hearty recognition of similar tastes and a love of nature in others, quite apart from the social position of the person :—

". . . . I am very tired and older every day, but this country is worth some fatigue to see. What lies people tell about it! Over and over again I have been told it is a most wretched country—no flowers, nothing! and I find quantities of the most beautiful things on every side. I came overland to Port Elizabeth, driving over the desert Karroo, and even there I found treasures, and saw wonderful effects of mirage and wild deer and long-legged birds. The railway down to the sea took me through the most glorious swampy valley of Euphorbias, prickly pears, and Aloes, with red flowers, often higher than men, all tangled up in ivy geranium and Plumbago in full flower, and the lovely wild vine, *Cephalandra*, with creamy flowers and scarlet egg-fruit, hanging in the most lovely festoons. And every now and then we came to groups of Kaffir-huts, and grand people stalking about in bright red drapery and feathers in their heads, like Mephistopheles on the stage. It was all too wonderful! A tame ostrich, too, walked on to the platform and made faces at the train at one of the stations. Port Elizabeth is quite a model little town for neatness and comfort, with the most delicious supply of water brought thirty miles from the gorge near this. I rode up there one day We found three sorts of *Harveya*. I have painted four ; they are so very lovely, and said to be parasites. On the very edge of the waterfall we found quantities of *Disa*, small but exquisite, growing (like its grand relative on Table Mountain) with its roots in the running water ; and blue Agapanthus, Zamias and Euphorbias were clinging to the rocks above us, with any quantity of Gladiolus, ferns, and other lovely things. We returned over the downs on the other side of the mountains, and found all the finest Proteas, most gorgeous, though nearly out of bloom ; also *Sparaxis pulcherrima*, pink bells waving in the wind on nearly invisible stalks. This house is quite perfect quarters —farm house and hotel combined—with the kindest people, who treat one like an old friend. It is quite solitary, with open flowery country all round, and deep cracks in the table-land filled with the richest tangled forest. The sides of these

'kloofs' are so steep that one hardly sees them till one reaches the very edge, and they are haunted by huge baboons ; and a leopard was caught lately a few miles off. I am warned to be careful ; what that means exactly I do not know ! so I only go as far as my strength allows me. One can but die once ; anyhow, it does not much matter to me. I leave this on Monday for a few days amongst the spekbooms (*Portulacaria afra*) and possible elephants. I then go up the Zuurberg, and on to Grahamstown, the Catberg, King, Queen, and East London, and again back to Knysna Forest, and hope to get back to the Cape in February to see the great *Disa* and summer flowers on the mountain and paint some landscapes, with the silver forests. It was too cold when I was there before. After that I shall go straight to Natal. I shall not be home so soon as I thought, unless I get ill, but shall want a new room at least to put all the work in."

Miss North succeeded in accomplishing the journeys and the paintings she alludes to in the foregoing letter, and returned to England in the spring of 1883, though further enfeebled by an attack of fever. However, after a few months' comparative repose, this courageous lady proceeded to the Seychelles, where she painted the peculiar palms, screw-pines, and other characteristic plants. In the meantime she had set the builders to work on a new wing to the gallery at Kew, to receive the new paintings.

Miss North's last journey was to Chili in the autumn of 1884. She had painted the Brazilian Araucaria in its home, and the Australian Bunya-bunya, and she wished to paint the Chilian Araucaria. In a characteristic letter, which appeared in the " Pall Mall Gazette " in March, 1885, she thus describes her visit :—

"Soon after reaching the first Araucarias we found ourselves surrounded by them, and all other trees gave way to them, though the ground was still gay with purple peas and orange orchids, and many tiny flowers, whose names I did not know, and which I had not time to paint. Such flowers, when picked, die almost directly. Many hills and the valleys between were covered with old trees, over some miles of space, and there are few specimens to be found outside their forest. I saw none over 100 feet high or 20 feet in circumference, and, strange to say, they seemed all very old or very young. I saw none of those noble specimens of middle age we have in some English parks,

with their lower branches resting on the ground. They had not become flat-topped, like those in Brazil, but were slightly domed, like those of Queensland, and their shiny leaves glittered in the sunshine, while their trunks and branches were hung with white lichen, and the branches weighed down with cones as big as one's head. The smaller cones of the male trees were shaking off clouds of golden pollen, and were full of small grubs, which, I suppose, attracted the flights of parroquets I saw so busily employed about them. These birds are said to be so clever that they can find a soft place in the great shells of the cone when ripe, into which they get the point of their sharp beak, and fidget it until the whole cracks, and the nuts fall to the ground. It is a food they delight in, and men, too, when properly cooked, like chesnuts. The most remarkable thing about the trees was the bark, which was a perfect child's puzzle of knobby slabs of different sizes, with five or six decided sides to each, and all fitted together with the neatness of a honeycomb. I tried in vain to find some system on which it was arranged."

On her return from South America in 1885, Miss North at once commenced hanging the new paintings, which, including those from South Africa and Seychelles, are some two hundred in number. Among the latter was the "Capucin," an imperfectly known tree. The drawing of the foliage and fruit brought by Miss North, with the flowers, which were subsequently sent at her request, enabled Sir Joseph Hooker to determine the tree to be a new genus, which he appropriately named *Northea*, in honour of the artist. Miss North is also commemorated in *Crinum Northianum*, Baker, *Kniphofia Northiana*, Baker, and *Nepenthes Northiana*, Hook. f., the former of which was described from her drawings,—the highest compliment which could be paid to their scientific accuracy.

After her work was finished at Kew, Miss North "tried to " find a quiet home in the country with an old house and a " garden to make after her own fashion."

In her "Recollections," under the date of 1886, she says:— " I have found the exact place I wished for at Alderley, in " Gloucestershire, and already my garden is becoming famous " among those who love plants ; and I hope it may serve to " keep my enemies, the so-called ' nerves,' quiet for the few " years which are left me to live. The recollections of my " happy life will also be a help to my old age. No life is so

" charming as a country one in England, and no flowers are
" sweeter or more lovely than the primroses, cowslips, blue-
" bells, and violets which grow in abundance all round me
" here."

But her life at Alderley only lasted five years, and of that
period more than half had been shadowed by painful illness.
She died on Saturday, August 30th, 1890, and was buried in
the churchyard at Alderley.

HISTORY AND EXTENT OF THE COLLECTION.

THE whole of the paintings in this gallery were executed by Miss Marianne North between 1872 and 1885, and nearly all of them in the countries inhabited by the plants. In order to give some idea of the extent to which the collection illustrates the vegetation of the temperate and tropical regions of the world a coloured map is appended; red indicating the countries actually visited by the artist, and green those countries whence she obtained many important ornamental and useful plants through various botanic gardens in both hemispheres. Of course, in so small a map it is impossible to show accurately the areas traversed; but it may be stated of the regions coloured red that the most striking features, as well as many of the smaller details, of their scenery are represented much more fully than might be supposed. In other words, the aspect of nature in those countries, though they might be indefinitely multiplied as to details, would not offer great diversity in their general characters. They might include different species of the same genera here depicted, and they might include other genera of the same natural orders; yet they would only differ in their composition, not materially in their physiognomy.

Nevertheless, from the particulars given further on of the floras of the various countries visited, it will be apparent, that large as the number of genera and species of plants portrayed is, it is only a very small proportion of the numbers inhabiting the countries under consideration. It has not been deemed necessary, or even desirable, to name every flower in each painting; still time has not been spared in the endeavours to identify all those possessing any special interest.

Many persons whose knowledge of botanical names is necessarily limited, ask why English names are not given to all the flowers. The only answer to such a question is that they possess none; and experience teaches that translations of the botanical names are equally perplexing. After all, few of the botanical names are really more formidable than Chrysanthemum, Rhododendron, Pelargonium, and others, which are familiar to most persons. At the same time, existing English names, as well as intelligible current native names, are always given in the descriptions of the paintings, and by preference in the titles.

The following is a list of the plants, as far as they have been named, arranged alphabetically under their respective natural orders. An analysis of its composition is given at the end of the list.

Enumeration of the Plants named, Alphabetically arranged under their Natural Orders.

1. RANUNCULACEAE.

Anemone rivularis	Himalaya
Aquilegia canadensis	N. America
—— *chrysantha*	California
Clematis	Japan
Delphinium variegatum	California
Paeonia Moutan	China
Ranunculus Lyallii	New Zealand

2. DILLENIACEAE.

Wormia ferruginea	Seychelles

3. CALYCANTHACEAE.

Calycanthus laevigatus	N. America

4. MAGNOLIACEAE.

Drimys Winteri	Chili
Liriodendron tulipifera	N. America
Magnolia grandiflora	N. America
—— *obovata*	Japan
Michelia Champaca	India
—— *excelsa*	India

5. ANONACEAE.

Anona Cherimolia	Trop. America
—— *muricata*	Tropical America
—— *reticulata*	Tropical America
Cananga odorata	Tropical Asia
Polyalthia macropoda	Perak

6. BERBERIDEAE.

Lardizabala biternata	Chili

7. NYMPHAEACEAE.

Nelumbium speciosum	Asia, Australia
Nymphaea gigantea	Australia
—— *Lotus*	S. India
—— *stellata*	S. Africa
Victoria regia	S. America

8. SARRACENIACEAE.

Darlingtonia californica	N. America
Sarracenia flava	N. America
—— *purpurea*	N. America

9. PAPAVERACEAE.

Argemone mexicana	Mexico
Meconopsis Wallichii	India

Papaver orientale	Asia Minor
—— *somniferum*	Asia

10. FUMARIACEAE.

Dielytra spectabilis	China

11. CRUCIFERAE.

Cheiranthus Cheiri	Europe
Matthiola	S. Europe

12. CAPPARIDEAE.

Capparis spinosa	Mediterranean Region

13. RESEDACEAE.

Reseda odorata	Asia Minor

14. CISTACEAE.

Cistus ladaniferus	Portugal

15. VIOLACEAE.

Viola maculata	Chili
—— *serpens*	India

16. BIXINEAE.

Bixa Orellana	Tropical America

17. PITTOSPOREAE.

Billardiera longiflora	Tasmania
Cheiranthera filifolia	W. Australia
Sollya heterophylla	W. Australia

18. TREMANDREAE.

Tetratheca filiformis	W. Australia

19. POLYGALEAE.

Comesperma volubile	W. Australia

20. CARYOPHYLLACEAE.

Silene californica	California

21. PORTULACEAE.

Calandrinia discolor	Chili
Claytonia perfoliata	California
Portulaca grandiflora	Chili
Portulacaria afra	S. Africa

22. TAMARISCINEAE.

Fouquieria splendens	Arizona

23. GUTTIFERAE.

Calophyllum Inophyllum	Seychelles
Clusia - - -	Brazil
Garcinia dulcis -	Borneo
—— Mangostana -	Borneo
Mammea americana	S. America
Mesua ferrea - -	India

24. TERNSTROEMIACEAE.

Camellia japonica -	Japan
—— theifera - -	China

25. DIPTEROCARPEAE.

Shorea robusta - -	India

26. MALVACEAE.

Adansonia digitata -	Africa
Bombax malabaricum	India
Chorisia speciosa -	Brazil
Durio zibethinus -	Singapore
Eriodendron anfractuosum	Jamaica
Gossypium barbadense	America
—— herbaceum -	India
—— peruvianum	America
Hibiscus calycinus -	Natal
—— cannabinus	Tropics
—— Cooperi -	New Caledonia
—— esculentus -	Tropics
—— heterophyllus -	Australia
—— Huegelii	W. Australia
—— liliiflorus -	Seychelles
—— pedunculatus	S. Africa
—— Rosa-sinensis -	China
—— Sabdariffa	Tropics, Old World
—— surattensis	Tropics, Old World
—— tiliaceus	Tropics
—— Trionum	Warm Regions, Old World
Pachira marginata -	Brazil
Paritium elatum -	Jamaica
Pavonia Mutisii -	Natal
Plagianthus Lyallii -	New Zealand
Thespesia populnea	Tropics, Old World

27. STERCULIACEAE.

Dombeya Burgessiae -	Natal
Pterospermum acerifolium	India
Sterculia coccinea -	Borneo
—— parviflora -	Malaya
—— rupestris	Queensland
Theobroma Cacao	Tropical America

28. TILIACEAE.

Aristotelia Maqui -	Chili
—— peduncularis -	New Zealand
Grewia lasiocarpa -	Kaffraria
Luhea rufescens -	Brazil
Tricuspidaria dependens	Chili

29. LINEAE.

Linum usitatissimum -	Europe

30. MALPIGHIACEAE.

Acridocarpus natalitius -	Kaffraria
Sphedamnocarpus pruriens	Kaffraria

31. ZYGOPHYLLEAE.

Guaiacum officinale -	Jamaica
Zygophyllum - -	S. Africa

32. GERANIACEAE.

Averrhoa Bilimbi	Tropical America
—— Carambola -	Tropical America
Geranium maculatum -	N. America
Impatiens -	Kaffraria, Himalaya
Monsonia speciosa -	S. Africa
Oxalis carnosa -	Chili
—— semiloba -	Natal
Pelargonium oxalidifolium	S. Africa
—— peltatum -	S. Africa
—— triste -	S. Africa
Tropaeolum tricolorum -	Chili

33. RUTACEAE.

Aegle Marmelos -	India
Boronia - -	N. S. Wales
Calodendron capense -	S. Africa
Citrus Aurantium -	Tropical Asia
—— decumana -	Tropical Asia
—— Medica -	Tropical Asia
Clausena Wampi -	China
Correa - -	N. S. Wales
Diosma ? -	S. Africa
Eriostemon -	N. S. Wales
Zanthoxylum capense -	S. Africa

34. SIMARUBEAE.

Ailantus glandulosa	Japan
Quassia amara -	Tropical America

35. OCHNACEAE.

Ochna - - - - S. Africa

36. BURSERACEAE.

Canarium commune - - Java

37. MELIACEAE.

Amoora Aphanamixis - - Java
Carapa moluccensis
 Tropics, Old World
Lansium domesticum - Borneo
Melia Azadirachta - Tropical Asia
Sandoricum indicum - Tropical Asia
Turraea obtusifolia - S. Africa

38. OLACINEAE.

Apodytes dimidiata - Kaffraria

39. CELASTRINEAE.

Maytenus chilensis - - Chili

40. RHAMNACEAE.

Ceanothus pallidus - N. America

41. AMPELIDEAE.

Cissus discolor - - - Borneo
Pterisanthes polita - - Borneo
Vitis himalayana - - India
 —— inconstans - - Japan

42. SAPINDACEAE.

Blighia sapida - Tropical Africa
Melianthus major - S. Africa
Nephelium lappaceum - Borneo

43. ANACARDIACEAE.

Anacardium occidentale - India
Corynocarpus laevigata - N. Zealand
Duvaua - - - - Chili
Harpephyllum caffrum - S. Africa
Mangifera indica - - India
Rhus caustica - - - Chili
Spondias dulcis - W. Polynesia

44. MORINGACEAE.

Moringa pterygosperma - Tropics

45. CONNARACEAE.

Rourea - - - Borneo

46. LEGUMINOSAE.

Abrus precatorius - Tropics
Acacia alata - - W. Australia
 —— armata - E. Australia
 —— Catechu - - - India
 —— cavenia - - - - Chili
 —— Cyclops - - W. Australia
 —— dealbata Tasmania, Australia
 —— horrida - - S. Africa
Albizzia Lebbek - - India
Amherstia nobilis - - Burma
Arachis hypogoea - - S. America
Bauhinia Vahlii - - India
 —— variegata - - India
Burtonia conferta - W. Australia
Butea frondosa - - - India
Cassia alata - - - Tropics
 —— corymbosa - - S. America
 —— fistula - Tropics, Old World
 —— mimosoides - - Tropics
 —— nodosa - - Tropical Asia
Clianthus Dampieri - Australia
 —— puniceus - - New Zealand
Clitoria ternatea - - Malaya
Crotalaria - - - - Java
Cynometra cauliflora - - Malaya
Daviesia - - - N. S. Wales
Dolichos - - - Kaffraria
Erythrina caffra - - - Natal
 —— indica - - - India
Gompholobium polymorphum
 W. Australia
Haematoxylum campechianum
 Yucatan
Indigofera - - Himalaya
Kennedya coccinea - W. Australia
 —— nigricans - - W. Australia
Koompassia excelsa - - Borneo
Lathyrus macropus - - Chili
Lupinus - - - - Chili
Mimosa pudica Tropical America
Mucuna - - - - Brazil
Ougeinia dalbergioides - India
Parochetus communis Tropical Asia
Periandra dulcis - - Brazil
Pithecolobium filicifolium
 Tropical America
Platylobium triangulare N. S. Wales
Podalyria calyptrata - S. Africa
Poinciana regia - Madagascar

Psoralea glandulosa - - Chili
Pterocarpus indicus - Trop. Asia
Rafnia amplexicaulis - S. Africa
Robinia Pseudacacia - N. America
Saraca declinata - - Java
—— *indica* - - India
Schotia speciosa - - Natal
Sesbania grandiflora
 Malaya, N. Australia
Sutherlandia frutescens - S. Africa
Tamarindus indica
 Tropics, Old World
Vigna vexillata - - Tropics
Wistaria chinensis - China, Japan

47. ROSACEAE.

Chamaebatia foliolosa - California
Crataegus Oxyacantha - Europe
Cydonia japonica - - Japan
Eriobotrya japonica - - Japan
Grielum tenuifolium - S. Africa
Quillaja Saponaria - - Chili
Rosa canina - - Europe
—— *laevigata* - - N. America
—— *rubiginosa* - - Europe
—— *sinica* - - China
Rubus australis - New Zealand
—— *rosaefolius* - India, Malaya

48. SAXIFRAGEAE.

Anopterus glandulosus - Tasmania
Cephalotus follicularis W. Australia
Hydrangea altissima - - India
—— *Hortensia* - - Japan
Lithophragma heterophylla
 California

49. CRASSULACEAE.

Bryophyllum calycinum
 Tropical Africa
Cotyledon - - S. Africa
Crassula coccinea - S. Africa
—— *perfoliata* - - S. Africa
Rochea - - - S. Africa
Sempervivum - - Teneriffe

50. DROSERACEAE.

Byblis gigantea - W. Australia
Dionaea muscipula - N. America
Drosera cistiflora - - S. Africa
—— *pauciflora* - S. Africa

51. BRUNIACEAE.

Brunia? - - - S. Africa

52. HALORAGEAE.

Gunnera scabra - - Chili

53. RHIZOPHORACEAE.

Anisophyllea trapezoidalis Singapore
Bruguiera gymnorhiza - Tropics

54. COMBRETACEAE.

Combretum grandiflorum
 Tropical Africa
Quisqualis indica - - India
Terminalia Catappa
 Tropics, Old World
—— *citrina* - - - India

55. MYRTACEAE.

Agonis flexuosa - W. Australia
Barringtonia speciosa
 Tropics, Old World
Beaufortia decussata W. Australia
Callistemon lanceolatus - Australia
—— *salignus* - - N. S. Wales
—— *speciosus* - W. Australia
Calothamnos - - Australia
Eucalyptus amygdalina Australia
—— *calophylla* - W. Australia
—— *cordata* - - Tasmania
—— *diversicolor* - W. Australia
—— *ficifolia* - W. Australia
—— *Globulus* - - Australia
—— *macrocarpa* - W. Australia
—— *marginata* - - W. Australia
—— *obliqua* - - Australia
—— *paniculata* - Australia
—— *piperita* - - N. S. Wales
—— *tetraptera* - W. Australia
Eugenia aquea - - - Burma
—— *caryophyllata* - - Moluccas
—— *grandis* - - - Tropics
—— *Jambos* - - - Malaya
Grias cauliflora Tropical America
Leptospermum laevigatum Australia
—— *scoparium* - - Australia
Melaleuca Leucadendron Australia
Metrosideros lucida - New Zealand
—— *tomentosa* - New Zealand
Psidium Guayava Tropical America
—— *pyriforme* - Tropical America
Syncarpia laurifolia - N. S. Wales
Tristania Whiteana - Malaya

56. MELASTOMACEAE.

Medinilla magnifica - Manila
Melastoma - - - Java
Pleroma granulosum - Brazil

57. LYTHRACEAE.

Lagerstroemia Flos-reginae
Tropical Asia
—— indica - - Tropical Asia
Lawsonia inermis - Tropical Asia
Punica granatum - N. W. India

58. ONAGRACEAE.

Fuchsia macrostemon - - Chili
Oenothera acaulis - - Chili

59. LOASACEAE.

Grammatocarpus volubilis - Chili
Loasa acanthifolia - Chili

60. PASSIFLORACEAE.

Carica Papaya Tropical America
Passiflora alata Tropical America
—— edulis - Tropical America
—— foetida - - - Brazil
—— laurifolia Tropical America
—— macrocarpa Tropical America
—— quadriglandulosa
Tropical America
Tacsonia mollissima - S. America
—— pinnatistipula - - Chili

61. CUCURBITACEAE.

Cephalandra palmata - S. Africa
Cucurbita digitata - - Arizona
Momordica involucrata - S. Africa

62. BEGONIACEAE.

Begonia maculata - - Brazil
—— natalensis - - S. Africa

63. CACTACEAE.

Cereus coerulescens - - Brazil
—— giganteus - - - Arizona
—— Quisco - - - - Chili
—— speciosissimus
West Indies, Mexico
Echinocactus - - - Chili
Echinopsis oxygona - Mexico
Opuntia Dillenii - - S. America
—— coccinellifera - S. America

64. FICOIDEAE.

Mesembryanthemum chilense - Chili
—— edule - - S. Africa

65. UMBELLIFERAE.

Aciphylla - - New Zealand
Actinotus Helianthi - N. S. Wales

Eryngium depressum - - Chili
—— paniculatum - - Chili
Xanthosia rotundifolia W. Australia

66. ARALIACEAE.

Aralia - - - - - Java
Cussonia spicata - - S. Africa
Hedera Helix - - - Britain
Panax crassifolium - Australia
—— Gunnii - - Tasmania
—— longissimum - New Zealand

67. CORNACEAE.

Aucuba japonica - - - Japan
Cornus capitata - Himalaya
—— Nuttallii - - California

68. CAPRIFOLIACEAE.

Lonicera sempervirens - N. America
Viburnum Opulus - - Europe

69. RUBIACEAE.

Anthocephalus Cadamba - India
Argostemma verticillata Himalaya
Burchellia capensis - S. Africa
Cinchona Calisaya - S. America
Coccocypselum discolor - Brazil
Coffea arabica - E. Tropical Africa
Gardenia Thunbergia - - Natal
Ixora coccinea - - Tropical Asia
Luculia gratissima - - India
Mussaenda macrophylla Trop. Asia
Pavetta - - - Kaffraria
Portlandia grandiflora
Tropical America
Vangueria edulis - Madagascar

70. CALYCERACEAE.

Boopis? - - - - Chili

71. COMPOSITAE.

Aspilia - - - - Brazil
Aster grandiflorus - N. America
Baccharis triptera - Brazil
Celmisia coriacea - New Zealand
Centaurea - - - - Chili
Chrysanthemum - - Japan
Cineraria cruenta - Teneriffe
Cryptostemma calendulacea - Cape
Cynara Cardunculus - Europe
Dahlia imperialis - Mexico
—— variabilis - - - Mexico

Helichrysum appendiculatum Natal
—— *speciosissimum* - S. Africa
Helipterum eximium - S. Africa
—— *phlomoides* - - S. Africa
—— *rubellum* - - W. Australia
Kleinia - - - Teneriffe
Layia platyglossa - California
Microstephium niveum - S. Africa
Mutisia decurrens - - Chili
—— *rosea* - - - Chili
Oldenburgia arbuscula - S. Africa
Olearia argophylla - Australia
Osmitopsis asteriscoides - S. Africa
Othonna amplexicaulis - S. Africa
Proustia pyrifolia - - Chili
Raoulia eximia - New Zealand
Senecio macroglossus - Natal
Sonchus - - - Teneriffe
Triptilion - - - Chili

72. STYLIDIACEAE.

Stylidium - - - Australia

73. GOODENOVIACEAE.

Leschenaultia biloba W. Australia
Scaevola Koenigii
Tropics, Old World

74. CAMPANULACEAE.

Campanula Medium
Central Europe
Canarina Campanula
Canary Islands
Cyphia volubilis - - S. Africa
Isotoma Brownii - W. Australia
Lobelia cardinalis - N. America
—— *salicifolia* - - - Chili
Pratia begoniaefolia - - Java

75. VACCINIACEAE.

Gaylussacia resinosa - N. America

76. ERICACEAE.

Andromeda mariana - N. America
Azalea nudiflora - N. America
Erica arborea - - Teneriffe
—— *grandiflora* - S. Africa
Gaultheria hispida - Tasmania
Kalmia latifolia - N. America
Pernettya mucronata - - Chili
Rhododendron arboreum Himalaya
—— *Auchlandii* - Himalaya

Rhododendron calophyllum
Himalaya
—— *catawbiense* - N. America
—— *cinnabarina* - Himalaya
—— *Dalhousiae* - Himalaya
—— *Falconeri* - - Himalaya
—— *formosum* Himalaya
—— *grande* - - Himalaya
—— *Griffithianum* - Himalaya
—— *javanicum* - - Java
—— *nilagiricum* - - S. India
—— *Nuttallii* - - Himalaya

77. MONOTROPACEAE.

Sarcodes sanguinea - California

78. EPACRIDACEAE.

Cyathodes glauca - - Tasmania
Dracophyllum Traversii
New Zealand
Epacris longiflora - Australia
Leucopogon verticillatus
W. Australia
Lissanthe strigosa - Tasmania
Richea dracophylla - Tasmania
Styphelia - - - N. S. Wales

79. PLUMBAGINACEAE.

Plumbago capensis - S. Africa
Statice scabra - - S. Africa

80. PRIMULACEAE.

Dodecatheon Meadia - N. America

81. SAPOTACEAE.

Achras Sapota - Tropical America
Bassia latifolia - - India
Chrysophyllum Cainito - Jamaica
Dichopsis Gutta - - Malaya
Mimusops Elengi - - India
Northea seychellana - Seychelles
Sideroxylon inerme - S. Africa

82. EBENACEAE.

Diospyros Kaki - - Japan

83. OLEACEAE.

Forsythia viridissima Andamans
Jasminum gracillimum - Borneo
Notelaea ligustrina - Tasmania
Nyctanthes Arbor-tristis - India
Olea europaea Mediterranean Region
Syringa vulgaris - - Europe

84. APOCYNACEAE.

Acokanthera venenata - S. Africa
Beaumontia grandiflora - India
Carissa grandiflora - S. Africa
Cerbera Tanghin - Madagascar
Dipladenia crassinoda - Brazil
Macrosiphonia longiflora - Brazil
Nerium odorum - Tropical Asia
—— Oleander - - Orient
Odontadenia speciosa - - Brazil
Plumeria acutifolia
　　　　　　Tropical America
Roupellia grata - - Brazil
Strophanthus dichotomus - Java
—— divergens - S. Africa
Tabernaemontana? - - Brazil
Trachelospermum jasminoides
　　　　　　　　China
Vinca rosea - - Seychelles

85. ASCLEPIADACEAE.

Asclepias curassavica
　　　　　　Tropical America
Calotropis gigantea - - India
Ceropegia Sandersoni - Natal
Dischidia Collyris - - Borneo
Gomphocarpus fruticosus S. Africa
—— grandiflorus - S. Africa
Hoya coriacea - - Malaya
—— imperialis - - Malaya
Microloma linearis - - S. Africa
Riocreuxia torulosa - Kaffraria
Sarcostemma aphylla - India
—— viminale - Seychelles
Stapelia bufonia - - S. Africa
Stephanotis floribunda Madagascar

86. LOGANIACEAE.

Buddleia globosa - - Chili
Fagraea auriculata - - Java

87. GENTIANACEAE.

Chironia pedunculata - S. Africa
Crawfurdia speciosa - Himalaya
Erythraea chilensis - - Chili
—— venusta - - California
Limnanthemum Thunbergii
　　　　　　　S. Africa
Lisianthus inflatus - - Brazil
—— pulcherrimus - - Brazil

88. POLEMONIACEAE.

Cobaea scandens - - Mexico
Collomia coccinea - - Chili
Phlox - - - California

89. HYDROPHYLLACEAE.

Phacelia grandiflora - California
—— Whitlavia - California
Wigandia - - - America

90. BORAGINACEAE.

Cordia subcordata
　　　　　Tropics, Old World
Echium simplex - - Teneriffe
Heliotropium indicum - Tropics
Lobostemon - - - S. Africa
Mertensia virginica - N. America

91. CONVOLVULACEAE.

Argyreia speciosa - - India
Cuscuta americana
　　　　　　Tropical America
Dolia tomentosa - - - Chili
Evolvulus - - - Brazil
Ipomoea Batatas Tropical America
—— biloba - - - Tropics
—— Bona-nox - - Tropics
—— macrorhiza - N. America
—— mutabilis - W. Indies, Mexico
—— palmata - - - Tropics
—— purpurea - Tropical America
—— Quamoclit - - Tropics
—— rubro-coerulea
　　　　　　Jamaica, Mexico
—— ventricosa - - W. Indies
Porana grandiflora - - India
Quamoclit Nationis - - Brazil

92. SOLANACEAE.

Anthocercis viscosa - W. Australia
Brunfelsia americana
　　　　　　Tropical America
—— Hopeana - - - Brazil
Cyphomandra betacea
　　　　　　Central America
Datura alba - - - Tropics
—— arborea - - - Tropics
—— sanguinea Tropical America
Fabiana imbricata - - Chili
Iochroma - - - America

Nicotiana Tabacum
 Tropical America
Physalis - - - Java
Salpiglossis sinuata - - Chili
Schizanthus pinnatus - Chili
Solandra grandiflora
 Tropical America
Solanum esculentum - Tropical Asia
—— *tuberosum* - - S. America

93. SCROPHULARIACEAE.

Antirrhinum Coulterianum
 California
Aptosimum depressum - S. Africa
Calceolaria - - Chili
Castilleia affinis - - California
Collinsia bicolor - California
Cycnium adoense - - S. Africa
—— *tubatum* - - S. Africa
Diascia - - - S. Africa
Escobedia scabrifolia
 Tropical America
Gerardia - - - California
Harveya - - - S. Africa
Hyobanche sanguinea - S. Africa
Mimulus glutinosus - California
—— *luteus* - - - - Chili
Orthocarpus purpurascens
 California
Ourisia coccinea - - Chili
Pentstemon azureus - California
—— *centranthifolius* California
Physocalyx - - - Brazil
Rhodochiton volubile - Mexico
Russellia juncea - Mexico
Striga coccinea - - S. Africa
Torenia asiatica - - India
Veronica speciosa - New Zealand

94. OROBANCHACEAE.

Aphyllon uniflorum - N. America

95. LENTIBULARIACEAE.

Utricularia montana
 Tropical America

96. GESNERACEAE.

Aeschynanthus bracteata - India
—— *longiflora* - - Borneo
Agalmyla staminea - - Java
Chirita urticaefolia - N. India
Codonanthe Hookeri - Brazil
Didymocarpus reticosus - Borneo
Stenogaster concinna
 Tropical America
Streptocarpus Rexii - S. Africa

97. BIGNONIACEAE.

Bignonia aequinoctialis - Brazil
—— *unguis* - - - Ceylon
—— *venusta* - - - Brazil
Colea pedunculata - Seychelles
Crescentia Cujete - - Jamaica
Kigelia pinnata - Tropical Africa
Millingtonia hortensis
 Malay Peninsula
Spathodea campanulata
 Jamaica, West Indies
Tecoma australis - - Australia
—— *Mackenii* - - S. Africa
—— *undulata* - - India
Tecomaria capensis - S. Africa

98. PEDALINACEAE.

Harpagophytum procumbens
 S. Africa
Sesamum indicum - - India

99. ACANTHACEAE.

Aphelandra - - - Brazil
Asystasia coromandeliana S. Africa
Barleria - - - Natal
Blepharis procumbens - S. Africa
Dipteracanthus - - Brazil
Hypoestes - - - Natal
Meyenia - - Tropical Africa
Stenandrium dulce - - Chili
Strobilanthes Wallichii - Himalaya
Thunbergia alata - - India
—— *coccinea* - - India
—— *erecta* - Tropical Africa
—— *grandiflora* - - Borneo
—— *lutea* - - - - India

100. VERBENACEAE.

Clerodendron paniculatum - Java
—— *Thomsonae* W. Tropical Africa
Duranta Plumieri - W. Indies
Gmelina Hystrix - Tropical Asia
Hosea Lobbiana - - - Penang
Lantana
Stachytarpheta mutabilis - America
Verbena - - - Chili

101. LABIATAE.

Lavandula vera - - Europe
Leonotis nepetaefolia - S. Africa
Ocimum sanctum - India
Plectranthus - - - S. Africa
Prostanthera lasianthos Tasmania

Pycnostachys reticulata - Natal
Salvia carduacea - California
—— *Columbariae* - California
—— *patens* - - - Mexico

102. NYCTAGINACEAE.
Bougainvillea spectabilis
Tropical America

103. AMARANTACEAE.
Gomphrena officinalis - Brazil
Iresine Herbstii - - Brazil
Trichinium Manglesii W. Australia

104. CHENOPODIACEAE.
Atriplex - - - Australia
Salicornia - - - S. Africa

105. POLYGONACEAE.
Antigonon leptopus Central America

106. NEPENTHACEAE.
Nepenthes ampullacea - Malaya
—— *distillatoria* - - Ceylon
—— *gracilis* - - - Borneo
—— *Northiana* - - Borneo
—— *Pervillei* - - Seychelles
—— *Phyllamphora* - Moluccas
—— *Rafflesiana* - - Borneo

107. ARISTOLOCHIACEAE.
Aristolochia brasiliensis - Brazil
—— *chilensis* - New Zealand
—— *Goldieana* - West Trop. Africa

108. PIPERACEAE.
Piper Betle - - - India
—— *excelsum* - - New Zealand
—— *nigrum* - - - Malaya
—— *porphyrophyllum* - Malaya

109. MYRISTICACEAE.
Myristica fragrans - Malaya

110. MONIMIACEAE.
Doryphora Sassafras - Tasmania
Peumus fragrans - - Chili

111. LAURACEAE.
Cinnamomum Camphora - Japan
—— *zeylanicum* - - Ceylon
Persea gratissima - America

112. PROTEACEAE.
Banksia attenuata - W. Australia
—— *coccinea* - W. Australia
—— *grandis* - - W. Australia
Bellendena montana - Tasmania
Conospermum triplinerrium
W. Australia

Embothrium coccineum - Chili
Grevillea Banksii - W. Australia
—— *bipinnatifida* - W. Australia
—— *leucopteris* - W. Australia
Hakea cucullata - W. Australia
—— *cyclocarpa* - W. Australia
Lambertia echinata - W. Australia
Leucadendron argenteum - S. Africa
—— *corymbosum* - - S. Africa
—— *platyspermum* - S. Africa
Leucospermum conocarpum
S. Africa
—— *nutans* - - S. Africa
Macadamia ternifolia - Queensland
Mimetes cucullata - S. Africa
Petrophila - - W. Australia
Protea cynaroides - S. Africa
—— *formosa* - - S. Africa
—— *grandiflora* - S. Africa
—— *mellifera* - - S. Africa
—— *pulchella* - - S. Africa
—— *speciosa* - - S. Africa
Telopea speciosissima - Australia
—— *truncata* - - Tasmania
Xylomelum occidentale W. Australia
—— *pyriforme* - N. S. Wales

113. THYMELAEACEAE.
Lagetta lintearia - - W. Indies
Pimelea rosea - - W. Australia

114. LORANTHACEAE.
Atkinsonia ligustrina - N. S. Wales
Loranthus aphyllus - - Chili
—— *aurantiacus* - - Victoria
—— *natalensis* - - Natal
—— *pendulus* - W. Australia
Nuytsia floribunda - W. Australia

115. SANTALACEAE.
Exocarpus cupressiformis Tasmania
Fusanus spicatus - W. Australia
Santalum album - - - India

116. EUPHORBIACEAE.
Dalechampia capensis - S. Africa
Emblica officinalis - India
Euphorbia canariensis - Teneriffe
—— *grandidens* - - Natal
—— *meloformis* - - S. Africa
—— *pulcherrima* Central America
Manihot utilissima
Tropical America
Phyllanthus - - S. Africa

Ricinus communis - - Tropics
Stillingia sebifera - China, Japan

117. URTICACEAE.

Artocarpus incisa - - Polynesia
—— *integrifolia*
 Indian Archipelago
Cecropia peltata Tropical America
Ficus bengalensis - Tropical Asia
—— *Benjamina* - Tropical Asia
—— *elastica* - - - India
—— *glomerata* - - - India
—— *religiosa* - - - India
Humulus Lupulus - - Europe
Laportea moroides - - Australia

118. CASUARINACEAE.

Casuarina equisetifolia
 Tropics, Old World
—— *quadrivalvis* - Australia

119. CUPULIFERAE.

Nothofagus Cunninghamii Australia
—— *obliqua* - - - Chili
Quercus incana - Himalaya
—— *lamellosa* - - - India
—— *serrata* - - - India
—— *suber* - - - W. Europe

120. SALICACEAE.

Populus trichocarpa - California
Salix babylonica - - Caucasus

121. GNETACEAE.

Ephedra andina - - Chili

122. CONIFERAE.

Abies Pindrow - - Himalaya
Araucaria Bidwillii - Queensland
—— *braziliensis* - - Brazil
—— *Cunninghami* - N. S. Wales
—— *excelsa* - - Norfolk Islands
—— *imbricata* - - - Chili
Callitris - - - Australia
Cedrus Deodara - - India
Cryptomeria japonica - - Japan
Dacrydium Colensoi - New Zealand
Frenela rhomboidea - Tasmania
Juniperus virginiana North America
Phyllocladus rhomboidalis Tasmania
Picea Morinda - - - India
Pinus canariensis - - Teneriffe
—— *Lambertiana* - California
—— *ponderosa* - - California
Podocarpus Thunbergii - S. Africa
Sequoia gigantea - California
—— *sempervirens* - - California

123. CYCADACEAE.

Cycas circinalis Tropics, Old World
—— *revoluta* - - - Japan
Macrozamia Fraseri - W. Australia
—— *spiralis* - - N. S. Wales
Stangeria paradoxa - S. Africa
Zamia - - - - S. Africa

124. ORCHIDACEAE.

Angraecum arcuatum S. Africa
—— *eburneum* - - Seychelles
—— *Saundersiae* - S. Africa
—— *sesquipedale* - - Madagascar
Arachnanthe Lowii - - Borneo
—— *moschifera* - - Singapore
Bletia - - - S. America
Broughtonia sanguinea - Jamaica
Calanthe vestita - - Borneo
Cattleya bicolor - - Brazil
—— *Forbesii* - - Brazil
—— *intermedia* - - - Brazil
—— *Loddigesii* - - Brazil
Chloraea - - - - Chili
Coelogyne asperata - - Borneo
—— *Dayana* - - Borneo
—— *pandurata* - - Borneo
Comparettia coccinea - - Brazil
Cymbidium Finlaysonianum Malaya
Cypripedium acaule - N. America
—— *cordigerum* - - India
—— *Hookerae* - - Borneo
—— *Lowii* - - Borneo
—— *pubescens* - - N. America
Dendrobium crumenatum - Malaya
—— *Jenkinsii* - Tropical Asia
—— *primulinum* - Himalaya
—— *secundum* - - Borneo
—— *superbum* - - Tropical Asia
Dendrophylax funalis - Jamaica
Disa cornuta - - S. Africa
—— *graminifolia* - - S. Africa
—— *grandiflora* - - S. Africa
—— *lugens* - - - S. Africa
—— *racemosa* - - S. Africa
—— *tripetaloides* - - S. Africa
—— *venusta* - - S. Africa
Diuris - - - N. S. Wales
Epidendrum cochleatum
 Tropical America
Epistephinum sclerophyllum - Brazil
Eria ornata - - - - Java
Habenaria Bonatea - S. Africa
—— *intermedia* - - India

Haemaria discolor - - China	
Laelia purpurata - - Brazil	
Lissochilus speciosus - S. Africa	
Oncidium ampliatum - - Brazil	
—— *concolor* - - - Brazil	
—— *divaricatum* - - Brazil	
—— *triquetrum* - - Jamaica	
Phajus bicolor - - - Ceylon	
Phalaenopsis amabilis - Singapore	
Pleione Wallichiana - India	
Pleurothallis - - - Brazil	
Polystachya pubescens - S. Africa	
Sarcanthus - - - Borneo	
Sarcochilus Calceolus - Philippines	
Satyrium carneum - S. Africa	
—— *coriifolium* - - S. Africa	
—— *longicolle* - - S. Africa	
—— *nepalense* - - - India	
Sophronitis coccinea - Brazil	
—— *grandiflora* - - Brazil	
Vanda coerulea - - - India	
—— *Hookeriana* - - Borneo	
—— *suavis* - - Tropical Asia	
Vanilla albida - - Malaya	
—— *Phalaenopsis* - Seychelles	
—— *planifolia* - Tropical America	
Zygopetalum brachypetalum Brazil	
—— *intermedium* - - Brazil	

125. BURMANNIACEAE.

Burmannia - - - India	
Geomitra - - - Borneo	
Thismia - - - Borneo	

126. SCITAMINEAE.

Alpinia nutans - Tropical Asia	
Amomum magnificum - Brazil	
Canna Ehemannii - - Gardens	
Costus speciosus - - - Java	
Curcuma Zedoaria - - Java	
Globba atrosanguinea - Borneo	
Hedychium chrysoleucum	
Tropical Asia	
—— *Gardnerianum* - India	
Musa chinensis - - - China	
—— *coccinea* - - - Java	
—— *Ensete* - - Abyssinia	
—— *paradisiaca* - - Tropics	
—— *Sapientum* - - Tropics	
Ravenala madagascarensis	
Madagascar	
Roscoea alpina - - Himalaya	
Strelitzia augusta - S. Africa	
—— *Reginae* - - - S. Africa	

127. BROMELIACEAE.

Ananas sativus - - Brazil	

Billbergia zebrina - - Brazil	
Bromelia Pinguin - - W. Indies	
Dyckia remotiflora - - Brazil	
Pitcairnia rubricaulis - - Chili	
Puya chilensis - - - Chili	
—— *Whytei* - - Chili	
Tillandsia usneoides - - Brazil	

128. HAEMODORACEAE.

Anigozanthus flavida W. Australia	
—— *Manglesii* - W. Australia	
Conanthera bifolia - - Chili	
Conostylis - - W. Australia	
Lanaria plumosa - S. Africa	
Ophiopogon intermedius - India	

129. IRIDEAE.

Antholyza aethiopica - S. Africa	
Aristea - - - S. Africa	
Babiana rubrocoerulea - S. Africa	
Bobartia - - - S. Africa	
Crocosma aurea - - S. Africa	
Dierama pulcherrima - S. Africa	
Freesia Leichtlinii - - S. Africa	
Geissorhiza - - S. Africa	
Gladiolus angustus - S. Africa	
—— *grandiflorus* - S. Africa	
—— *orchioides* - - S. Africa	
Hesperantha falcata - S. Africa	
Homeria collina - - S. Africa	
—— *miniata* - - S. Africa	
Iris germanica - - Europe	
—— *persica* - - - Persia	
Ixia flexuosa - - S. Africa	
—— *speciosa* - - S. Africa	
—— *viridiflora* - - S. Africa	
Lapeyrousia corymbosa - S. Africa	
Libertia ixioides - - - Chili	
Marica - - - Brazil	
Montbretia - - - S. Africa	
Moraea - - - S. Africa	
Patersonia - - N. S. Wales	
Romulea - - - S. Africa	
Sisyrinchium - - - Brazil	
Sparaxis grandiflora - S. Africa	
—— *pulcherrima* - S. Africa	
—— *tricolor* - - S. Africa	
Tigridia Pavonia - - Mexico	
Vieusseuxia Bellendeni - S. Africa	
—— *tripetaloides* - S. Africa	
Watsonia rosea - - S. Africa	

130. AMARYLLIDACEAE.

Agave americana - - Mexico	
Alstroemeria aurantiaca - Chili	
—— *peregrina* - - Chili	

Bomarea Salsilla - -	Chili
Brunsvigia multiflora -	S. Africa
Buphane toxicaria -	- S. Africa
Clivia miniata - -	S. Africa
—— *nobilis* - - -	S. Africa
Crinum augustum -	Borneo
—— *Moorei* - - -	S. Africa
—— *Northianum* -	Borneo
Cyrtanthus angustifolius	S. Africa
—— *obliquus* - -	S. Africa
Doryanthes Palmeri -	Australia
Haemanthus magnificus -	S. Africa
—— *multiflorus* -	Brazil
Hippeastrum Reginae -	Jamaica
Hymenocallis rotata -	W. Indies
Hypoxis stellata - -	S. Africa
Narcissus poeticus -	Europe
Pancratium caribaeum -	Jamaica
Phycella - - -	Chili
Placea ornata -	- Chili
Vellozia verruculosa -	Brazil
Zephyranthes rosea -	America

131. TACCACEAE.

Tacca cristata - -	Singapore

132. DIOSCOREACEAE.

Testudinaria elephantipes	S. Africa

133. LILIACEAE.

Agapanthus umbellatus -	S. Africa
Aloe abyssinica -	Tropical Africa
—— *africana* - -	S. Africa
—— *Bainesii* - -	- Natal
—— *latifolia* - -	Natal
—— *saponaria* - -	S. Africa
—— *vera* - - -	Teneriffe
Bulbine - -	- W. Australia
Calochortus venustus -	California
Cordyline New Zealand,	Australia
Dipidax triquetra - -	S. Africa
Dracaena Draco-	Teneriffe
Drymophila cyanocarpa	Tasmania
Eucomis punctata - -	S. Africa
Fritillaria imperialis -	Asia Minor
—— *latifolia* - -	Caucasus
Gloriosa superba - -	India
Johnsonia lupulina -	W. Australia
Kniphofia aloides -	S. Africa
—— *Northiae* - -	S. Africa
Lachenalia orchioides -	S. Africa
—— *pallida* - -	S. Africa
Lapageria rosea - -	Chili
Leucocoryne - -	- Chili
Lilium auratum -	Japan
—— *Brownii* -	Corean Archipelago

Lilium canadense -	- America
—— *elegans* - - -	Japan
—— *giganteum* -	-Himalaya
—— *japonicum* - -	- Japan
—— *pyrenaicum* -	- Europe
—— *superbum* -	E. N. America
—— *testaceum* - -	- Japan
—— *Wallichianum* -	N. India
—— *Washintonianum*	
	W. N. America
Littsonia modesta -	S. Africa
Ornithogalum narbonense	S. Europe
—— *thyrsoideum* -	S. Africa
Pasithea coerulea - -	Chili
Phormium tenax -	New Zealand
Polygonatum biflorum -	N. America
Scilla nutans - - -	Europe
Smilacina racemosa -	N. America
Thysanotus - -	W. Australia
Trillium grandiflorum -	California
Triteleia laxa - -	California
Tulbaghia alliacea -	S. Africa
Yucca gloriosa -	N. America

134. PONTEDERIACEAE.

Eichornia azurea	Tropical America

135. XYRIDACEAE.

Xyris - - - -	Brazil

136. COMMELYNACEAE.

Coleotrype natalensis -	Kaffraria
Commelina nudiflora -	S. Africa
Rhoeo discolor - -	- Mexico
Tradescantia virginica	N. America

137. FLAGELLARIACEAE.

Flagellaria indica	Tropics, Old World

138. JUNCACEAE.

Kingia australis -	W. Australia
Xanthorrhaea - -	Australia

139. PALMAE.

Acrocomia - - -	Brazil
Archontophoenix Cunninghamii	
	Australia
Areca Catechu -	Tropical Asia
—— *Northiana* -	Queensland
Arenga saccharifera -	- Java
Attalea - - - -	Brazil
Bactris - - -	- Brazil
Bacularia monostachya	Queensland
Borassus flabelliformis	Tropical Asia
Calamus - -	Tropical Asia
Caryota mitis -	- Tropical Asia
—— *urens* - -	Tropical Asia

Cocos nucifera - - Tropics
Corypha Gebanga - - Malaya
—— *umbraculifera* - - India
Cyrtostachys Lakka - - Malaya
Deckenia nobilis - - Seychelles
Dictyosperma alba - Seychelles
Elaeis guineensis - Tropical Africa
Euterpe - - - - Jamaica
Hyphaene thebaica - - Africa
Jubaea spectabilis - - Chili
Kentia minor - - Queensland
Livistona australis - N. S. Wales
Lodoicea sechellarum - Seychelles
Mauritia flexuosa - - Brazil
—— *vinifera* - - - Brazil
Metroxylon Sagu - - Moluccas
Nephrosperma Vanhoutteana
　　　　　　　　　　Seychelles
Nipa fruticans - Tropical Asia
Oreodoxa oleracea - W. Indies
—— *regia* - - - Brazil
Phoenix dactylifera - - Africa
Pinanga malaiana - - Malaya
Ptychosperma - - N. S. Wales
Rhopalostylis sapida - New Zealand
Roscheria melanochaetes - Seychelles
Stevensonia grandifolia - Seychelles
Verschaffeltia splendida Seychelles

140. PANDANACEAE.

Pandanus Hornei - - Seychelles
—— *Kaida* - - - India
—— *odoratissimus* - India, Java
—— *sechellarum* - - Seychelles
—— *tectorius* - - - India
—— *utilis* - - - Madagascar

141. TYPHACEAE.

Typha latifolia - Cosmopolitan

142. ARACEAE.

Amorphophallus campanulatus Java
Anthurium Andraeanum
　　　　　　　　New Granada
Arisaema curvatum - Himalaya
—— *speciosum* - - Himalaya
—— *triphyllum* - N. America
—— *utile* - - - Himalaya
Caladium - - - India
Colocasia Antiquorum Tropical Asia
—— *esculenta* - - Tropical Asia
Dracunculus canariensis - Teneriffe
Gamogyne Burbidgei - Borneo
Philodendron - - - Brazil
Rhaphidophora - - Java

Richardia aethiopica - S. Africa
—— *albo-maculata* - S. Africa
—— *hastata* - - - S. Africa

143. NAIADACEAE.

Aponogeton distachyum - S. Africa

144. RESTIACEAE.

Restio subverticillata - S. Africa

145. CYPERACEAE.

Cyperus Papyrus - - Egypt
—— *syriacus* - - Sicily, Syria

146. GRAMINEAE.

Arundo conspicua - New Zealand
—— *Donax* - - Europe, Asia
Bambusa arundinacea - Tropics
Briza maxima - S. Africa, &c.
Chusquea Quila - - Chili
Dendrocalamus giganteus - Burma
Eleusine coracana - - India
Eragrostis cynosuroides - India
Miscanthus sinensis - China, Japan
Oplismenus - - - India
Oryza sativa - - - Asia
Saccharum officinarum
　　　　　　Tropical America
Setaria - - - India
Zea Mays - - - America

147. FILICES.

Alsophila australis - Queensland
Asplenium Nidus Tropics, Old World
Cyathea medullaris - New Zealand
—— *sechellarum* - - Seychelles
—— *Serra* - - - Jamaica
Dicksonia antartica - Australia
Drymoglossum pilosellides - India
Gleichenia linearis - - Borneo
Lomaria procera
　　South Temp. and Tropical Regions
Lygodium scandens
　　　　　　Tropics, Old World
Pellaea hastata - - S. Africa
Platycerium grande
　　　　　　Malaya, Australia
Polypodium drynaria - Borneo
—— *Phymatodes* Trop. Asia & Africa
Todea barbara S. Africa, Australia
Trichomanes reniforme - N. Zealand

148. LYCOPODIACEAE.

Lycopodium Phlegmaria - Tropics

149. ALGAE.

Sargassum vulgare - - Atlantic

From the foregoing enumeration, it appears that out of about 200 Families of Flowering Plants, as defined and limited by Bentham and Hooker, 146 are represented in this collection of paintings; and the plants depicted belong to no fewer than 727 different genera. With regard to species, the number actually named is about 900 ; but as specific names have only been given to such as could be identified with ease, or without too great an expenditure of time, this number is considerably below the total number painted. A large proportion of those specifically unnamed in the descriptions consists of bulbous plants from South Africa, where the forms are so numerous and closely allied as not to be readily distinguishable except by a specialist. Besides these there are a few small-flowered subjects from various countries. The reason why such distinct plants as the various showy species of *Harveya* (404) are unnamed, is that the dried specimens, the only material we have for comparison, are quite black and not recognisable.

General Features of the Vegetation of the Countries Visited.

Having given a general idea what the present collection of paintings contains, it may be useful to add short paragraphs describing the prominent features and peculiarities of the vegetation of the various countries whose floras are illustrated with some degree of fulness therein, following the order observed in the arrangement of the pictures.

CHILI.

This is a narrow strip of country on the western side of South America, extending through about thirty-five degrees of latitude, from just within the tropics to Cape Horn ; and it is bounded on the east by the Cordilleras, which present a succession, from north to south, of lofty snow-clad peaks and volcanos, the highest of which, Aconcagua, is no less than 23,000 feet. Hence it presents a great range in climatal conditions, which are not more strongly exemplified in the amount of heat than they are in the amount of rainfall or moisture. The northern part lies within the almost rainless desert zone ; the intermediate part enjoys alternate dry and rainy seasons, the latter of short duration ; while the southern part is very rainy. In the north the vegetation is of the

scantiest nature ; in the south the country is clothed with impenetrable evergreen forests ; while the central part, the essentially Chilian region botanically, and the one with which we are concerned more particularly, supports a flora so distinct in character as to merit a special name. Apart from certain limited districts, the almost total absence of an arboreous element is the most remarkable feature in the scenery. Thorny bushes, often with brightly coloured strongly scented flowers, and succulent plants abound ; and conspicuous among the latter are columnar and spherical cactuses, and the gigantic puyas. There is also a great variety of herbaceous and small shrubby plants, generally bearing showier flowers than those of north temperate regions ; and, as in most southern floras, many genera are represented by a large number of species. Thus of *Adesmia* (*Leguminosae*), a genus peculiar to South America, and mainly to Chili, there are upwards of 120 Chilian species ; and *Calandrinia, Chloraea, Alstroemeria,* and *Mutisia,* which are specially characteristic of the region, number from forty to eighty species each. Among more familiar genera may be named *Senecio* with 212 species ; *Oxalis,* 82 ; *Solanum,* 64 ; *Valeriana,* 60 ; *Viola,* 48 ; *Plantago,* 47 ; and *Gnaphalium, Verbena, Poa,* and *Ranunculus,* with about 40 each.

BRAZIL.

The area of Brazil is so vast that it is difficult, or rather impossible, to convey in a few words any definite idea of its vegetation, beyond the fact that it is the richest, densest, and most varied of that of all tropical countries. There are probably not fewer than 15,000 distinct species of flowering plants within its limits, and the number of forms and varieties is infinite. Immense tracts are covered with virgin forests in which are some of the most gigantic trees in the world, belonging to the *Leguminosae, Myrtaceae, Lauraceae,* and other families, and supporting an extraordinary variety of parasitic and epiphytic plants. It is in Brazil that the greatest concentration of Palms is found, they being especially numerous in the valleys of the Amazon. Another family having its headquarters in this country is the *Melastomaceae* ; and among orchids the genera *Cattleya* and *Laelia* are prominent. Of course, it will be understood that the paintings of Brazilian plants do not by any means so fully illustrate the flora of the region as the South African, Australian, and others do the floras of their respective regions.

JAMAICA.

The peculiarities of the vegetation of Jamaica, as distinguished from that of Tropical America generally, are not readily appreciable. Further, the introduced and cultivated plants are at least equally prominent with the native in the paintings done in this island, therefore it is unnecessary to enter into particulars here.

NORTH AMERICA.

The paintings of North American Vegetation fairly exhibit the principal types of the north-eastern and western or Californian floras, and less adequately that of the intermediate region. California is especially rich in pines and firs and other *Coniferae*, including the famous mammoth and redwood trees ; many of them besides those named being remarkable for their great height. They constitute the chief forests of the country, though several species of oak, alder, poplar, willow, and birch are abundant in certain districts. Another prominent feature in the flora of California is the large number of showy flowered herbaceous plants (see 203), many of which are familiar denizens of our gardens. Foremost among these are the *Polemoniaceae* and *Hydrophyllaceae*, including such genera as *Gilia*, *Leptodactylon*, *Phlox*, *Collomia*, *Nemophila* and *Phacelia*. Of *Gilia* alone there are between forty and fifty species.

Turning to the eastern side of the North American continent, and excluding the southern sub-tropical part, we there encounter a very different vegetation. Trees with deciduous leaves prevail ; and the number of different species occurring within a given area is very much larger than in Europe. Oaks are most numerous ; and there is a variety of walnuts, maples, poplars, willows, alders, and birches, with such other genera as lime, plane, horse-chestnut, sweet chestnut, beech and hornbeam, associated with the tulip tree, false acacia, and others, of which there are no wild representative species in Europe. Then there is a number of shrubs having showy flowers, belonging to the genera *Rhododendron*, *Azalea*, *Kalmia*, etc. The herbaceous plants offer some noteworthy endemic types, such as the carnivorous plants (see 212), and numerous *Compositae*, etc.; a large proportion of our common English genera, such as *Ranunculus*, *Geranium*, and *Hypericum* are represented by different, or occasionally the same, species ; and finally there is a third and most interesting category of

herbaceous plants whose nearest allies inhabit the extreme east of Asia, though none of these is in the paintings.

Before leaving this part of the world attention should be directed to the painting (185) of plants characteristic of the dry region of Mexico, which extends northward into the United States territory in Western Texas, New Mexico, Arizona, and Eastern California.

INDIA, INCLUDING CEYLON.

For the purpose of this little book, it is convenient to divide the flora of India into its temperate and tropical elements, answering to the mountain flora above certain altitudes, varying according to locality, and the flora of the plains. The temperate flora is largely composed of species of genera represented by different or the same species in Europe and North America, or in one of these two regions. It should be mentioned here, that generally speaking the genera and species of the north temperate floras have a much wider range than those in the corresponding southern zone. This is explained by the greater isolation of the southern areas of land. In the mountains of Northern India, as in North America, there is a great variety of oaks and maples, and various other deciduous trees enumerated above in the sketch of the vegetation of North America, together with a small proportion of endemic genera. The evergreen trees of the temperate regions of the Himalayas comprise species of *Pinus*, *Abies*, *Cupressus*, *Juniperus*, and *Larix;* but the total number of species is small. There is also a species of *Cedrus*, the familiar Deodar Cedar, which is characteristic of the forests of the north-west. Botanically it is very closely allied to the remotely isolated Lebanon and Atlas Cedars. Shrubs and herbaceous plants stand in the same relation to the European and North American as the trees. Conspicuous among the former are the numerous species of *Rhododendron*, *Viburnum*, and Honeysuckle. Herbaceous plants of genera peculiar to the region are not unplentiful, but far more prominent are the numerous species of such European genera as *Primula*, *Gentiana*, *Corydalis*, *Sedum*, *Saxifraga*, and a host of others.

Descending to the tropical parts, we encounter in the intermediate region a vast number of endemic forms ; but the vegetation of the tropical plains is not so distinct from tropical vegetation generally that the differences are easily detected by the untrained eye. It is largely composed of local genera and species belonging to natural orders universally

spread in tropical countries; yet at the same time there is a considerable infusion of species belonging to genera having a wide range. There are no families restricted to India, or even to tropical Asia; the nearest approach to it being the *Dipterocarpaceae*, a family consisting mainly of large timber trees, confined to the Old World, and almost exclusively to tropical Asia. The *Rutaceae*, or orange family, are also essentially Asiatic. Among genera in cultivation characteristic of subtropical and tropical Asia, though not restricted to it, *Nepenthes*, *Vanda*, and *Dendrobium* are familiar examples.

SOUTH AFRICA.

We have here to deal with a flora so distinct in character as to strike the most unobservant on landing in the country. It is true that no family of plants is absolutely confined to extratropical South Africa, except perhaps the *Bruniaceae*, a small order of shrubs with inconspicuous flowers almost unknown in cultivation. Further, many of the genera there represented by an extraordinarily large number of species have a much wider range, though the exotic species be but few: such are *Pelargonium*, with nearly 200 species; *Mesembryanthemum*, with about 300 species; and *Erica*, with between 400 and 500 species. Nevertheless the great concentration of species of these and other genera coming in the same category give character to the vegetation in almost as great a degree as the strictly endemic genera, which, it may be observed, are very numerous.

The paintings of South African plants embrace samples of the vegetation of the east and the south-west, and the central regions, each of which is characterised by certain dominating elements. Broadly speaking the south-western and central regions are destitute of forests, and such trees as exist are all of small dimensions. The flora of the former, which extends eastward to Port Elizabeth, is characterised by the essentially "Cape" element, as distinguished from the flora of South Africa generally, and it consists largely of bulbous plants, almost endless in variety and brilliancy of colouring, belonging to the Iris, Amaryllis and Lily families, and shrubs belonging to the *Rutaceae*, *Bruniaceae*, *Ericaceae* and *Proteaceae*, &c., associated with the sedge-like plants constituting the *Restiaceae*. To the north of this comparatively limited region is the Karroo or region of succulent plants where, according to Bolus, shrubby plants of the families just enumerated are entirely absent, being replaced by plants with succulent

leaves or stems of the genera *Crassula, Sempervivum, Mesembryanthemum, Stapelia, Euphorbia, Aloe,* and numerous others belonging to various orders, and exhibiting a wealth of species hardly surpassed. In the eastern region extending from Port Elizabeth to Natal the vegetation is of a more subtropical character, with more wood, and in Kaffraria considerable forests. On the confines there is an overlapping of the elements characteristic of the several regions. Some districts of the eastern region are remarkable for their arboreous Aloes and Euphorbias with various Cycads ; and one species of Palm belonging to the same genus as the Date inhabits Natal.

THE SEYCHELLES.

This group of numerous small islands is situated about 500 miles northward from the nearest point of Madagascar, and 900 miles from Mauritius ; and the largest of them, Mahé, is seventeen miles long, with an area of 30,000 acres, and an altitude in the interior of 3000 feet. Praslin is next in size, being however only about 8000 acres in extent.

The vegetation is wholly of a tropical character, and at the present time contains a large intermixture of introduced plants. But the indigenous element, though consisting, as in most remote islands, of a small number of species, is highly interesting on account of its composition. Foremost come the Palms, of which there are seven, or perhaps eight, species belonging to as many different genera, six of which are monotypic, and not found elsewhere. Famous among these is the Coco de Mer or Double Cocoa-nut. Another striking feature in the endemic vegetation is the Screw Pines (*Pandanus*), of which there are three species. Hardly less so is the Capucin Tree (*Northea seychellana*), which is one of the few large trees in the islands, and now from some cause dying out, its whitened trunks being one of the most conspicuous objects in the scenery. One species of Pitcher Plant (*Nepenthes*), and one leafless species of *Vanilla*, are among the remaining endemic plants meriting notice.

TENERIFFE.

From the Indian Ocean we turn to the Atlantic, to the celebrated island of Teneriffe, one of the Canaries, the Fortunate Islands of the older geographers. Many thousands have had a distant view of the peak, which rises upwards of

12,000 feet above the sea; but comparatively few have any knowledge of its vegetation. When first discovered the island was clothed with forests, except the highest part of the peak; and the successive zones of different composition afforded an oft-cited lesson on the distribution of plants as affected by temperature, governed by altitude, as opposed to latitude. Now, the original vegetation, especially of the arboreous kind, is only found in the less accessible parts, being largely replaced by cultivated plants and foreign weeds. Still there are spots where the succulent cactus-like Euphorbias, Stone-crops, Aloes, and other fleshy plants, characteristic of the lower zone, linger. The cactuses (*Opuntia*) and the Date Palm are both introduced plants in Teneriffe; yet it is con-jectured that the latter may be indigenous in some of the islands of the group. A notable production of this region is the Dragon Tree, particulars of which will be found in the descriptions of the paintings. Above this is the zone of laurels, so called in consequence of the preponderance of trees of the laurel family, or bearing laurel-like leaves, succeeded by a zone of Pines (*Pinus canariensis*), a zone of *Retama* (a kind of broom), and a zone of grasses. The Tree Heath inhabits the Pine zone, and sometimes attains a height of forty feet, with a trunk two feet in diameter.

BORNEO AND JAVA.

The vegetation of the tropical regions of these countries is, in its broad features, that of India; and even the mountain flora is very similar in composition to that of the Himalayas, save that the plants of the colder zone of the latter are wanting altogether in consequence of insufficient altitude. Oaks and Rhodo-dendrons are there, but the species are peculiar to the countries. Pitcher Plants (*Nepenthes*) attain their maximum development in Borneo and Java, where also there are a very few plants belonging to genera essentially Australian.

JAPAN.

Most of the paintings of Japanese flowers represent familiar subjects, commonly met with in English gardens, and some of them are very old favourites. The flora of the Japanese islands, considering their area and latitude, is exceedingly rich, and abounds especially in evergreen trees and shrubs, the

majority of the latter having showy flowers. Upwards of
2,000 species of flowering plants are recorded as growing in
Japan. Associated with the bulk of temperate types is a con-
siderable number of a subtropical character.

NEW ZEALAND.

About a thousand species of flowering plants are native of
New Zealand, where there are upwards of a hundred species of
ferns, including many arboreous ones ; proportions probably
unparalleled in any other part of the world, except in some
small oceanic islands. Greater anomalies, however, than this
exist in the New Zealand flora, which is not less remarkable
than that of St. Helena even, and those of other remote islands.
Leguminosae, which are so generally distributed and so exceed-
ingly numerous in Australia and Tasmania, are almost wanting
in New Zealand ; and the universal gum trees of Australia are
wholly absent : yet the strongest affinities of the flora are
Australian, especially in the *Myrtaceae, Rubiaceae, Compositae*,
and *Epacrideae*, not to mention some minor orders. Several
essentially tropical or subtropical orders are represented by a
single species ; thus, there is one Palm and one Pepper. Of
such genera as *Fuchsia* and *Calceolaria*, otherwise exclusively
American, there are two or three species. Some genera are
numerous in species out of all proportion ; thus *Veronica* num-
bers upwards of forty, and *Ranunculus* twenty. The forests
consist chiefly of various species of Beech (*Fagus*) and *Coniferae*
(*Dacrydium, Podocarpus*, etc.). It may be added that Euro-
pean plants have become naturalised to such an extent in some
parts of New Zealand as to threaten the existence of the native
vegetation. The climate of New Zealand is very similar to
that of the south-west of England.

TASMANIA.

In all respects the vegetation of Tasmania is thoroughly
Australian, and the country is to be regarded as a part of the
same botanical region. Gum trees, Acacias, and other cha-
racteristic Australian types pervade the whole country. Here,
as in New Zealand, there are beech forests, but so there are
also in the mountains of Victoria. Comparatively few forms
are peculiar to the island.

AUSTRALIA.

Little is known botanically of immense areas of the interior and the north-west of Australia; yet nearly nine thousand species of flowering plants and ferns have been collected in the country. The actual number given by Baron Mueller in 1882 is 8,800, whereof 7,550 were not known to occur elsewhere. In the whole of extratropical Australia, and especially in the south-western part, very few plants are found growing wild, except those known to have been introduced either accidentally or intentionally, which inhabit other countries; but within the tropics there is a considerable number of Asiatic types, often even of the same species, associated with the strictly Australian element. Brilliantly coloured flowers predominate, even among the very numerous kinds of trees and shrubs, in striking contrast to the usually inconspicuous flowers of the great mass of the arboreous vegetation of Europe. On the other hand, the pervading bluish-green of the persistent foliage is by no means so pleasing and refreshing to the eye as the delightful variety of beautiful shades of green exhibited by the deciduous foliage of our northern trees. Again, fleshy edible fruits are exceedingly rare in Australia, particularly in the extratropical parts; the seed vessels being instead usually of a woody nature, and often large and of great density, like the "wooden pear" and the fruits of many of the Gum Trees, and enclosing very small or delicately-formed seeds. These differences in the physiognomy of the vegetation are in harmony with, or rather the outcome of, great divergences of climatal conditions. In the coldest parts of Australia there is very little frost, and throughout the extratropical parts a clear sky prevails, the average rainfall is very small, and long droughts are frequent.

The nearest botanical affinities of the flora generally are with that of South Africa, for although the dominant genera of plants are not the same, there are parallel or representative groups of genera in the two countries. Thus the *Diosmeae* of South Africa are replaced in Australia by the *Boronieae*, the Heaths by the Epacrises, the Proteas and Leucadendrons by Banksias and Grevilleas, etc. On the other hand, numbers of the large division of the Myrtle family to which the Gum Trees and "Bottle-brushes" belong are prominent everywhere and peculiar to the vegetation of Australia, and together with the numerous species of *Acacia* constitute a large bulk of it. Of *Acacia* alone there are upwards of 300 species, and with few

exceptions they are remarkable in having the ordinarily feathery leaves of the genus in other parts of the world reduced to hard, thick organs, often very singular in shape. Of the Gum-tree genus (*Eucalyptus*), there are more than a hundred distinct species, varying from dwarf bushes to the loftiest trees in the world. Forests of valuable timber are not wanting in Australia ; yet on the whole it is by no means a forest-clad country ; immense tracts are covered with low bushes, called scrub, with or without scattered trees ; while in the drier, almost desert, treeless regions of the interior the vegetation is extremely scanty. Grassy plains of great extent support enormous flocks and herds ; but these are sometimes reduced to terrible straits in consequence of the long droughts. Palms, Bamboos, and Bananas are wholly wanting in South-west Australia, South Australia, and Victoria, with the exception of a single Palm found in the Snowy Range ; and Bamboos and Bananas are very rare even in the tropical regions. In the place of Palms, there are the peculiar grass trees (*Xanthorrhoea*), the allied genera *Kingia* and *Dasypogon*, and in some parts Cycads and Cordylines. The various species of *Casuarina* constitute another common and almost universal feature in Australian scenery, and from the graceful habit of many of the species often an ornamental feature.

With this we must conclude these notes. merely adding that information on points of detail concerning the various floras is embodied in the descriptions of the paintings.

MAP OF THE GEOGRAPHICAL DISTRIBUTION OF VEGETATION IN THE CENTRE OF THE ROOM.

By TRELAWNEY SAUNDERS, *Geographer.*

IT has for its basis the principal features of both land and water. The continents and islands which form the land are carefully drawn with their mountain systems and inland waters. Upon this foundation, the broadest aspects of the vegetation are distinguished by various harmonising tints. No names appear, but a few numerals are inserted to secure the identification of the tints with the explanatory reference at the bottom of the map.

CATALOGUE.*

1. **Victoria regia.**—This majestic plant and largest of all Water Lilies inhabits many of the rivers of the north-eastern part of South America. It was first discovered at the beginning of the last century by Father La Cueva and the botanist Haenke, and it was first successfully introduced and cultivated in this country in 1849. The picture was not painted from nature, but from Fitch's splendid illustrations, and done in the fogs of a London winter, assisted by the memory of its magnificence in many tropical gardens. The leaves are of enormous size, often over six feet across, and have upturned rims four or five inches high, so that the Indian mothers, who go down to the rivers to wash, place their babies on them with perfect safety. In the right-hand corner a portion of the under side of the leaf is shown. When the flowers first open they are of a pure white, but on the second day they are tinged with rose, which deepens with the age of the flower.

2. **Common Tobacco.**—A plant belonging to the same family as the Potato. Several other kinds of tobacco are culti-vated, but this kind (*Nicotiana Tabacum,* L.) furnishes a very large proportion of the tobacco smoked in Europe and America. It is now four centuries since Columbus landed in America, where he found the inhabitants commonly smok-ing tobacco ; and the practice was soon adopted in Spain, though it seems that nearly a century elapsed before it was introduced into England, where, as well as in other countries, the authorities tried in vain to stop it. At the present time tobacco is the most universally used vegetable product, being consumed alike by civilised and uncivilised races in every part of the world, and duties on it are a chief source of revenue in many countries.

* For catalogue of the woods forming the panelled wainscot below the paintings, *see* p. 130.

A

CHILI.

3. Burning Bush and Emu Wren of Chili.—The Burning Bush (*Embothrium coccineum*, Forst.) belongs to the same family as the South African genera *Protea* and *Leucadendron* and the Australian *Banksia* and *Grevillea*. It is common from the Straits of Magellan down to about the 35th degree of south latitude, and when in blossom is one of the most conspicuous objects in Chilian scenery, *see* 6. The bird on the right (*Sylviorthorhynchus desmursi*) is most nearly related to the West Australian *Malurus malacurus*, in 734.

4. Puzzle - Monkey Trees and Guanacos, Chili.—Pehuen is the Chilian name of the familiar *Araucaria imbricata*, Pav. here represented in full development at home close under the Cordilleras of Chili, where there are no monkeys, and where it loses its branches as it grows old, and its thick bark breaks up into picturesquely irregular patches or blocks. This is the only species of Araucaria quite hardy in England, whither seeds of it were brought by Archibald Menzies, botanist in Vancouver's voyage, in 1795, and one of the original trees survived until 1892 in the Botanic Gardens, near No. 5 Greenhouse. Its seeds are edible. The Guanaco, or Wild Llama, Darwin states, is the characteristic quadruped of Patagonia, and the South American representative of the Camel of the East, and that it is easily domesticated. See 105, 738 and 763, and panel 10.

5. Fern and Flowers bordering the river at Chanleon, Chili.—Behind the robust fern (*Lomaria procera*, Spreng.) with rosy young fronds unfolding ; on the right *Tropaeolum tricolorum*, Sweet, a showy sister of the Canary Creeper, with the drooping bells of *Ourisia coccinea*, Pers. below on the left.

6. Seven Snowy Peaks seen from the Araucaria Forest, Chili.—A view of the Cordilleras near Angole, with Burning Bush (*Embothrium coccineum*), an orange-coloured Ground Orchid (*Chloraea* sp.), the white-flowered *Libertia ixioides*, Spreng. and other flowers, in the foreground.

7. A Chilian Stinging Nettle and Male and Female Beetles.—The *Loasaceae*, to which the present plant (*Loasa acanthifolia*, Juss.) belongs, are a small family of about a dozen genera and 100 species, which, with the exception of one African species, are restricted to America, and are specially numerous in the Chilian region. Many of the most showy

species are furnished with exceedingly venomous stinging hairs, and are therefore undesirable in a garden, especially as the sting is not only very severe at the moment of infliction, but the effects are often felt for as long as a fortnight. The beetles are a remarkable example of great dissimilarity in the two sexes of the same species.

8. **Chilian Palms in the Valley of Salto.**—*Jubaea specta-bilis*, H.B.K., is the only kind of palm native in Chili and although it wants the grace and elegance of many of its family it is not less useful, every part being employed in domestic ecomony. Indeed its great productiveness and the improvidence of the natives have resulted in its almost total extirpation. Formerly it was exceedingly abundant in many parts, especially in the country near Valparaiso, where on one estate near Petarca, according to Darwin, they tried to count them, but failed, after having numbered several hundred thousand. Darwin also mentions having met with it at an elevation of 4500 feet on the mountains near Quillota. Dr. Philippi writing in 1859 says : " There are now few palm groves remaining, as at Cocalen, at Ocoa in the valley of Aconcagua, and the Cuesta de las Palmas between Petarca and Illapel." Its principal product is the *miel de palma*, or palm honey, a saccharine juice only obtained by sacrificing the tree. See 781 for younger specimens of this palm.

9. **Common Flowers of Chili.**—The large white flower, which changes to pink, is one of the Evening Primrose genus—*Oenothera acaulis*, Cav. (syn. *O. grandiflora*, Ruiz et Pav. and *O. taraxacifolia*, Sweet) ; the blue and white flower on the right is a kind of " Everlasting " (*Triptilion* sp.) ; and the tufted plant above *Stenandrium dulce*, Cav., with a yellow *Triteleia ?*

10. **The Baths of Cauquenas in the Cordilleras South of Santiago, Chili.**—Columnar Cacti, *Pitcairnia*, *Alstroemeria*, *Echinocactus, Calandrinia*, etc., in the foreground on the right. These plants are all represented life size in the paintings around and particulars of them are given in the corresponding descriptions.

11. **Mexican Poppies, Chilian Schizanthus and Insects.**— The Mexican Poppy (*Argemone mexicana*, Linn.) colonises freely, and is now widely spread in warm countries of both hemispheres. *Schizanthus* belongs to the same family as *Salpiglossis* (see 22), and like that is peculiar to the Chilian

region. There are several species; the one here depicted is *S. pinnatus*, Ruiz et Pav.

12. Some Wild Flowers of Quilpué Chili.—Beginning at the top on the right are the tufted leaves and hanging orange-red flowers of *Lobelia salicifolia*, Don, and intermingling with the foliage the graceful blue *Conanthera bifolia*, Ruiz et Pav. Next comes a green and white *Chloraea* and the small pale yellow Litré, *Rhus caustica*, Hook. et Arn. (syn. *Lithraea venenosa*, Miers), which has the reputation of being poisonous like some of its North American congeners (see Panel No. 13). Below this is an *Alstroemeria*, probably *A. peregrina*, Ruiz et Pav. having pink and orange-purple flowers with *A. aurantiaca* on the right of it, another species of *Chloraea*, and the pale blue racemes of the "Mint Bush" (*Psoralea glandulosa*, Linn.). The streaked leaves and curiously formed dull purple and green flowers at the bottom are those of *Aristolochia chilensis*, Miers, with a purple species of *Oenothera*, a yellow variety of the many-coloured *Salpiglossis sinuata*, Ruiz et Pav. and a red-coloured shrub which has not been identified. Near the handle of the jug is the green-flowered soap-bush, *Quillaja saponaria*, Molina, with seed-vessels lying below. See 831 on the screen opposite, and panel 13.

13. Two Climbing Plants of Chili and Butterflies.— Hanging above *Tacsonia pinnatistipula*, Juss. (syn. *T. chilensis*, Miers); below the dull purple flowers and green fleshy edible fruit of *Lardizabala biternata*, Ruiz et Pav., whose nearest relatives inhabit the remote regions of Northern India, China, and Japan. The yellow butterfly is the male of the same species as the white female, another instance of great diversity in the sexes of an insect. See 7.

14. Some Flowers of the Sterile Region of Cauquenas, Chili.—Here is represented a portion of the inflorescence of the *Pitcairnia* to be seen in the foreground of 10, which is probably the same as one formerly in cultivation under the name of *P. rubricaulis*. On the right, the rosy flowers of *Calandrinia discolor*, Schrad., springing from a tuft of fleshy leaves, which are purplish on the underside; on the left crimson and yellow varieties of a climbing *Mutisia*, the leaves of which take the form of tendrils, and a formidably armed species of *Echinocactus*.

15. Armed Bird's Nest in Acacia Bush, Chili.—Trabajor, that is labourer, is the name given to this bird (*Izuallaxis*

sordida), a delicate creature that builds an impregnable nest of the spiny branchlets of *Acacia cavenia*, Molina, one of the commonest and most unapproachable bushes of the country. See 832.

16. **Wild Flowers of Chanleon, Chili.**—*Fuchsia macrostemon*, Ruiz et Pav., on the right, is the wild parent of our hardy varieties; above it is the blue *Puya* with orange anthers, the orange balls of the not unfamiliar *Buddleia globosa*, Lam. a pale purple Lupin, a yellow *Chloraea*, and the crimson *Ourisia coccinea*. Immediately below the last the orange heads of a species of *Boopis?* (*Calyceraceae*) succeeded by the rosy *Mutisia* (*M. decurrens?*) and the white-flowered Winter's Bark (*Drimys Winteri*, Forst.). Lying on the table are the purple brown *Bomarea Salsilla*, Mirb., a lilac and yellow *Solanum*, the pure white *Libertia ixioides*, Spreng., and *Pernettya mucronata*, Gaud. The greenish white pea-flower is *Lathyrus macropus*, Hook. The leaves of *Buddleia globosa* are a universal remedy in Chili for all kinds of wounds and sores. They are roasted, pounded, and made into poultices and plasters.

17. **View of Concon, Chili, with its two Palms.**

18. **Chilian Flowers in Twin Maté Pot, and Chilian Strawberries.**—Behind, the heath-like *Fabiana imbricata*, Ruiz et Pav. and a miniature irid (*Tigridia* sp ?), with the deep blue *Pasithaea coerulea*, Don, yellow *Mimulus luteus* Linn., pink *Eyrthraea chilensis*, Pers., a small *Centaurea*, fruit of the Maqui (*Aristotelia Maqui*, Herit.), and a flower-head of a species of *Senecio?* Lying in front, a branch of the Patagua (see 20). All parts of the Maqui tree, from the bark to the fruit, are used in various ways, and the latter mixed with grapes, is said to make an exquisite wine. The Pichi (*Fabiana*) is highly esteemed by the Chilians as a medicine.

19. **View near Quilpué, Chili.**—On the rocks in front a gigantic species of *Calceolaria*, with *Puya chilensis*, Molina, above, and Boldo trees and Columnar Cacti in the distance. A life-size painting of the inflorescence hangs in the entrance porch—see description of 25. The Boldo, *Peumus fragrans*, Pers. (syn. *Boldoa fragrans*, Gay) belongs to the *Monimiaceae*, is agreeably fragrant in all its parts and yields an edible fruit. *Calceolaria* is a genus of upwards of 100 species, two of which are natives of New Zealand, and the

rest of America, ranging from the Falklands and Magellan's Straits to Mexico.

20. The Permanent Snows, from Santiago ; Patagua in front with Humming Bird and Nest.—*Tricuspidaria dependens*, Ruiz et Pav., the Patagua, is of the same family as our lime-tree. On the left, near the Patagua tree, and on the right, beyond the building, are trees of the North American *Magnolia grandiflora*, Linn. The highest point of the distant mountains is about 22,000 feet, but it is not actually visible from Santiago.

21. Parasites on Beech Trees, Chili.—"Robble," literally oak, is the name given to the common large-leaved Chilian "Beech"(*Nothofagus obliqua*, Mirb.),which is represented here with a parasitic plant (*Loranthus* sp.) having very similar foliage, a common occurrence in nature (see 734). Below are the leaves of *Gunnera scabra*, Ruiz et Pav., and on the left a bush of *Drimys Winteri* (see 16); beyond these a native Bamboo (*Chusquea Quila ?*) backed up with "beech-trees" of different species. See panels 3 and 4.

22. Chilian Ground Orchids and other Flowers.—Here are three species of the large, peculiarly South American, and mainly Chilian, genus of ground orchids, *Chloraea ;* the orange-coloured one matching *Alstroemeria aurantiaca* in 12. The yellow twiner is *Grammatocarpus volubilis*, Presl. (syn. *Scyphanthus elegans*, Don), closely allied to the *Loasa* in 7, but not furnished with stinging hairs. Below is a yellow violet, *Viola maculata*, Cav. (syn. *V. pyrolaefolia*, Poir.), with *Collomia coccinea*, Lehm. On the left, above, a purple *Lathyrus* and a crimson variety of *Salpiglossis* (see 12), and behind a piece of *Eryngium depressum*, Hook.

23. A Chilian Cactus in flower and its leafless Parasite in fruit.—Referring to the various Chilian landscapes, we see that columnar cacti are a conspicuous feature. This, the commonest species, is *Cereus Quisco*, Gay, which grows to a height of 15 to 20 feet, and is often preyed upon by a leafless parasite, *Loranthus aphyllus*, Miers (syn. *L. cactorum*, Hook. et Arn.). In this case both nurse-plant and parasite are leafless ; in others it may be seen that the leaves of the two are often similar (see 21 and 734). In 26 the cactus and its parasite are shown in their natural habitat. The ripe white berries of the *Loranthus* are edible

24. **Sea-shore near Valparaiso, Chili.**—The vegetation on the rocks consists largely of *Puya, Cereus* and *Mesembryanthemum chilense*, Molin. This is the only species of the last-named genus in Chili, whereas in South Africa they are numbered by hundreds ; elsewhere the species are very few, though widely scattered.

25. **Inflorescence of the Blue Puya, and Moths, Chili.**—Common inhabitants of the Cordilleras are two noble representatives of the Pine-Apple Order, the *Bromeliaceae*, namely *Puya Whytei*, Hook., the present, and *P. chilensis* (see 19) In situations the most favourable to their development they attain a height of ten to fifteen feet.

26. **The Blue Puya and Cactus at home in the Cordilleras, near Apoquindo, Chili.**—The grand *Puya*, depicted above life-size, is here seen associated with *Cereus Quisco*, Gay (see 23), in its home on the steep, stony slopes of the Cordilleras, where there is little other vegetation. The valley below is filled with cloud, which for a moment has blown away, revealing to the artist this fine group in various stages of growth and decay. This excursion was made after the above comparatively poor inflorescence had been painted.

27. **Chilian Lilies and other Flowers in Black Jug and ornamented Gourd for Maté.**—Behind is a yellow *Calceolaria* and a blue Heliotrope, with the beautiful striped *Placea ornata*, Miers, in the centre, and three varieties or species of *Leucocoryne* below. The scarlet flower is a species of *Phycella*, and the small yellow-flowered shrub behind on the left is a species of *Duvaua*. On the table a purple-red *Oxalis*, a *Calceolaria*, a sprig of the Maiten tree (*Maytenus chilensis*, DC.), and a white *Verbena* on the left.

BRAZIL AND WEST INDIES.

28. **Group of Sago-yielding Cycads in the Botanic Garden at Rio Janeiro.**—Behind some Date Palms (*Phoenix dactylifera*, Linn.). In the right foreground is the trunk of a Camphor tree with Vanilla growing thereon. The cycad is *Cycas circinalis*, Linn., a native of the tropics of the Old World.

29. **Some Fruits and Vegetables used in Brazil.**—In front the Ochro (*Hibiscus esculentus*, L.), the seed-vessels of which

are used in thickening soups ; the Guianga, a myrtaceous fruit, with a kind of Pumpkin called Borbora, and flowers and tuber of Sweet Potato (*Ipomoea Batatas*, Lam.) behind.

30. **The Wild Tamarind of Jamaica with scarlet Pod and Barbet.**—This showy Leguminous tree is *Pithecolobium filicifolium*, Benth., which ranges through the West Indies and Central America. The barbet builds an ingenious nest in banks, cleverly tunnelled straight in, and then at a right angle to prevent curious strangers from seeing it.

31. **Inflorescence of the West Indian Pinguin.**—This, the *Bromelia Pinguin* of Linnaeus, is a native of the West Indies, where it is also commonly planted for hedges. It belongs to the same family as the Chilian *Puya*, and is introduced here to show the similarity of the growth of the inflorescence in the two ; the separate clusters of flowers being securely wrapped up while young, casting off their clothing only when their full beauty has been developed.

32. **A tall Brazilian Climber.**—This is *Aristolochia brasiliensis*, Mart. & Zucc. var., and the strangely-formed, veined flowers have a very unpleasant smell. It is cultivated in the Palm House, where it flowers profusely almost every year.

33. **Flowers of Cassia corymbosa in Minas Geraes, Brazil.**— A South American forest tree whose twin leaflets close together at sunset. The insects *Pterochroya ocellata* are called Leaf Insects (see 676), on account of the close resemblance of their wings to leaves. The genus *Cassia* is numerous in species which are widely dispersed in warm countries. Other species are represented in 332, 336, and 698 of this collection.

34. **View in Mr. Morit's Garden at Petropolis, Brazil.**

35. **View of the Jesuit College of Caracas, Minas Geraes, Brazil.**—Coral Trees (*Erythrina* sp.) in flower in the foreground. The College is at an elevation of about 3000 feet above the sea level, and nine priests educate about 200 of the most intelligent boys of the surrounding country.

36. **View in Brazil near Ouro Preto with Oil Palms.**— (*Elaeis guineensis?*), Cacti (*Cereus* sp.) and Papaw Tree (*Carica Papaya*, L.) in the foreground. The figure on the left is the Papaw, which is also shown in 91, and its fruit in 700.

37. **Flowers and Fruit of the Maricojas Passion Flower, Brazil.**—The fruit of this (*Passiflora alata*, Ait.) and several other species of the genus are edible. See 112.

38. **A Tropical American Water Plant.**—*Eichornia azurea*, Kunth. This was found growing in the Lake of Lagoa Santa, Brazil, where it was planted by Dr. Lund, a Danish Naturalist.

39. **Orchids and Creeper on Water-worn Boulders in the Bay of Rio Janeiro, Brazil.**—The creeping plant at the top is *Codonanthe Hookeri*, Hanst. (syn. *Hypocyrta gracilis*, Mart.); the large-flowered Orchid is a variety of *Cattleya Forbesii*, Lindl., and the yellow-flowered one in the lower right-hand corner is apparently a *Pleurothallis*.

40. **Boulders, Fisherman's Cottage and Tree hung with Air Plant, at Paquita, Brazil.**—*Tillandsia usneoides*, Linn., also called Old Man's Beard and Long Moss, as well as Air Plant, is a member of the *Bromeliaceae* (see 139 and 232), and is very common in America from the Southern United States southward to Uruguay and Chili. When out of flower, it looks more like a coarse moss or lichen than a flowering plant.

41. **Indian Palm at Sette, Lagoa, Brazil.**—Probably a species of *Attalea*.

42. **Flor Imperiale, Coral Snake and Spider, Brazil.**— The flower is *Haemanthus multiflorus*, Martyn, which has long been cultivated in this country ; and the Snake is a species of *Elaps*.

43. **Tijuca, Brazil, with a Palm in the foreground.**—The palm is apparently a species of *Cocos*, a considerable genus restricted to South America, except *C. nucifera*, the cocoa-nut.

44. **Some Brazilian Flowers.**—A white-flowered *Convolvulacea*, associated with a species of *Dipteracanthus*—a shrub smelling like onions, and a yellow-flowered *Composita* (*Aspilia ?*) that smells like vanilla.

45. **Harvesting the Sugar-Cane in Minas Geraes, Brazil.**— The solid stems of the sugar-cane (*Saccharum officinarum*, Linn.) grow ten, or even as much as fifteen, feet high, and the sugar-juice is expressed from them by machinery. The harvest is always a festival for men and beasts, the latter growing very fat on the refuse and young green leaves. Formerly cane-sugar

was the only, or almost the only, kind of sugar consumed in Europe, as well as in tropical countries where it is cultivated ; but now enormous quantities of sugar are extracted from the beet-root, cultivated in France and Germany and other Continental countries.

46. Flowers cultivated in the Botanic Garden, Rio Janeiro, Brazil.—Red and White Indian Water Lilies, with the large flowers of *Solandra?* and the crimson flowers of an Australian shrub (*Calothamnos* sp.).

47. Flowers of Datura and Humming Birds, Brazil.—*Datura arborea*, Linn., is a native of tropical America, and is commonly cultivated in other countries, as it grows like a rank weed. It is better known in English greenhouses under the name *Brugmansia arborea*, Pers. See 132, 227, and 689. The leaves are smoked to cure asthma ; and the Greeks use them to procure pleasant dreams. The Humming Bird is *Trochilus anais*.

48. Palm Trees and Boulders in the Bay of Rio, Brazil.—Painted at Paquita ; the Organ Mountains in the distance.

49. Trees laden with Parasites and Epiphytes in a Brazilian Garden.

50. Landscape at Morro Velho, Brazil.—In the foreground is a colony of Butterflies (*Heliconius phyllis*) going to roost on a single segment of a palm leaf, from which they will never move until the sun's rays reach them in the morning. This insect has a powerful musk-like scent by which the artist often found her way to it.

51. Foliage and Flowers of a Madagascar Plant.—This is *Amomum magnificum*, Benth. (syn. *Alpinia magnifica*, Roscoe). For a long time it was supposed to be a native of Mauritius, where, however, it is only naturalised. The yellow-flowered orchid is a Brazilian species of *Oncidium*.

52. Twining Plant and Butterfly of Brazil.—This beautiful twining plant is a species of *Dipladenia*, allied to *D. crassinoda*, and the butterfly is *Morpho achillaena*.

53. View of the Piedade Mountains, from Congo, Brazil.

54. Cabazina Pears, Brazil.—One of the many varieties of *Psidium Guayava*, Raddi (syn. *P. pyriforme*, Linn.) ; a somewhat bitter fruit having a peach-like skin.

55. Brazilian Wild Flowers.—*Vellozia verruculosa*, Mart. (blue), *Xyris* sp. (yellow), a purple-flowered orchid (*Bletia* sp.), and a delicately-scented epiphyte (*Clusia*), to which the artist was attracted by its scent.

56. View under the Ferns at Gongo, Brazil.—In front a Slave Woman who brought the artist's provisions over eight miles of forest road.

57. Wild Flowers of Brazil.—The large, greenish-white flowers with a crimson and yellow centre are those of a shrubby epiphyte (*Clusia*) belonging to the Gamboge family ; associated with it is a species of *Sisyrinchium* having indigo flowers. *Oncidium ampliatum*, a *Bletia*, and the purple-clustered *Periandra dulcis*.

58. Study of the Traveller's Tree of Madagascar in the Botanic Garden of Rio.—This tree (*Ravenala madagascariensis*, Sonn.), is called the Traveller's Friend, as its broad leaves collect the precipitated moisture which filters into its tightly-plaited sheaths ; and a drink of pure water may always be obtained by tapping them. It is a member of the *Musaceae*, and is described as one of the most striking features in the scenery of the coast region of Madagascar. See the description of 543.

59. A Brazilian Climbing Shrub and Humming Birds.— Observe the curious looped-shaped seed-vessel of *Odontadenia speciosa*, Benth. (syn. *Dipladenia Harrisii*, Purdie) in the upper right-hand corner ; the carpels forming it cohere at the base and tip only. *Lophornis magnificus* is the name of the Humming Bird. Humming Birds are exclusively confined to the New World, where they are dispersed throughout the country from the extreme south to Sitka in the north ; but they are by far most abundant within the tropics. There are many genera, and numerous species ; and they present the utmost diversity in form and plumage. They are small or minute birds, some of them not larger than a Bumble Bee, as the *Mellisuga minima* (see 119). Their plumage is often splendid beyond description, yet little of the splendour is seen by man when the birds are alive, because their movements are so rapid. Even when poised under a flower, their wings are in quick motion, causing the humming noise from which they take their name. The English Humming-Bird Hawk-Moth, and some others, have a similar motion, which has given rise to the error that a species of Humming Bird

actually inhabited this country. Bates relates in his "Naturalist on the Amazons" that he several times shot by mistake a kind of Humming-Bird Hawk-Moth (*Macroglossa Titan*) instead of a bird. Humming Birds live on insects and honey; and it is believed that they as often visit flowers for the insects as for the honey they find in them. It is note-worthy that these birds, or at all events most of them, lay only two eggs in a clutch; and, what is more remarkable, the eggs are always white.

60. **Flor de Pascua or Easter Flower at Morro Velho, Brazil.**—This plant, *Euphorbia pulcherrima*, Willd. (syn. *Poinsettia pulcherrima*, Grah.), is a native of Central America, commonly cultivated in England, but it is not usual to see such large inflorescences, because, as grown for market, the plants are small, bearing only one inflorescence. The flowers them-selves are inconspicuous, the showy part being the coloured leaves or bracts surrounding them. See 120. Compare with the inflorescence of *Clerodendron* (538).

61. **Organ Peak at Theresoplis and Bay of Rio below.**

62. **Foliage, Flowers, and fruit of False Tomato, painted in Brazil.**—This plant, *Cyphomandra betacea*, Sendt. (syn. *Solanum betaceum*, Cav.), is a native of Western and Central America, and is cultivated in some countries for its fruit, which is similar to the Tomato in flavour.

63. **Avenue of Royal Palms at Botafogo, Brazil.**—This avenue of *Oreodoxa regia*, Kth., is half a mile long, and the trees, which are about 40 years old, are 100 feet high. Five rings are left on the trunks each year by the fallen leaves, one of which is as much as a man can lift. The Royal Palm is a native of the West Indies, as is also *O. oleracea*, Mart., which is said to attain a height of 170 feet.

64. **Foliage and Fruit of Mammee Apple, or South American Apricot.**—A tropical American tree (*Mammea americana*, L.) of the *Guttiferae*, cultivated for its fruit, the outer rind of which is bitter; but the flesh is sweet and aromatic, and is made into preserves. A kind of wine is made from the young shoots, and a scent from the white flowers.

65. **Foliage and Flowers of a climbing plant with Royal Palms and Sugarloaf Mountain in the background, Brazil.**—This handsome climbing shrub (*Roupellia grata*, Wall.) is a

native of Sierra Leone, and its flowers are very sweet scented. It is occasionally cultivated in this country.

66. Screw Pines and Avenue of Royal Palms in the Botanic Gardens, Rio.—The Screw Pine to the left in the foreground is a male plant in flower (see 246), and that on the right is a female in young fruit (see 692). For further particulars consult the descriptions of 246 and 571.

67. Flannel Flower of Casa Branca and Butterflies, Brazil. —The Flannel Flower (*Macrosiphonia longiflora*, Muell.) is so called on account of the plant being densely clothed with woolly hairs. It is a member of the *Apocynaceae*, and is remarkable for the very long tube of the flower. The Butterflies are a species of *Catagramma* on the left and *Callicore Clymene* on the right. Observe the mark 88 on their wings.

68. Tree Ferns and Climbing Bamboos in Gongo Forest, Brazil.

69. Wild Flowers of Casa Branca, Brazil.—The principal figure having longitudinally ribbed leaves and large blue flowers is a *Melastomacea* (*Pleroma* sp.) with an orange-flowered *Tillandsia* and a species of *Evolvulus* behind.

70. Palma de Santa Rita, and Atlas Moth, Brazil.—The inflorescences of the *Marica* are so heavy that they fall to the ground on all sides ; and the seeds germinate before they leave the pod, and send down their roots therefrom, forming a wide circle of young plants around the old one. The caterpillar of the Atlas Moth (*Saturnia* sp.) builds itself a house from the leaves of this plant. Perhaps the young plants are not developed from seeds, but viviparously from bulblets formed in the inflorescence, as is commonly the case in *Marica gracilis* under cultivation, which may be seen in the Palm House at almost all seasons.

71. Palm, Bamboos and India-rubber Trees in the Botanic Garden, Rio.

72. Flowers of Hedychium, Botanic Gardens, Brazil.—The species of *Hedychium* are mostly very ornamental plants and their flowers are fragrant. They inhabit tropical Asia. That on the left is *H. chrysoleucum*, Hook., a species cultivated in this country.

73. **Yellow Bignonia and Swallow-tail Butterflies with a view of Congonhas, Brazil.**—*Bignonia aequinoctialis*, Linn., and *Papilio thoas*.

74. **The Iron Rocks of Casa Branca, Brazil.**—They are 5000 feet above the level of the sea.

75. **View from the Sierra of Petropolis, Brazil.**—The Bay of Rio, and its Islands, and Sugarloaf Mountain in the distance. This summit is 3000 feet above the sea, and is reached by a zigzag road of ten miles.

76. **Group of Wild Meadow Flowers, of Brazil. Golden Banana and Euemba's (Crotophaga major) Egg.**—Among the flowers are a species of white *Clusia* (?), a *Pleroma* and *Thunbergia alata*, Boj., yellow with dark centre.

77. **Wild Flowers at Morro Velho, Brazil.** — *Bignonia venusta*, Ker., and a *Convolvulacea (Quamoclit Nationis* Hook. ?), climbing over *Luhea rufescens*, St. Hil., a forest tree.

78. **Brazilian Orchids.**—A species of *Zygopetalum (Z. brachypetalum*, Lindl.), with the orange-scarlet *Comparettia coccinea*, Lindl., in front.

79. **View of the Old Gold Works at Morro Velho, Brazil.**

80. **Cocoera Palms and Bananas, Morro Velho, Brazil.**—The Palm (*Acrocomia* sp.) is a favourite nesting-place of birds, as its trunk is so armed with prickles that no climbing enemies attempt to reach them.

81. **Brazilian Flowers.**—*Begonia maculata*, Raddi (syn. *B. argyrostigma*, Fisch.), the blue-berried *Coccocypselum discolor*, Hort., and Blue Bird (*Coereba cyanea*).

82. **Butterflies' Road through Gongo Forest, Brazil.**

83. **View from Mr. Weilhorn's House, Petropolis, Brazil.**

84. **Brazilian Orchids.**—The rosy-purple flowers are those of *Cattleya Loddigesii*, Lindl., which magnificent genus has its headquarters in Brazil; the other is *Zygopetalum intermedium*, Lodd.

85. **Side Avenue of Royal Palms at Botafoga, Brazil.**—See the remarks under 63.

86. **Lagoa de Freitas, near Rio, Brazil.**—Cypress and Frangipani (*Plumeria* sp.) trees in the foreground.

87. **Group of Brazilian Forest Wild Flowers änd Berries.**—Lying in front, on the left, is a head of the handsome orange-red *Amarantacea* (*Gomphrena officinalis*, Mart.); above it a *Melastomacea* in fruit; the azure-blue flowers of a *Stachytarpheta;* the crimson flowers of a species of *Physocalyx*, &c.; and on the right a purple *Convolvulacea* and a white *Bignoniacea.*

88. **Flowers of a Brazilian Forest Tree.**—*Pachira marginata*, A. Juss., is related to the Baobab and the genera *Bombax* (247) and *Eriodendron* (632).

89. **Peaches and Humming Birds, Brazil.**—The peach is an introduced fruit in Brazil. It is here represented growing against a mat fence instead of a wall. *Petasophora serrirostris* is the name of the Humming Bird.

90. **Glimpse of Mr. Weilhorn's House at Petropolis, Brazil.**—The late owner of this house was a friend of Humboldt.

91. **Papaw Trees at Gongo, Brazil.**—The Papaw (*Carica Papaya*, L.) is a tropical American tree now commonly cultivated in warm countries. Its stem is usually unbranched and grows about twenty feet high, bearing a crown of foliage, beneath which hangs the fruit. The fruit is represented in 700.

92. **"Scotchman hugging a Creole," Brazil.**—A Palm in the embrace of the roots of a Fig tree. The tree that is now strangling the palm was at first the nurse child of the latter, and its history is this. A seed was dropped by a bird among the leaves of the Palm, where it germinated and grew, forming root after root, which descended and spread till they formed an unbroken sheath around its trunk. Soon the Palm will be strangled and die, after which it may fall carrying its destroyer with it. Nests of the Sociable Oriole (*Ostinops* or *Ocyalus*) hang from the tree, and near it is a Giant Ants' nest, the only entrance to which is by a long underground tunnel.

93. **Brazilian Orchids and other Epiphytes.**—The Orchids in flower are *Cattleya intermedia*, Grah., and *Oncidium concolor*, Hook., the latter below.

94. **Oil Palm at Tijuca, Brazil.**

95. **View of the Old Gold Works from the verandah at Morro Velho, Brazil.** North American *Magnolia grandiflora*, L., and pet animals in the foreground.

96. **Orchid and Humming Birds, Brazil.**—One of the numerous forms of the genus *Cattleya—C. bicolor*, Lindl., and a species of *Chlorostilbon*.

97. **Foliage and Flowers of a Chorisia and double-crested Humming Birds, Brazil.**—The *Chorisia* is probably *C. speciosa*, St. Hil., and the birds *Trochilus cornutus*.

98. **Flowers of a Coral Tree and King of the Flycatchers, Brazil.**—*Erythrina* sp., and *Muscivora Swainsoni*.

99. **Flowers of a Twiner, Brazil.**—These flowers (*Mucuna* sp. ?) are sweet and of a waxy consistency, and were found growing at the mouth of the Cave of Curvelho, where Dr. Lund found the teeth of a "nut-eating man."

100. **Flowers of another Kind of Coral Tree.**

101. **Palma Christi or Castor Oil, painted in Brazil.**— Behind are some leafless stems bearing clusters of the prickly seed-vessels at the top. The castor-oil tree (*Ricinus communis*, L.) is a native of India, but it has long been cultivated in other warm countries, and has become naturalised in many places. It is also grown in this country for the embellishment of gardens and public parks in summer. The oil is extracted from the seeds. The butterfly is a species of *Pyrameis*.

102. **A Brazilian Orchid.**—This is *Laelia purpurata*, Lindl., one of the handsomest orchids known. It was first cultivated in this country about the year 1852, when Messrs. Backhouse exhibited a plant in flower at one of the meetings of the Horticultural Society of London.

103. **Foliage, Flowers, and Fruit of Poma de Lupa, Brazil.**—A species of *Solanum*, which genus numbers at least 700 species, 160 of them inhabiting Brazil.

104. **Foliage, Flowers, and Fruit of the Soursop, Brazil.**— *Anona muricata*, L., is a native of the West Indies, where, as well as in continental America and other countries, it is cultivated for its excellent fruit.

105. Buriti Palms with old Araucaria trees on the distant ridge, Brazil.—The Buriti (*Mauritia vinifera*, Mart.) is one of the most gigantic of palms, and its rich, red and yellow fruit, " like quilted cannon balls," hang in bunches five feet long ; and from it flour, wine, and butter are made ; and the fibre of the leaves supplies thread for weaving hammocks, baskets, nets, and clothing. Another species of the genus, *M. flexuosa*, inhabits the valleys of the Amazon, Orinoco, and other rivers in north-eastern South America, growing in places that are often inundated. It is an equally tall and robust palm, and the native Indians subsist almost entirely on its products ; and what is more strange, they build their houses high up amongst its leaves, where they live during the floods. *Araucaria brasiliensis*, A. Rich., forms forests of considerable extent between 21° and 24° south latitude.

106. Brazilian Flowers.—On the left the elegant, feathery leaves and crimson flowers of *Ipomoea Quamoclit*, L.; above, a scarlet and white *Acanthacea ;* in the centre a species of *Tabernaemontana* (?), with the richly coloured foliage of *Iresine Herbstii*, Hook., below, and a blue-flowered *Evolvulus* on the right.

107. Foliage, Flowers, and Seed Vessels of Cotton, and Fruit of Star Apple, Jamaica.—Cotton was cultivated and cotton fabrics were made as far back as records go in the Old World ; and when America was discovered cotton was in general use there. Three species with their varieties yield all the different kinds of cotton of commerce. The North America cottons are the produce mainly of two varieties, long staple and short staple, of *Gossypium barbadense*, the one here represented ; *G. peruvianum* yields most of the cotton grown in South America ; and *G. herbaceum*, which is indigenous in India, was the source of all the cotton used in earlier times in the Old World. As may be seen, cotton is the soft down with which the seeds are clothed, whilst flax (linen) is a long fibre obtained from the slender stems of an herbaceous plant, *Linum usitatissimum*, L., which is represented on the left side of the entrance door-way. The dark brown foliage of the Star Apple tree, *Chrysophyllum Cainito*, Linn., makes it as conspicuous in a landscape as our Copper Beech. Its fruit tastes like blanc mange.

108. Foliage and Flowers of a Brazilian Climbing Shrub and Humming Birds.—There are three or four species or

varieties of *Bougainvillea*, to which genus the climber belongs, all of them endemic in Brazil, though one or two are now commonly cultivated in warm countries, and in the greenhouses of this country. They climb to the tops of tall trees (see 521) and cover them with rosy or rosy-purple festoons. The real flowers are those small yellow bodies of which there are three clustered in each set of three coloured bracts, and more than two of them are rarely fertile. The bird is *Clytolaema rubinea.*

109. **Foliage and Double Flowers of the Sandal-wood Bramble.**—This elegant Bramble, *Rubus rosaefolius*, Smith, is commonly cultivated in warm countries, and widely spread in a wild state. Leaves sweet-scented, see 490.

110. **Night-Flowering Lily and Ferns, Jamaica.**—The "Lily" is a species of *Crinum*, of which there are many in tropical regions, growing chiefly on sandy sea-shores though this inhabits stony hills.

111. **Jamaica Orchids growing on a branch of the Calabash tree.**—The most interesting of these orchids is the one hanging from the top, *Dendrophylax funalis*, Benth. (syn. *Aeranthes funalis*, Rchb. f., and *Angraecum funale*, Lindl.), being as near what might justly be called an Air-Plant as any to which the name is applied. It is quite leafless, and has no pseudo-bulbs. *Oncidium triquetrum*, R. Br., is the name of the small white and purple flower. The Calabash tree, *Crescentia Cujete*, Linn., a flower of which is here represented, produces a large fruit, the shell of which is used for various domestic purposes, see 144.

112. **Foliage, flowers, and fruit of the Granadilla, Jamaica.** —The fruit of several species and varieties of Passion Flower is edible ; this is *Passiflora macrocarpa*, Mast. Seeds and pulp —in fact all the inside is eaten.

113. **Road near Bath, Jamaica, with Cabbage Palms, Bread Fruit, Cocoa, and Coral trees.**—Some account of the Cocoa and Bread Fruit trees will be found in the descriptions of 532 and 536 respectively. The palm is probably a species of *Euterpe.*

114. **Foliage, Flowers and Fruit of the Pitanga, and Sulphur Butterflies, Jamaica.**—Pitanga is the name applied to more than one myrtaceous fruit in the West Indies and Brazil ; this is apparently a species of *Eugenia.* The butterfly is *Callidyas philea.*

115. **The Aqueduct of Morro Velho, Brazil.**—Coral Mountain in the background, and part of an inflorescence of Banana, a *Convolvulacea,* and Amethystine Humming Birds (*Calliphlox amethystina*) in front.

116. **The Bog-walk, Jamaica, with Bread Fruit, Banana, Cocoanut, and other trees.**

117. **Scene in Dr. Lund's Garden at Lagoa Santa, Brazil.** —The large trunk in front covered with a Cactus (*Cereus* sp.), a large aroid (*Philodendron* sp.), and Orchids. On the left a Palm (*Acrocomia* sp.) with a large mass of *Cattleya* on the lower part of the trunk.

118. **Foliage and Flowers of the Mahoe, Jamaica.**—The dark-coloured wood of this tree (*Paritium elatum,* G. Don) is most valuable. If not a variety of *P. tiliaceum,* Juss., it is very closely allied to it ; and this species is found on nearly all tropical sea-shores. See 397.

119. **Foliage, flowers and fruit of the Nutmeg tree, and Humming Bird, Jamaica.**—This Humming Bird (*Mellisuga minima*) is the smallest known. The genus *Myristica* is rather numerous in species, widely scattered in tropical regions, including America ; but the present species, *Myristica fragrans,* Houtt. (syn. *M. moschata,* Thunb.), is indigenous only in the Indian Archipelago. It furnishes a large proportion, if not all of the nutmegs of commerce. The outer rind of the fruit makes a good preserve ; and the inner scarlet wrapper immediately enclosing the nutmeg is the spice called mace. Male flowers and female flowers are produced on separate trees. For the habit of the tree, see 337. The butterfly is *Papilio polydamas.*

120. **Bananas and Orange Trees, a Palm and a Bush of Noche Buena in a Garden at Morro Velho, Brazil.**—As mentioned under 816 the Banana is one of the most striking types of tropical vegetation ; and it is also one of the most important, as its fruit is the staple food of a large number of the human race. There are many varieties bearing edible fruits, and some writers distinguish the Plantain (*Musa paradisiaca,* L.) and the Banana (*Musa Sapientum,* L.), attributing to the latter a purple spotted stem, and a shorter, rounder fruit ; but these differences seem to be lost in some of the varieties, hence in this guide all the varieties are called Bananas. The Banana, although arboreous in habit, is herbaceous in character, each

stem usually coming to its full growth in less than a year. It grows from ten to twenty feet high, or sometimes higher, and bears only one crop of fruit. When this is ripe, its great weight, often sixty or seventy pounds, brings down the stem that is almost leafless ; and the old stems are soon replaced by new ones springing from the same root-stock. As may be seen, it is only the basal portion of the spike that bears fruit ; yet the spike goes on growing and producing flowers until the fruit is nearly ripe. But the fruit is not the only useful product of the plant, almost every part of which is applied to some purpose. Next to the fruit, the fibre of the leaf stalk is the most valuable product. Its quality varies in different varieties, some of it being very fine, from which muslin is made. Another species of the genus, *M. textilis*, Nees, yields the valuable fibre known as Manila Hemp. For some particulars respecting the orange, see 520. The Noche Buena or Catalina, *Euphorbia pulcherrima*, Willd. (syn. *Poinsettia pulcherrima*, Grah.), is a native of Mexico and Central America, where it flowers about Christmas time, hence the first name, which is the Spanish for Christmas (see 60). *Acrocomia* is the genus to which the Palm belongs ; it is allied to *Cocos* and peculiar to tropical America.

121. **A Bank of Quaresma and Trumpet Trees, Brazil.**— Quaresma is a name given to a *Melastomacea—Pleroma granulosum*. For further particulars of the Trumpet Tree, see 823.

122. **Peak of Casa Branca, with its Iron Rocks and Tree Lilies, Brazil.**—The peak is 5000 feet high ; and various arboreous species of *Vellozia*, or "Tree Lilies," are characteristic of this sterile mountainous region.

123. **Foliage and Flowers of Alpinia nutans, and a pair of Doctor Humming Birds, Jamaica.**—The *Alpinia* is a native of Tropical Asia.

124. **Leonotis nepetaefolia and Doctor Humming Birds, Jamaica.**—The noble herb here represented is a native of South Africa, and now a common " weed " in some tropical countries. *Aithurus polytmus* is the name of the bird in this and 123.

125. **Selection of cultivated Flowers, painted in Jamaica.** —In the vase, associated with the crimson flowers of one of the Coral trees (*Erythrina* sp.), is a panicle of the sweet-scented lilac and white flowers of *Melia Azedarach*, L. This hand-

some tree, having elegant, much divided (bipinnate) leaves, is a native of the warm parts of Asia ; and it is also a favourite tree of cultivation in other warm countries, including the south of Europe. It bears a variety of names in different countries, such as Pride of India, Holy Tree, Bead Tree (in allusion to the seeds being strung for chaplets), Persian Lilac, Hill Margosa and Jamaica Lilac. A valuable oil is extracted from the seeds. The other flowers are (beginning in front on the left) a crimson *Hibiscus*, behind this a lilac *Lantana*, and the pretty crimson and orange *Asclepias curassavica*, L., now common in nearly all warm countries, with rosy and white varieties of the Oleander (*Nerium Oleander*, Lour.) on the right.

126. **View from the Artist's House in Jamaica, with Double Rainbow.**—Rose-Apple, and Bananas in the foreground.

127. **Foliage and Flowers of the Cinnamon Tree.**—This tree (*Cinnamomum zeylanicum*, Bl.), whose fragrant aromatic bark is the cinnamon of commerce, is a native of Ceylon, but it is cultivated and has become wild in Jamaica. Several other species of the genus produce aromatic bark. See 337.

128. **Foliage and Flowers of the Loquat or Japanese Medlar, Brazil.**—The Loquat (*Eriobotrya japonica*, Lindl.) is a native of China and Japan, and is closely related to our Medlar, bearing a singular edible fruit (see 155). It is almost hardy in the south of England, though it rarely ripens its fruit. In Brazil it bears the name Amatia. The birds are *Lampornis violicauda*.

129. **An Old Cotton Tree at the Ford, Morant's Bay, Jamaica.**—*Eriodendron anfractuosum*, DC. Consult the description of 176.

130. **Bamboos, Cocoa Nut Trees, and other vegetation in the Bath Valley, Jamaica.**

131. **Tree Fern and "Whish-whish" in the Punch Bowl Valley, Jamaica.**—The Fern is *Cyathea Serra*, Willd., and the flower *Ipomoea purpurea*, Linn.

132. **Valley behind the Artist's House at Gordontown, Jamaica.**—*Datura arborea*, L., is the plant in the foreground.

133. **Distant View of Newcastle, Jamaica.**—Native Huts, Date Palms, &c., and a Mango in flower in front, on the left.

134. **Group of Epiphytal Orchids and Bromeliads, Brazil.** —Species of *Tillandsia, Oncidium divaricatum*, Lindl., &c.

135. **A piece of Sugar Cane.**—Consult the description of 45.

136. **Pancratium caribaeum and a Passion Flower, Jamaica.**

137. **Foliage and Fruit of the Akee, Jamaica.**—*Blighia sapida*, Kon., is a tree, native of Guinea and other parts of tropical Africa, and was conveyed to Jamaica in 1778 in a Slave ship under the name Akee. The genus is named in honour of Captain Bligh, of H.M.S. Bounty. It was this navigator who introduced the Bread Fruit into the West Indies. See description of 532.

138. **View of the Bay of Rio and the Sugar-loaf Mountain, Brazil.**

139. **A Brazilian Epiphyte or Air Plant.**—This most gorgeous plant (*Billbergia zebrina*, Lindl.) is a member of the *Bromeliaceae*, a family that includes the Pine Apple, and that was originally restricted to America. Now several species, among them the Pine Apple, are naturalised in tropical Asia and elsewhere. Many members of this family are called Air Plants, because they merely cling to trees and rocks, and have no very evident source of nutrition except the air, though they doubtless absorb organic and inorganic matter that collects on the surfaces to which they attach themselves. See 25 and 26.

140. **Tree Frogs, found amongst dead leaves, Brazil.**—A species of *Hyla*.

141. **Organ Peaks, seen over the morning mists from Theresopolis, Brazil.**

142. **Ground Orchid, Carqueja and Giant Snail, Brazil.**— *Epistephium sclerophyllum*, Lindl., *Baccharis trimera*, DC., and a *Bulimus*. The Carqueja, or Carqueja amargosa, is a curious member of the *Compositae* having wing-like expansions on the stem in lieu of leaves. It is one of the most widely-spread and one of the commonest weeds of tropical South America. In Brazil it is used medicinally as a tonic, and also by brewers as a substitute for hops.

143. **Brazilian Wild Flowers.**—In front on the bottom is the orange and red inflorescence of a species of *Aphelandra*; above it the lilac flowers of *Lisianthus inflatus*, Mart. ?

Further to the right *Canna*, and above it the handsome *Lisianthus pulcherrimus*, Mart. The large white flowers appear to be those of *Escobedia scabrifolia*, Ruiz et Pav., a plant ranging from Brazil to Mexico; and above it is a small *Melastomacea*, with *Dyckia remotiflora* on the left, and a *Marica* below.

144. **Bermuda Mount, Jamaica.**—A Calabash Tree (*Crescentia Cujete*, L.) covered with Epiphytes, in the foreground, see 111.

145. **Study of Banana and Trumpet Tree, Jamaica.**—Consult the descriptions of 120 and 823.

146. **The Garden of King's House, Spanish Town, Jamaica.**—A tree of *Spathodea campanulata*, Beauv., &c. An inflorescence of the *Spathodea*, which is a native of west tropical Africa, is represented natural size in 165.

147. **Cultivated Flowers, painted in Jamaica.**—Below on the left is a white-flowered *Gardenia*, and the showy scarlet *Passiflora quadriglandulos*, Rodsch. (syn. *Tacsaonia sanguinea*, DC.); above, *Datura sanguinea*, L., and *Broughtonia sanguinea*, R. Br., with a cluster of *Brunfelsia americana*, Swartz, in the centre; a leaf of a *Caladium*, a spike of *Lagerstroemia Flos-reginae* and flowers and fruit of a Passion Flower (*Passiflora alata*, Ait.) on the right.

148. **Valley of Bamboos, near Bath, Jamaica.**—The arboreous grasses called Bamboos form a very prominent feature in the vegetation of most tropical countries, and more especially of tropical Asia, where the true Bamboos (i.e., the genus *Bambusa*) are at home. Their useful applications are almost endless, in consequence of which they are, in common with the Banana and Cocoanut, extensively cultivated, or protected—for they need very little attention. The Common Bamboo (*Bambusa arundinacea*, Retz.), is now very common in the tropical regions of the New World, though it is supposed to have been originally introduced by man. Further particulars may be found in the description of 304.

149. **View over Port Royal, Jamaica, with Bamboos in the foreground.**

150. **Bananas and Rocks at Paquita, Brazil.**

151. **Flowers of a Brazilian Coral Tree and Vegetable Mercury.**—*Erythrina* sp., and *Brunfelsia Hopeana*, Benth.

(syn. *Franciscea Hopeana*, Hook.). The latter is used medicinally, hence the popular name.

152. **The Bilimbi or Blimbing, Jamaica.** — *Averrhoa Bilimbi*, L., is a small tree, native of the Malayan Islands, cultivated for its fruit, which makes good tarts; a cooling drink is also prepared from it. Observe the flowers and fruit borne on the trunk. The Carambolo, another species of the genus, is represented in 544.

153. **Foliage, flowers, and fruit of the Coffee, Jamaica.** — This is a small tree or shrub, native of the mountains of eastern tropical Africa, now cultivated and naturalised in the lower mountainous regions of many other tropical countries. In consequence of the common coffee (*Coffea arabica*, Linn.) being very much injured under cultivation by various animal and vegetable parasites, it has been largely replaced during the last few years by another species (*Coffea liberica*), which is a more robust plant, and therefore, it is hoped, better able to resist the attacks of parasitic organisms.

154. **The Calaveras Grove of the Big Tree, or Wellingtonia, in the evening.** — The Big or Mammoth Tree, *Sequoia gigantea*, Decaisne (syn. *Wellingtonia gigantea*, Lindl.), is here associated with the Sugar Pine (*Pinus Lambertiana*, Dougl.), which has cones a foot to eighteen inches long, and when they are ripe they weigh down the ends of the branches, making the tree look like a Chinese pagoda. The Big Tree, or Mammoth Tree of California, occurs in groups with other trees, along a line of country on the western slope of the Sierra Nevada, some 240 miles in length. This is the largest and tallest tree in America, and is only exceeded in height by some of the gum Trees of Australia. The height of the tallest one yet discovered, which is in the Calaveras Grove, is 325 feet. One of the finest and largest trees of this grove was cut down, and its age ascertained to be about 1,300 years; yet it is possible that others considerably exceed this age, as, for instance, the "Grisly Giant," of the Mariposa Grove (214). For some time only the Calaveras Grove was known, and this grove, it is recorded, was first discovered in 1852 by an American hunter; and it was re-discovered in 1853 by W. Lobb. This tree was first cultivated in this country by Messrs. Veitch in 1854. See 171, 213, 214, &c. The Pine is also a very tall tree, growing from 150 to 300 feet high.

Panel 72 is a specimen of the wood of the Big Tree, and 73 of the Sugar Pine.

155. **Foliage and Fruit of the Loquat, or Japanese Medlar, Brazil.**—*Eriobotrya japonica*, Lindl., is a native of Japan, cultivated in Brazil and elsewhere. The flowers are represented in 128.

156. **Inflorescence and ripe Nuts of the Cocoanut Palm.** —The inflorescence of the Cocoanut (*Cocos nucifera*, Linn.) is a branched spadix bearing innumerable flowers, only a few of which are female and fertile, the rest containing only stamens. When young the spadix is enclosed in a large spathe, which is partly seen above the flowers in the picture. As commonly seen in this country, the nut is divested of its dense fibrous outer coat, and consists of a hard bony shell (endocarp) containing one seed which is noteworthy for its size. The seed itself consists of a very small embryo near one of the three holes at one end of the nut, a layer of a solid substance (albumen) and a quantity of liquid (also albumen) in a central cavity, which in germination serve to nourish the young plant until it has formed roots and is able to draw its food from the soil. See the description of 229, and panel 87 of the wainscot below.

157. **Date Palm and Negro Hut, near Craigton, Jamaica.** —*Alpinia nutans*, Roscoe, in the foreground. This showy plant is represented natural size in 123.

158. **Flowers of a Shrubby Convolvulus, Jamaica.**

159. **Group of small Palms, Rio Janeiro, Brazil.**—A species of *Bactris*, of which genus it is estimated that there are at least one hundred distinct species, all natives of tropical America.

160. **Foliage and Fruit of Arnatto and Foliage and Flowers of Logwood, Jamaica.**—These are both dye plants indigenous in tropical America. Arnatto, *Bixa Orellana*, Linn., is used for dyeing silks an orange-yellow and colouring cheese. It is obtained from the pulp in which the seeds are embedded. Logwood, *Haematoxylum campechianum*, Linn., is largely used in combination with other things by calico printers, &c.; and it is one of the ingredients that give the glossy black to silk hats.

161. **View over Kingston and Port Royal from Craigton, Jamaica.**—Star Apple Trees (*Chrysophyllum Cainito*, L.) in the foreground, the fruit of which is represented in 107.

162. **Foliage, Flowers, and Fruit of a variety of Guava.**

163. **Study of Gulf Weed.**—*Sargassum vulgare*, Agardh, is a seaweed that accumulates in enormous quantities in the warm Gulf Stream of the Atlantic.

164. **View over Ochos Rios, Jamaica.**—The beginning of a river flowing out of the limestone caves, beneath masses of bananas and *Colocasia Antiquorum*, Schott., and finding its way down through the terraces of Allspice and Orange trees to the bay, in which the coral reefs give a lilac tint to the clear water. Cabbage and Cocoanut Palms in the foreground.

165. **Cultivated and Wild Flowers, Jamaica.**—Large inflorescence of *Spathodea campanulata*, Beauv., a West African *Bignoniacea*, with flowers of *Cordia* spp., a *Rubiacea*, and of the blue *Clitoria ternatea*, L.

166. **One of the Sources of the Roaring River, Jamaica.**—Trees of *Grias cauliflora*, L., embedded in stalagmites.

167. **View of the Sandy River at Spanish Town, Jamaica.**

168. **Foliage, Flowers, and Fruit of Lignum Vitae, Jamaica.**—Lignum Vitae (*Guaiacum officinale*, L.) is an exceedingly hard wood, used for making pulley blocks, rulers, pestles, &c.; and the resin called gum guaiacum is an exudation from the stem.

169. **Two Tropical American Flowers.**—The one having white flowers (*Utricularia montana*, Jacq.) is a congener of the Bladderworts of our ponds and ditches. It has a wide range of distribution. Associated with it is the pretty little Brazilian *Stenogaster concinna*, Hook. f.

170. **Flowers of Jasmine Mango or Frangipani, Brazil.**—A species of *Plumeria*, whose flowers come before the leaves, and when the latter appear a large caterpillar also often comes and eats them all up.

171. **Looking into the Calaveras Grove of Big Trees, California.**—See the description of 154.

172. **View from Spring Gardens, Buff's Bay, Jamaica.**—Cocoanut Palms, Bread Fruit Trees, and Trumpet Tree in the foreground.

173. Under the Redwood Trees at Goerneville, California.
—Consult the description of 204.

174. Study of Cocoanut Palm.—See 156 and 229.

175. Study of Screw Pine.—See 246.

176. Great Cotton Tree, Jamaica.—Before the discovery of the Californian Big Tree and the larger Gum Trees of Australia, this (*Eriodendron anfractuosum*, DC.) was one of the tallest trees known. The natives hold it in superstitious veneration, and will neither cut it down when alive nor remove it when dead. Its wood is soft and spongy, and it sheds its leaves in winter, yet it is so covered with parasites and epiphytes that the leaves are hardly missed. The silky cotton enveloping the seeds is used to stuff beds and pillows, and Humming Birds line their nests with it. There is an Asiatic species, flowers and fruit of which are represented in 632.

177. Coffee Plantation at Clifton Mount, and the Blue Mountains beyond Jamaica.

178. Snake Tree and Bamboos, on Spanish River, Jamaica.—The botanical name of the Snake Tree has not been ascertained. It is so called on account of its twining aerial roots.

179. View in the Fernwalk, Jamaica.—This is at an elevation of 5000 feet above the sea, and it is nearly always bathed in a mist.

180. Group of Flowers, Wild and Cultivated, in Jamaica.
—The large white flower (*Portlandia grandiflora*, L.) in the centre and the lovely blue Morning Glory (*Ipomoea rubro-coerulea*, Hook.), are two of the most beautiful of all climbing plants. Above the latter is *Bougainvillea spectabilis*, Willd., the blue *Duranta Plumieri*, Jacq., and *Heliotropium* (*H. indicum*, L. var. ?), and the scarlet *Hippeastrum Reginae*, Herb. ; and on the right, beginning at the top, the singular *Epidendrum cochleatum* L., *Eugenia Jambos*, L., *Hibiscus Rosa-sinensis*, L., and *Meyenia*. The branch bearing small, white flowers at the bottom on the left, belongs to the celebrated Lace-Bark Tree of Jamaica, *Lagetta lintearia*, Lam.

181. View on the Flamsted Road, Jamaica.—Mango tree in flower, Cabbage Palm, Bananas, and Bamboos.

182. **Study of the "Plant of Life."**—This is *Bryophyllum calycinum*, Salisb., with *Ipomoea purpurea*, L., and *Thunbergia alata*, Boj., plants naturalised in Jamaica. When placed on damp earth the leaves of the first produce in the notches buds that grow into independent plants; and in a warm moist climate, it will do the same if merely pinned to a wall.

183. **Study of Cocoanut Palm.**—Mango in flower and Sugar Plantations beyond. See descriptions of 229, 309, and 688.

UNITED STATES.

184. **"Castor and Pollux" in the Calaveras Grove of Big Trees, California.**

185. **Vegetation of the Desert of Arizona.**—There are various Cacti, including the Suarrow or Suguaro of the Mexicans (*Cereus giganteus*, Englm.), the largest and most striking member of the family, sometimes as much as sixty feet high, and two feet in diameter. The plant with whip-like branches is *Fouquieria splendens*, Engelm. represented of the natural size in front; and the trailer is a kind of Gourd, most likely *Cucurbita digitata*, A. Gr.

186. **Foliage, Flowers and Fruit of the Citron, and Butterfly; painted in Brazil.**—The native country of the Citron (*Citrus Medica*, Risso) is not known with certainty, though there is little doubt that it is some part of tropical Asia.

187. **View of both Falls of Niagara.**

188. **Old Cypress or Juniper Tree, Nevada Mountains, California.**

189. **The Mariposa Grove of Big Trees, California.**—Consult the description of 154.

190. **Foliage and Flowers of the Californian Dogwood, and Humming Birds.**—At first sight the inflorescence of the Dogwood (*Cornus Nuttallii*, Audubon), seems so like the flowers of a Clematis that one might take it to be a flower. In reality it consists of a number of small flowers closely packed together, encircled by a number of white leaves (bracts). *Selasophorus rufus* is the name of the bird.

191. **Autumn Tints in the White Mountains, New Hampshire, United States.**—The leaf-shedding trees of North

America generally assume more brilliant colours in autumn than the trees of Europe. This is not altogether due to climate, for the North American trees retain this peculiarity when transplanted to this country.

192. Wild Flowers from the Neighbourhood of New York.—The plant in front resembling our native Cuckoo Pint, or Lords-and-Ladies, is the Indian Turnip of the Americans (*Arisaema triphylla*, Torr.) associated with a species of Lady's Slipper (*Cypripedium pubescens*, Willd.), a Solomon's Seal (*Polygonatum biflorum*, Ell.), False Spikenard (*Smilacina racemosa*, Desf.), and a purple Geranium (*G. maculatum*, L.). On both sides in front are flower-bearing branchlets of the Black Huckleberry (*Gaylussacia resinosa*, Torr. & Gr.).

193. The American Fall from Pearl Island, Niagara.

194. Wild Flowers from the Neighbourhood of New York.—In front, on the left, is the singular Cancer Root, or Naked Broomrape (*Aphyllon uniflorum*, Torr. & Gr.), a root-parasite allied to our Broomrapes, remarkable in having only one flower on each stem; behind is the scarlet and yellow Columbine (*Aquilegia canadensis*, L.), with the purple Lady's Slipper (*Cypripedium acaule*. L.), in the centre; and the Pinxter Flower (*Azalea nudiflora*, L.), and the Stagger Bush (*Andromeda mariana*, L.), on the right.

195. A View of Lake Tahoe and Nevada Mountains, California.—Pine Trees (*Pinus ponderosa*, Dougl.) in the foreground.

196. Rainbow over the Bridal Veil Fall, Yosemite, California.—Cypress, Douglas Fir, Alder and Dogwood Trees in the foreground.

197. On the Rocks, near West Manchester, Massachusetts.

198. A Fallen Giant, Calaveras Grove, California.

199. Flowers of North American Trees and Shrubs.—The Tulip Tree (*Liriodendron tulipifera*, L.), the False Acacia or Locust Tree (*Robinia Pseudacacia*, L.), and the Calicoe Bush or Mountain Laurel (*Kalmia latifolia*, L.), with varieties of *Azalea* and *Rhododendron*.

200. View of Mrs. Skinner's House at West Manchester, Massachusetts.—Indian corn in the foreground.

201. **View of Lake Donner, Sierra Nevada.**—The Great Pacific Railway on the right.

202. **Lake Tahoe, California.**—Foreground of Yellow Pine and Cypress hung with yellow Lichen.

203. **Group of Californian Wild Flowers.**—Beginning in front, on the left is a yellow Columbine (*Aquilegia chrysantha*, A. Gr.), and behind it the dark blue Spiderwort (*Tradescantia virginica*, L.), which are not really wild in California; above, in the pot, the large showy Mariposa Lily (*Calochortus venustus*, Benth.), with the pink-flowered Centaury (*Erythraea venusta*, A. Gr.), the blue-flowered "Chia" (*Salvia Columbariae*, Benth.), and the buff Monkey Flower (*Mimulus glutinosus*, Wendl.); then come the purple and white whorled flowers of *Collinsia bicolor*, Benth., the large pale blue *Phacelia Whitlavia*, A. Gr., the smaller darker blue flowers of *P. grandiflora*, A. Gr., and the narrow spike of white flowers is *Antirrhinum Coulterianum*, Benth.; these are succeeded by the azure *Pentstemon azureus*, Benth.; the more slender crimson *P. centranthifolius*, Benth.; and the plumelike scarlet *Castilleia affinis*, Hook. and Arn.; nestling down among the other flowers are the purple and white clusters of *Orthocarpus purpurascens*, Benth., with the large yellow *Gerardia* (?), and the yellow starlike flower-heads of *Layia platyglosa*, A. Gr. in front; and in front of the pot are the dull blue *Triteleia laxa*, Benth., the dark blue and white *Delphinium variegatum*, Torr. & Gr., finishing with the showy white Wake Robin (*Trillium grandiflorum*, Salisb.).

204. **View in a Redwood Forest, California.**—The Redwood (*Sequoia sempervirens*, Endl.) is the most valuable tree of the Californian forests, and is almost equal in size to the Big Tree or Mammoth Tree, many examples being forty feet in circumference at the base, and from 200 to 300 feet high. Forests of this tree produce even a more striking effect on one than those of the Mammoth Tree itself. The Redwood inhabits the coast ranges from Oregon to San Luis Obispo, and was first discovered by Menzies, in Vancouver's expedition, about the year 1794, and was rediscovered by Douglas in 1833. Panels 68 and 70 of the wainscot are specimens of the wood.

205. **Home of an Old Trapper in the Trunk of a Big Tree, Calaveras Grove, California.**

206. **Another View of Lake Tahoe and Nevada Mountains, California.**—See 195 and 202.

207. **An old Red Cedar on the rocks near West Manchester, Massachusetts.**—This is one of the " Pencil Cedars," though actually a Juniper(*Juniperus virginiana*,Linn.),which ranges from the West Indies and Florida to Hudson's Bay, varying in size according to the situation from a bush to a tree ninety feet high.

208. **Some Wild Flowers of California.**—In front is the curious Thistle-leaved Sage (*Salvia carduacea*, Benth.), with a species of *Calochortus* on the right; a scarlet Catchfly (*Silene californica*, Dur.), and a species of *Phlox* above ; and the American Cowslip or Shooting Star (*Dodecatheon Meadia*, L), on the left. This last is very widely dispersed in North America.

209. **The Yosemite Waterfall, California.**—Balsam Poplars (*Populus trichocarpa*, Torr. & Gr.) in the foreground. The Upper Yosemite Fall is stated to be about 1550 feet high ; and below it the stream descends, by a series of cascades and falls, about a thousand feet more to the bed of the valley, making altogether a fall of 2550 feet.

210. **Californian Flowers.**—The crimson " Snow Plant " (*Sarcodes sanguinea*, Torr.) grows in decaying vegetable matter in the Big Tree groves and other coniferous woods. Above, on the right, is the elegant little shrubby *Chamaebatia foliolosa*, Benth., and below, on the left, the slender flower stem of *Lithophragma heterophylla*, Torr. & Gr., a member of the Saxifrage family, with tufts of the widely spread *Claytonia perfoliata*, Don, on the right and at the top. Behind the *Lithophragma* are two young seedlings of the Big Tree, which have not yet thrown off the shell of the seed.

211. **Autumn Tints, near Niagara, United States.**

212. **North American Carnivorous Plants.**—Painted from plants grown in this garden. Behind, on the left, is *Darlingtonia californica*,Torr., with *Sarracenia purpurea*, L.. in front of it ; *S. flava*, L., on the right, and Venus's Flytrap (*Dionaea muscipula*, Ellis), in front. The flower of *S. flava* was faded when it was painted. Among the many plants provided with the means for entrapping insects, the North American *Sarraceniaceae*, or Sidesaddle Flowers, are not the least interesting, being curious alike in their leaves and flowers. The genus *Sarracenia* numbers several species, all of which inhabit the Eastern States, ranging from New England to Florida, whilst

the solitary species of *Darlingtonia* is confined to the moun-
tains of North California, from the Truckee Pass, through
which the great Pacific Railroad is carried, northward to
Oregon. *Heliamphora nutans*, a native of Guiana in South
America, is the only other member of the family known.
Dionaea belongs to the same family as our Sundews.
Only one species is known, and that is restricted to Bogs and
Pine Barrens in North and South Carolina.

213. **Ghost of a Big Tree, Calaveras Grove, California.**—
This tree was barked up to a height of 116 feet, and the bark
exhibited at the Crystal Palace, Sydenham, until destroyed by
fire a few years ago.

214. **The "Great Grisly" Big Tree of the Mariposa Grove.**
—It is ninety-three feet seven inches in girth at the base, and
about sixty feet at eleven feet from the ground ; and its first
branch is six feet in diameter.

The flowers around the doorway are : Coffee (*Coffea arabica*,
L.) from Eastern Africa, in the centre, with *Gloriosa superba*,
L., from India, and *Ipomoea macrorrhiza*, Michx., from
Mexico, on the right; and *Rhodochiton volubile*, Zucc., from
Mexico, on the left.

On the panels of the door are a hybrid *Clematis* of the
Japanese type, and, to the right, *Clerodendron Thomsonae*,
Balf., a native of western tropical Africa.

INDIA AND CEYLON.

215. **Indian Almond.**—A tree of the same in the distance on
the left. This tree (*Terminalia Catappa*, L.) is commonly
planted in India for shade ; and it is remarkable in its mode of
branching, the branches being given off from the trunk in tiers
or whorls like the shelves of a dumb waiter. In autumn the
foliage changes to a brilliant crimson. The seeds resemble
almonds and are edible, but they have not the flavour of the
almond.

216. **Wild Flowers of Mussooree, India.**—Although wild,
the cactus (*Echinopsis oxygona*, Zucc.) and the little yellow
Calceolaria are not indigenous in India. The Primulas are
indigenous.

217. **The South Indian Rhododendron.**—This (*Rhododendron nilagiricum*, Zenk.) is the only species found in the Peninsula of India. Some botanists have regarded it as distinct from the Himalayan *R. arboreum;* but the differences are very trifling, and it is usually treated as a variety. See 243.

218. **Clump of Bamboo in the Royal Botanic Gardens, Peradeniya, Ceylon.**—It was planted about 1852, and is now probably sixty feet high. This is *Dendrocalamus giganteus,* Munro.

219. **Foliage, Flowers and Fruit of the Cashew, Tanjore, India.**—A tree of the same and an Ant's Nest in the background. The Cashew (*Anacardium occidentale,* L.) is common in most hot countries now, yet it is believed to have been originally introduced from the West Indies. Its acid astringent fruit is peculiar in its structure, the nut or seed vessel being seated on a fleshy stalk. The shell of the nut contains a very acrid, caustic oil. The kernel is the edible part.

220. **Panch Choola, from Binsur, with Oak Trees and Grey Apes in the foreground.** The oaks are *Quercus incana,* Roxb.

221. **Foliage, Flowers and Fruit of a common Indian forest tree.**—This is *Bauhinia variegata,* Linn. The genus *Bauhinia* is numerous in species, widely diffused in warm countries. It belongs to the *Leguminosae* and is allied to *Cassia* (332), and *Poinciana* (343). Observe the twin leaflets, a character which suggested the happy idea of dedicating the genus to the brothers John and Caspar Bauhin, botanists of the sixteenth century.

222. **Roadside Scene under the Cocoanut Trees at Galle, Ceylon.**—See description of 156 and 229.

223. **Foliage and Fruit of the Wampee and American Passion Flower.**—The Wampee (*Clausena Wampi,* Oliv.) belongs to the same family as the orange, and the fruit is esteemed in China and the Indian Archipelago. *Passiflora quadriglandulosa* Rodsch. is a native of the West Indies and eastern tropical South America.

224. **Study of Cereals cultivated in Kumaon, India.**—An old brass chatty, with a Cob of Maize or Indian Corn (*Zea Mays,* L.) lying in front. The purple brown and the green spikes hanging on the left are varieties of Millet (*Setaria* sp.), behind them the Ragi (*Eleusine coracana,* Gaertn.), and on the right a spike

of *Oplismenus*. On the right is a flowering branch of *Sesamum indicum,* DC., an annual plant which yields the Sesamum or Gingelly Oil, universally used in India in cooking and for various other purposes.

225. **Flowers and Young Fruit of the Chinese Banana.**—*Musa chinensis,* Sweet, differs little from the common Banana except in stature. See the description of 816.

226. **View of the Himalaya Mountains from Mussooree.**—Roses and Rhododendrons in the foreground.

227. **View from the top of the Waterfall at Ramboddy, Ceylon.**—*Datura arborea*, Bananas and Ironwood tree (*Mesua ferrea*, L.) in the foreground, and Rice and Tea Plantations in the distance.

228. **The Taj Mahal at Agra, North-West India.**—This magnificent mausoleum was built by the Shah Jahan in memory of his wife Arjamand Benu Begam, who died in 1629. The Taj was finished in 1648. In the foreground Poinsettia (*Euphorbia pulcherrima*, Willd.), *Bougainvillea*, Cypresses, and a species of Rattan Palm (*Calamus tenuis*, Roxb.) attached to the tree on the right.

229. **Cocoanut Palms on the coast near Galle, Ceylon.**—Dead leaves are tied to the trunks of the Cocoanut Palm in Ceylon to tell by their rustling when thieves are climbing over them : this at least is the popular explanation. Although the Cocoanut Palm (*Cocos nucifera*, L.) will thrive at a considerable distance inland, it is essentially a maritime tree, growing most luxuriantly on sandy and rocky shores. And it exists, cultivated or wild, in such situations, on the coasts of tropical Asia especially, in such vast numbers as to constitute the most striking feature in the scenery. It is without exception the most extensively cultivated tree of any clime, being now seen in almost every tropical country, insular and continental ; and its importance to countless numbers of the human race is almost beyond conception. Even in this country we are familiar with some of the products in the form of cocoa-nut matting, stearine candles, and the nuts themselves ; yet these, valuable as they are, give but a very imperfect idea of the usefulness of this Palm in the countries where it grows. Marco Polo, one of the earliest European writers who described the Cocoanut, says, "The Indian nuts grow here (in the Indian Archipelago) of the size of a man's head, containing an edible substance that is sweet and pleasant to the taste,

and white as milk. The cavity of this pulp is filled with a liquor clear as water, cool and better flavoured and more delicate than wine or any other kind of drink whatever. " Another writer says, " The Cocoanut Palm is alone sufficient to build, rig, and freight a ship with bread, wine, water, oil, vinegar, sugar, and other commodities."

> The Indian Nut alone
> Is clothing, meat and trencher, drink and can,
> Boat, cable, sail, mast, needle, all in one.—*G. Herbert*.

The cultivated Cocoanut Palm begins to bear from the fifth to the eight year, according to soil and situation, and continues bearing from seventy to eighty years. It grows from forty to eighty or even one hundred feet high, bearing annually from thirty to sixty nuts, or sometimes, when in its greatest vigour, as many as a hundred. The Cocoanut Palm is represented in many of the landscapes in this collection, notably in 183, 222, 251 and 619 ; and 156 is a picture of its inflorescence and nuts, which are briefly described under that number. The wood is represented in panel 87 of the wainscot.

230. **View from Rungaroon, near Darjeeling, India.**—An Old Tree covered with Epiphytes in the foreground.

231. **Foliage, Flowers, and Fruit of an African Tree painted in India.**—This tree (*Kigelia pinnata*, DC.), inhabits both the east and west sides of tropical Africa, and presents a most singular appearance when in fruit, the pods being sometimes two feet or more in length, hanging from long slender stalks. The flowers open only at night : and this was painted by candle-light. A tree of the same behind.

232. **Wild Pine Apple in Flower and Fruit, Borneo.**—The Pine Apple (*Ananas sativus*, Mill. var.) is believed to be really indigenous only in Brazil, whence it has spread to other countries, in some of which it has become naturalised and wild. It first became known to Europeans in Peru some three centuries ago ; and it was successfully cultivated in this country at the beginning of the eighteenth century if not earlier. Another plant of the same family is the gorgeous *Billbergia zebrina*, Lindl. (139). See description of that painting.

233. **Foliage and Flowers of an Indian Tree.**—*Tecoma undulata*, G. Don, is a most beautiful tree when its hanging branches are laden with flowers.

234. **Foliage and Flowers of the Indian Rhododendron grande.**—A native of the Sikkim Himalaya, where it forms a tree thirty feet high or more, at elevations of 8000 to 9500 feet. It is in this region that the genus Rhodedendron reaches its greatest development, both in number and diversity of species. Sir Joseph Hooker collected thirty-two species in one valley. See 217 and 243.

235. **Valley of ferns near Rungaroon, India.**

236. **View of the Cathedral Rocks from Mattaran, India.**—Monkeys in the foreground.

237. **Gardening at Nainee Tal, India.**—On the other side of the lake, below the Oak Trees, the Willows (*Salix babylonica*, L.) are seen that formerly shaded the Temple of a Goddess, now covered by a landslip.

238. **Deodars and the Choor Mountain, from Nahl Dehra, India.**—The Deodar or India Cedar (*Cedrus Deodara*, Loud.) is one of the noblest trees of the mountains of North India. See remarks under 297.

239. **Wild Flowers of Simla, India.**—Ladies' Slipper Orchid (*Cypripedium cordigerum*, D. Don.), Violet (*Viola serpens*, Wall.), and *Ophiopogon intermedius*.

240. **Some of Mrs. Cameron's Models, with Cocoanut and Teak Trees, Kalutara, Ceylon.** The Teak trees are on the left.

241. **Tomb of Ali ud Deen and Neem Tree, Delhi.** The Neem tree is *Melia Azadirachta*, L.

242. **Ceylon Pitcher Plant and Butterflies.**—*Nepenthes distillatoria*, Linn., and *Papilio crino*.

243. **Foliage and Flowers of two Indian Rhododendrons.**—The one having white flowers, *R. Griffithianum*, Wight, is better known in gardens under the more recent name of *R. Aucklandii*, Hook.f. In its native country it sometimes grows forty feet high, and has a trunk as thick as a man's body. The other is *R. arboreum*, Sm., the commonest species in the mountains of North India, and a variety of it inhabits the Nilgiri Mountains in the Peninsula. See 217.

244. **Singular Plants of the Dark Forests of Singapore and Borneo.**—These highly curious organisms are members of a small family (the *Burmanniaceae*), related to the *Orchidaceae*. Some of them draw their nourishment from decaying vegetable matter, hence are called saprophytes; some from

the roots of other plants to which they attach themselves parasitically; and as the food thus obtained is ready for assimilation, there is no necessity for green leaves, which are essential to most plants in the preparation of the food absorbed from the earth in a crude state by their roots. The plants here represented belong to the genera *Thismia*, *Geomitra*, and *Burmannia* and were painted mainly from Dr. Beccari's figures and descriptions.

245. **The Elephant Creeper of India.**—Leaves of this, (*Argyreia speciosa*, Sweet), are used by the natives in the preparation of poultices, and also in cutaneous diseases.

246. **Male Inflorescence of a Screw Pine.**—Trees of the same behind and Buffaloes wallowing in the mud of the swollen river. Screw Pines are so called in allusion to the spiral arrangement of their long prickly leaves, which resemble those of a gigantic pine-apple. There are perhaps thirty or more distinct species, chiefly inhabiting the coasts of the Mascarene Islands and the Indian Archipelago. They often cover large tracts of tidal swamps; and their stilted roots which are always increasing in number, enable them to resist the rush of the water. The male and female flowers are borne on separate trees, each inflorescence containing a large number of flowers. A ripe fruit, the matured female inflorescence of this species, *Pandanus tectorius*, Sol. is depicted in 692. The male flowers are dried and used as a scent by Indian ladies. See also 66, 349 and 571.

247. **Foliage and Flowers of the Red Cotton Tree and a pair of Long-tailed Fly-catchers, Ceylon.**—This tree (*Bombax malabaricum*, DC.) is very large and it is common in the forests of South India and Burma. Like the White Cotton Tree (632) the seeds of this tree are enveloped in silky cotton which is used for stuffing pillows and cushions. These so-called Cotton Trees belong to the same family as the true Cotton Plant (107), *Eriodendron*, &c., but the staple of the cotton of their seeds is too short and brittle for manufacturing purposes. The bird is *Muscipeta paradisi*.

248. **Bombay Pedlars in Mrs. Cameron's Verandah, Kalutara, Ceylon.**

249. **Wild Fowers of Mt. Tonglo, Sikkim, India.**—The trailer with blue flowers is *Crawfurdia speciosa*, Wall., a Gentianaceous plant, and its associate *Impatiens falcifera*, Hook. f.

250. **Young Shoots of the Iron Wood Tree.**—Ironwood (*Mesua ferrea*, Linn.) is very widely spread in India, both

in a wild state and cultivated. See also 271. The insect is
a species of *Orthopteron*.

251. **Cocoanut Palms on the River Bank near Galle, Ceylon.**
—For some information respecting this Palm the reader
is referred to the descriptions of 156 and 229.

252. **Blue Poppy growing on Mt. Tonglo, Sikkim-Himalaya.**
—This ornamental plant (*Meconopsis Wallichii*, Hook.) has
several times been introduced and cultivated in this country,
where, however, it does not develop its full beauty, owing,
doubtless, to the impossibility of providing the climatal con-
ditions it enjoys at its home at 10,000 feet above the level of
the sea. See 261.

253. **Wild Flowers of Kumaon, India.**—On the left a robust
species of *Habenaria*—*H. intermedia*, D. Don, with the purple
Strobilanthes Wallichii, Nees, above; the large lilac flower is
Roscoea alpina, Royle, and the plant over it, having small
white flowers, *Argostemma verticillatum*, Wall. The other
orchid is *Satyrium nepalense*, D. Don.

254. **Foliage and Fruit of the Cherimoyer.**—*Anona Cheri-
molia*, Mill., is a delicious fruit of Peru. Several other species
of the same genus yield excellent fruits, as *A. reticulata*, L.
See 275.

255. **Indian Rhododendrons and North American Honey-
suckle.**—The Rhododendrons are *R. cinnabarinum*, Hook. f.,
yellow and red, and *R. formosum*, Wall., and the Honeysuckle
Lonicera sempervirens, Ait.

256. **Foliage and Flowers of the Suriya or Portia ; the
Pagodas of Madura in the distance.**—The Portia (*Thespesia
populnea*, Corr.) is a fast-growing tree, commonly planted for
shade in Southern India. When the flowers first open they
are yellow, changing to red as they get older.

257. **Foliage, Flowers, and Fruit of a Forest Tree of
India.**—A tree of the same in the distance. This (*Lagerstroemia
Flos-reginae*, Retz.) is one of the showiest of Indian forest trees
when in blossom. It belongs to the same family as our native
Purple Loosestrife (*Lythrum Salicaria*, L.). See 645.

258. **Foliage and Flowers of an Indian Forest Tree of
great beauty.**—It is the *Pterospermum acerifolium*, Willd.,
a member of the *Sterculiaceae*. The texture of the buds is
like velvet and of the leaves like satin.

259. **Iron Pillar of Old Delhi, India.**—Though the English
by digging have found that its foundations are only twenty

inches below the surface, the Hindoos still maintain that its roots are in the centre of the earth. An inscription upon it gives its age to be about the fifth century, though how it was forged of solid iron at that period is a mystery. The height of it is twenty-three feet, with a diameter of twelve to sixteen inches. The Great Arch of the Mosque of Kutub ud Deen is seen in front, with trees of Neem (*Melia Azadirachta*, Linn.) on the left and Peepul (*Ficus religiosa*, L.) on the right.

260. **Avenue of Indian Rubber Trees at Peradeniya, Ceylon.**—*Ficus elastica*, Roxb., is a native of Assam in Northern India, and is familiar to most people in this country in a small state ; the evergreen with large glossy leaves so commonly grown in rooms being the same plant. It is a wonderful example of a plant that can exist in a healthy state under widely different conditions. Compare the massive buttressed trunks of the trees in the picture with the plant growing in a handful of earth, and imagine the latent vital energy in the latter that favourable conditions would bring forth! Many other trees beside the present yield caoutchouc ; but the product of this tree, under the name of Indian Rubber, was one of the first kinds employed in the manufactures. In all cases it is obtained in the form of a milky juice from incisions in the trunk.

261. **View of Kinchinjunga from Tonglo.**—Rhododendrons (*Rhododendron arboreum*) and Blue Poppies in the foreground. Consult 252 and 270.

262. **African Baobab Tree in the Princess's Garden at Tanjore, India.**—*Adansonia digitata*, Linn., the African Baobab, is remarkable for the gigantic proportions of its relatively short trunk, which sometimes, it is recorded, exceeds 100 feet in girth in its native country, tropical Africa. In consequence of the enormous size of its trunk and some other circumstances, travellers and writers of repute have assigned a very great age—as much as 5000 years—to some of the larger specimens of this tree in western tropical Africa ; but there are good reasons for doubting these estimates, notably the rapid growth of the tree. Further, the wood is soft and spongy and soon decays, leaving the trunks hollow. In these hollow trunks the negroes suspend the dead bodies of those who are refused the honour of burial ; and in this position the bodies are preserved without any process of embalming. The useful products of the Baobab are not unimportant. Amongst other things the foliage is used medicinally and as a condiment ; a

fibre is obtained from the bark that is so strong as to have given rise in Bengal to the saying " as secure as an elephant bound with a Baobab rope ; " and the gourd-like fruit, which is called Monkey-bread and Ethiopian Sour Gourd, is also eaten, and is especially valuable for its febrifugal qualities. The botanical affinities of *Adansonia* are with *Bombax* (247), *Durio* (550), and *Eriodendron* (632). A second species, having an equally bulky trunk, occurs in Australia, and a third species inhabits Madagascar.

263. A Darjeeling Oak, festooned with a climber.— *Quercus lamellosa*, Sm., and *Thunbergia coccinea*, Roxb.

264. The Cobra Plant, under Deodars, at Simla, India.— *Arisaema curvatum*, Roxb.

265. Nepalese Temple and Peepul Tree, with Blue Pigeons bathing, Benares, India.—The Peepul, a kind of fig (*Ficus religiosa*, Linn.), and the pigeon (*Columba livida*) are both sacred to the Hindoos. It is the skeleton leaves of the Peepul on which Chinese Buddhists paint flowers. See 315.

266. Loose - skinned Orange of Colombo, Ceylon.—A variety of *Citrus Aurantium*, Linn.

267. Bauhinia Creeper crushing Tombs, Saharunpur, India. The *Bauhinia* is *B. Vahlii*, Wight and Arn.

268. Temple in a Dell, Binsur, Kumaon, India.

269. Study of a Deodar, in full cone and clothed with a creeper, near Simla.—The creeper is probably *Vitis himalayana*, Brandis. Look at 283 and 297.

270. Distant View of Kinchinjunga from Darjeeling.— Tree Ferns and Oaks, festooned with *Thunbergia coccinea*, Roxb., in the foreground. Kinchinjunga is 28,136 feet high, and the highest mountain in the world except the neighbouring Mount Everest, which is 29,002 feet high, and Peak K. 2 in the Karakoram Mountains, which is 28,278 feet. See 261 and 263.

271. A View in the Royal Botanic Garden, Peradeniya, Ceylon. —An Iron-wood tree (*Mesua ferrea*, L.) clothed with a young growth of rosy leaves, and a yellow-flowered climber (*Bignonia* sp., *B. unguis?*) with the Director's house on the left. See 250 for young foliage of the Iron-wood tree natural size.

272. **Jain Tower and Temple at Chittore, India.**—A Fig tree growing on the top of the former and loosening the stones which were laid a thousand years ago. The tower is eighty feet high, and the Fig tree is sacred and must not be touched.

273. **Flowers of Darjeeling, India.**—*Hydrangea altissima*, Wall., and yellow *Thunbergia lutea*, T. And. The large flowers in the circumference of the inflorescence of the Hydrangea are sterile.

274. **Himalayan Flowers embedded in Maidenhair Fern.** —Blue Anemones (*Anemone rivularis*, Ham.), a purple Columbine (*Aquilegia*), two species of *Arisaema*—the taller one *A. utile*, Hook., the other *A. speciosum*, Mart., &c. At the bottom on the left is *Parochetus communis*, Ham., a plant having clover-like leaves and solitary blue pea-flowers. In the middle below is *Roscoea alpina*, Royle.

275. **Custard Apple, Native "Gooseberry" of Sarawak, and Leaf Locust.**—*Anona squamosa*, L., is a tropical American fruit, commonly cultivated in the tropics. In the West Indies the fruit of *A. reticulata* is called Custard Apple, while in India the latter name is applied to the fruit of *A. squamosa*.

276. **Road up to Nainee Tal, India, in Spring time.** The tree in flower is *Ougeinia dalbergioides*, Benth.

277. **On the way from Tibet near Nagkunda, North India.** —Sheep carrying their loads of tea and borax from Tibet into India. The trees are a kind of Fir (*Picea Morinda*, Link), and on the left *Abies Pindrow*, Spach.

278. **Michelia and Climber of Darjeeling, India.**—The tree is *Michelia excelsa*, Wall., a lofty congener of the Champak, and the climber is *Porana grandiflora*, Wall., which is remarkable in its family (*Convolvulaceae*) for being sweet-scented.

279. **African Baobab Trees, a large Tamarind, the God Aiyanar and his two Wives.**—The god and his wives are supposed to take a ride every night, leaving good gifts at the houses of all who give them earthenware horses. The natives of India, it is stated by Drury, have a prejudice against sleeping under the Tamarind tree (*Tamarindus indica*, Linn.), and the acid damp from the trees does affect the cloth of tents that are pitched under them for any length of time. For foliage and fruit, natural size, see 700. A short account of the Baobab (*Adansonia digitata*, Linn.) is given in the description of 262.

280. **Wild Flowers of Darjeeling, India.**—Hanging above are the crimson flowers of *Aeschynanthus bracteata*, Wall., with *Torenia asiatica*, L., on the right; the handsome *Pleione Wallichiana*, Lindl., in the centre, and a delicate species of *Utricularia* below.

281. **Open Seed-vessels of a Species of Sterculia and a Nettle in Flower, Sarawak, Borneo.**—See 638.

282. **A Himalayan Oak and Birds, Nainee Tal, India.**—This oak is *Quercus incana*, Roxb., and the bird a species of *Erythrospiza*.

283. **Dibee Dhoora Dee, with its Well and Deodar trees, Kumaon, India.**—A place of pilgrimage. Consult 297 and its description for particulars of the Deodar.

284. **Talipot Palm, near the Botanic Garden, Peradeniya, Ceylon.**—This Palm (*Corypha umbraculifera*, L.) is a native of Ceylon and the Malabar coast, where it grows sixty or seventy or sometimes as much as a hundred feet high, and then flowers and dies. It is a number of years—ten or more—before it begins to form a visible trunk ; but when the trunk starts it grows very rapidly. When about thirty years old, it is stated, the enormous terminal inflorescence of hermaphrodite flowers is developed, and the leaves drop off, leaving the fruit to ripen alone. This process takes at least a year, when the stem is borne down by the weight of the fruit, and the Talipot's life is over. The leaves of the Talipot are commonly used by all classes for umbrellas, and are often large enough to cover eight persons. This Palm is said to flower gregariously like some of the Bamboos. See 670.

The road-makers in the foreground are working in the native fashion, singing a ballad and letting their rammers fall at the end of each verse only, with a long rest between.

285. **The Great Lily of Nainee Tal, in North India.**—This fine Lily (*Lilium Wallichianum*, R. & S.) grows six or seven feet high, and is here associated with *Chirita urticaefolia*, Ham., and a species of *Begonia*.

286. **Foliage, Flowers, and Fruit of Millingtonia hortensis.**—This tree is a native of the Malay Peninsula, cultivated in South India for its ornamental character. Bark used for the same purposes as cork.

287. **Orchids of Tropical Asia.**—*Dendrobium superbum*, Rchb. f., purple, and *D. Jenkinsii*, Wall., yellow.

288. **Mussulman Tombs in the Plain of Old Delhi.**

289, 290, 291. **Pine-clad slopes of Nagkunda, North India, and view of the distant mountains.**

292. **Nassick, in the Bombay Presidency.**—The city of Nassick is regarded by Brahmins as the seat of learning and piety, and is more highly venerated than even Benares.

The twenty-eight paintings in oval mounts (293 to 320) represent a selection of plants often quoted in Sanskrit and other Indian literature. Some of them are used in the sacrifices of the Brahmins, of which the *Soma* is the most important ; others supply themes for poets, though it is impossible to understand what they mean without seeing the plants and flowers themselves ; others, again, are valuable in medicine.

293. **Foliage and Fruit of the Banyan.**—*Ficus bengalensis*, L., is commonly planted for shade, and often covers immense areas, supported by a perfect labyrinth of subsidiary stems and trunks formed from aerial roots that have successively descended from the main branches. There is a record of one being capable of affording shade to 20,000 men. See pictures 665 and 677.

294. **The Sacred Lotus or Pudma.**—*Nelumbium speciosum*, Willd., is the most beautiful and graceful of all the Water Lilies, its leaves and flowers usually rising considerably above the surface of the water ; and at the same time it is the most interesting on account of its remote historical associations. Four thousand years ago it was the emblem of sanctity in Egypt amongst the priests of a religion long ago extinct ; and the plant itself has long been extinct in that country, though very widely spread in the warmer parts of Asia, extending through the Malay Islands to Australia. In India and China, Drury states, the flowers are held especially sacred, and the plant is commonly cultivated. For this purpose the seeds are first enclosed in balls of clay and then thrown into the water— the same method was employed by the early Egyptians. See description of 684.

295. **Holy Basil or Tulsi.**—A most holy herb is *Ocimum sanctum*, L., of the Mint order, grown in pots near every temple and dwelling of devout Hindoos. It is sacred to both Vishnu and Krishna. The root is made into beads, which are worn round the neck and arms ; and it is also used medicinally. The Butterfly is *Papilio sarpedon*.

296. **Flowers of Sal.**—*Shorea robusta*, Roxb., is one of the most valuable of Indian timber trees, 100 to 150 feet high. It also yields a large quantity of resin, which is extensively used as a substitute for pitch in naval yards, and burnt for incense in Hindoo temples. The sweetness of the flowers is sung by Indian poets.

297. **The Deodar or Indian Cedar.**—*Cedrus Deodara*, Loud., forms large forests in the mountains of northern India, growing to a height of 50 to 100 feet and upwards, and yielding a valuable durable timber. It was introduced into this country in 1822, and has been much planted for ornamental purposes; but it does not appear to thrive so well in the vicinity of London as the cedar of Lebanon. It is often mentioned by the Indian poets. See 269 and 283.

298. **The Neem.**—The Neem tree (*Melia Azadirachta*, Linn.) is described by the poets as the type of all that is bitter; and its bark is said to be a fair substitute for Cinchona in cases of fever, &c. It is moreover a very beautiful tree. The leaves are very commonly applied to wounds, either fresh or in poultices. See 259.

299. **The Bael Fruit.**—*Aegle Marmelos*, Corr., is a member of the same family as the orange. Its leaves, which are divided into three separate leaflets, are sacred to the Hindoo Trinity; and one of them is doubled up in the turban or sash of a native to propitiate Shiva and ensure safety from accidents. The pulp of the fruit possesses emollient and aromatic pro-perties, and is used in India as a remedy for diarrhœa and dysentery.

300. **Indian Coral Tree.**—The gorgeous flowers of this tree (*Erythrina indica*, Lam.) are often mentioned by Indian poets. Since Krishna stole it from the Celestial Garden for his wives, it has been under a curse, and is never used in Hindoo worship. Being armed with prickles it is commonly planted for hedges, and in Malabar it is used as a support for the Betel Pepper. The leaves and bark are used medicinally.

301. **Foliage, Flowers, and Fruit of a Tree sacred to Krishna.**—This is *Mimusops Elengi*, Linn., an odoriferous water is distilled from the flowers; the fruit is edible; and the astringent bark is used medicinally.

302. **Foliage and Fruit of Emblica officinalis.**—A Euphor-biaceous tree, whose seeds are used medicinally. The fruit is sometimes preserved in vinegar or sugar.

303. The Dhak or Bastard Teak.—The Dhak (*Butea frondosa*, Roxb.) is one of the most striking of the Indian arboreous *Leguminosae* ; its wood and leaves and flowers, the latter dried and reduced to a fine powder, which is sprinkled, are used in religious ceremonies. The natives are fond of offering the flowers in their temples ; and the females effectively intertwine the blossoms in their hair. It also exudes a ruby-coloured substance employed as catechu.

304. Flowers of the Common Bamboo with Tufts of the Plants behind.—Jungle fires are said to be caused by the dead stems rubbing together during high wind and thus kindling a flame. The waving plumes of these gigantic grasses form one of the most pleasing and characteristic features in tropical scenery ; and the grasses themselves, although they furnish little in the way of food, rank amongst the most useful members of the vegetable kingdom. Indeed their uses are innumerable, every part and every condition being applied in a variety of ways. One may be mentioned here for its novelty. Sections of the full-grown green stems while still containing moisture are capital receptacles for sending cut-flowers to a distance. Bamboos are represented in several of the landscapes in this collection, notably in 71, 547, 553, and 678. They grow from seventy to eighty feet high. Like the lowliest grass the stems of bamboo flower only once and then die. A peculiarity of this (*B. arundinacea*, Linn.) and some other species is that they flower gregariously, that is to say, all the clumps of the same species in a district flower the same year, and no more flowers of that species are to be had until another generation comes to maturity. The duration of the period seems to vary according to circumstances, but data are wanting to answer this question. It is supposed that *B. arundinacea* is about thirty years old before it flowers.

305. The Gool-achin or Caracucha.—A tree (*Plumeria acutifolia*, Poir.) of American origin, commonly planted in Indian gardens, and particularly in cemetries, because it keeps the graves white with its daily fall of fragrant flowers. The branches are very stout, and exude a milky juice when wounded.

306. Foliage and Fruit of Fig Tree held Sacred by the Hindoos.—It is apparently *Ficus glomerata*, Roxb.

307. The Night Jessamine.—The very sweet-smelling flowers of *Nyctanthes Arbor-tristis*, Linn., open at sunset and fall

about sunrise, so that it is unadorned during the day ; hence the specific name, *Arbor-tristis*, or sad-tree. The flowers are much used in temples.

308. **The Soma-lata.**—*Sarcostemma aphylla*, Roxb., a sacred plant, from which a liquid is extracted that is used in Brahminical sacrifices. What the Soma of the Vedas may have been is still an unsolved problem.

309. **Foliage, Flowers and Young Fruit of the Mango.**— The Mango (*Mangifera indica*, L.) is generally regarded as one of the most delicious tropical fruits, though there are many varieties, differing very much in quality. In an unripe state the fruit is much used in tarts, and preserved in sugar or vinegar. Ripe fruit is shown in 688. Along with Sandal-wood, the wood of the Mango is used by the Hindoos in burning their dead. The poets make their Cupid head his arrow with the tiny flowers.

310. **Foliage of Betel Pepper and Areca Nuts.**—*Piper Betle*, Linn., and *Areca Catechu*, Linn., are favourite masticatories of the Indian races. The nuts are cut into narrow pieces and rolled up with a little lime in the leaves of the Pepper, and chewed. So addicted are the natives to this practice, says Blume, that they would rather forego meat and drink than their Areca nuts, which are exported by ship-loads from the Malayan Islands and Cochin China. See 568 and 583.

311. **The Kuddum or Cadamba.**—*Anthocephalus Cadamba*, Miq., is a Rubiaceous tree often mentioned by poets. It has a deep yellow wood recommended for furniture. The yellowish-brown flowers are small and collected in dense balls.

312. **The Asoka.**—*Saraca indica*, L., is an evergreen tree commonly planted in India for the beauty of its foliage and flowers, the latter reminding one at first sight of a *Clerodendron* or an *Ixora* rather than of a member of the *Leguminosae*. The piece with the flower growing through the honey comb was picked for the artist by the priest of Karlee.

313. **Foliage and Fruit of the Mahwa.**—*Bassia latifolia*, Roxb., is a timber tree, interesting also on account of its being one of the few plants whose flowers are eaten by the human race. They are eaten raw by the poor of India, and are largely used in the distillation of a spirit ; they also serve as food for cattle.

314. Foliage and Fruit of two Indian Trees.—They are *Acacia Catechu*, Willd., having spikes of small yellow flowers, and *Terminalia citrina*, Roxb. The former is a sacred tree, and yields a very astringent substance by decoction, formerly known as Terra Japonica, and now as one of the kinds of Indian Catechu.

315. Peepul or Bo.—This is *Ficus religiosa*, Linn., a tree, commonly met with near temples and houses, which the natives are very unwilling to cut down at any time. The Hindoos hold it sacred in the belief that their God Vishnu was born among its branches.

316. The Akunda or Muda.—*Calotropis gigantea*, R. Br., is also an Asclepiad, various parts of which are used medicinally ; and an exceedingly strong fibre is obtained from the branches.

317. The Chumpa or Champak.—*Michelia Champaca*, L., is commonly cultivated for the fragrance of its flowers, which is so strong, according to Sir W. Jones, that bees seldom, if ever, alight upon them. This tree is sacred to Vishnu, and is therefore an object of superstitious regard on the part of the Hindoos, who adorn their hair with the flowers—

> The wandering airs they faint
> On the dark, the silent stream,
> And the Champak odours fail
> Like sweet thoughts in a dream.—*Shelley*.

Panel 166 is Champak wood.

318. White-flowered Thorn Apple.—*Datura alba*, Nees., like several other species of the genus, which are very widely spread in warm and temperate climates, is used both as a medicine and as a poison. The Rajpoot mothers are said to besmear their breasts with the juice of the leaves, in order to destroy their new-born female children.

319. Sandal-wood of India.—*Santalum album*, L., is a small tree celebrated by the poets on account of the sweet scent of its wood. An oil is extracted which is used to incense temples, and also medicinally.

320. A sacred Grass.—*Eragrostis cynosuroides*, R. & S. ; it is used for strewing the floors of temples.

321. Mosque of Delhi from the Lahore Gate of the Citadel. —On the far horizon is seen the celebrated tower of the

Kuttub, and the whole intervening plain is covered with ruins of noble buildings.

322. **Bridge of Chittore in Rajpootana.**—*Ailantus glandulosa*, and tomb in the foreground

323. **Mosque of Lahore from the Palace.**

324. **An Orchid and Butterflies.**—This orchid, *Phajus bicolor*, Lindl., is a native of Ceylon, whence it was introduced into the hothouses of this country in 1843.

325. **Deodar Grove at Simla, with Wild Rose in the foreground.**—See description of 297.

326. **View from the Great Cave Temple of Elephanta, with Fan Palms, Bombay.**

327. **Orchids and other Flowers of Sarawak, Borneo.**—The Orchid having large green-and-black flowers is *Coelogyne pandurata*, Lindl. ; the light-coloured one above, on the left, is probably *C. Dayana*, Reichb. f. ; and intertwined with the first, *Cymbidium Finlaysonianum*, Lindl. On the right, clusters of the gorgeous *Aeschynanthus longiflora*, Bl.

328. **Limestone Mountains of Sarawak, Borneo.**—Leafless flowering branches of a tree (*Sterculia* sp.) of the region in front, and tree of the same glittering in the distance. Below, on the left, remains of its old seed-vessels.

329. **The Giant and other Lilies in Dr. Allman's Garden at Parkstone, Dorset.**—The Giant Lily (*Lilium giganteum*, Wall.) in front is a native of the Himalaya Mountains, and fully merits its specific name, as it grows from six to twelve feet high. On the right is *L. canadense*, Linn., a species with whorled leaves, having the widest range of the American species ; *L. japonicum*, Thunb., with purple-brown and white flowers from the Corean Archipelago ; and *L. pyrenaicum*, Gouan, a European species. On the left is *L. testaceum*, believed to be of hybrid origin. True lilies (genus *Lilium*) are restricted to the temperate regions of the northern hemisphere.

330. **Foliage, Flowers, and Seed-Vessels of an Indian Tree.**—*Albizzia Lebbek*, Benth. Panel 151.

331. **Temple of Tanjore, Southern India.**—This has been described as the finest of pyramidal pagodas of India; in front is a colossal figure of a black bull.

332. **Flowers of a Cassia, with Tree of the same in the distance, and Bornean Butterflies.**—*Cassia nodosa*, Hamilt., a native of tropical Asia, is exceptional in the colour of its flowers, nearly all the numerous species having yellow ones. The butterflies are *Papilio bathycles.* See 33, 336, and 698.

333. **Jak Fruit, Singapore.**—*Artocarpus integrifolia*, Willd., is a larger tree than the Bread-fruit, of which it is a congener, though so different in aspect; the leaves are not lobed as in the latter, and the fruit is borne on short branches from the trunk and older branches. The fruit, too, is larger, sometimes weighing as much as sixty pounds; and it is a favourite article of food among the natives. The custard-like pulp is eaten raw; the large seeds are only eaten when roasted. An excellent birdlime is made from the milky sap. It may be mentioned that the most esteemed of the cultivated varieties of the Bread-fruit are seedless, and the whole substance of the fruit edible.

334. **Rhododendron Nuttallii and Tailor Bird, North India.**—Painted from a plant growing in the large "Temperate House" in these gardens. This is the finest of all the Rhododendrons. It is native of the Duphla Hills, Bhotan, at altitudes of 4000 to 5000 feet; and it exists as a straggling epiphyte or an independent tree as much as thirty feet high. The bird is a species of *Orthotomus.*

335. **Rhododendrons of North India.**—Above, *R. Dalhousiae*, Hook. f., painted from a plant grown under glass in Messrs. Jackman's Nursery at Kingston. This is a shrubby or sometimes epiphytic species, which inhabits the mountains of Sikkim and Bhotan, at 6000 to 7000 feet. Below is *R. calophyllum*, Nutt., painted from a plant growing in these gardens. It is one of the more tender kinds; its home being in Bhotan at an elevation of about 4000 feet.

336. **Foliage and Flowers and a Pod of the Amaltas or Indian Laburnum.**—This showy tree (*Cassia fistula*, Linn.) is a native of India, but it has been introduced into the West Indies and elsewhere, whence its long cylindrical pods are imported into this country. A sugary substance, extracted from the pulp between the seeds, is commonly used as a

D

laxative. The pods of this and a few allied species differ from those of the remainder of the large genus *Cassia* in having transverse partitions, so that each seed has a compartment to itself. Senna leaves of the druggists are the product of various species of *Cassia*. Look at 33, 332, and 698.

337. **Lane near Singapore.**—On the left is an Areca Palm ; and the small compact pyramidal tree in front of it is the Nutmeg, *Myristica fragrans*, Houtt., flowers and fruit of which are represented in 119. Then comes a *Dracaena* having broad leaves, followed by a large Cananga tree, *Cananga odorata*, Hook. f. et Thoms. (syn. *Uvaria odorata*, Lam.)—seə 533—with a Cinnamon Tree on the right, and Mandioc (*Manihot utilissima*, Pohl.) in the right corner.

338. **Mount Everest or Deodünga, from Sundukpho, North India.**—This is believed to be the highest peak of the highest range of mountains in the world ; its estimated height being 29,002 feet, or about five miles and a half. It is interesting to note in this connection that the deepest sounding obtained on the cruise of the "Challenger" was five miles and 150 yards, in about 11° 30′ N. lat. and 143° E. long., thus giving a vertical distance of nearly eleven miles. See 270.

339. **Sunrise among the Pines near Fagoo, in the Himalayas.**

340. **Vegetation and Ourang-Outang in forest of Mattanga, Borneo.**—Rattans (*Calamus*) and an orchid (*Arachnanthe Lowii*, Benth.) are conspicuous.

341. **The Oleander.**—*Nerium odorum*, Sol., is a native of tropical Asia, and very commonly cultivated in gardens for its handsome flowers, which are much used in the decoration of temples. There are varieties having deep red or rose-coloured flowers ; and there are others having double flowers.

342. **Looking down the Bazaar and Lake of Nynee Tal, Kumaon, North-West India.**

343. **Foliage and Flowers of a Madagascar tree at Singapore.**—A tree of the same (*Poinciana regia*, Boj.) in the distance.

344. **View in Singapore, with Nyum-Nyum tree.**—*Cynometra cauliflora*, L., is one of the few arboreous *Leguminosae*

having a fleshy edible seed-vessel. Observe the flowers and fruit are borne on the trunk. See the young, tender foliage in 548.

345. **Hedychium Gardnerianum and Sunbird, India.**—The one projecting stamen from each flower is the most striking characteristic of the group to which this plant belongs, namely, the *Zingiberaceae*, a sub-order of the *Scitamineae*, see 72. *Nectarinia ignicauda* is the name of the bird.

346. **Rhododendron Falconeri, from the Mountains of North India.**—Painted from a plant growing out of doors in Mr. Douglas Heath's garden, under Leith Hill, Surrey. In its home on the Himalaya Mountains, at elevations of 9000 to 13,000 feet, this handsome species is arboreous, attaining sometimes a height of thirty feet, with a trunk six or seven feet in girth.

SOUTH AFRICA.

347. **Foliage and Flowers of a South African tree, beautiful but poisonous.**—A common small tree or shrub, (*Acokanthera venenata*, G. Don) especially in the eastern subtropical parts of South Africa, and apparently extending northward into the tropics. It has the reputation of being poisonous to animals, and an arrow poison is obtained in Somaliland from one or two closely allied species. The family, *Apocynaceae*, to which it belongs comprises many poisonous members.

348. **Fruit de Cythère and Sugar Birds and Nest, Seychelles.**—The Fruit de Cythère (*Spondias dulcis*, Forst.) is an introduced and cultivated plant in the Seychelles and Mauritius. Some part of western Polynesia, where it is now widely spread, is most likely its home. Seemann states that it is very common in the Fiji Islands, and the best native fruit for making pies, etc., appreciated alike by the natives and settlers.

349. **Male Inflorescence and Foliage of a Screw Pine, Natal.**—See 66 and 246.

350. **Red and green Cyrtanthus, Crassula, and Orchids, South Africa.**—On the left *Cyrtanthus obliquus*, Ait., with

yellow *Polystachya pubescens*, Reichb. f., and on the right the fleshy-leaved *Crassula perfoliata*, Linn., and the singular fringe-lipped Orchid, *Disa lugens*, Bolus.

351. **View of the Mountains from the railway between Durban and Maritzburg, Natal.**—This view is from the highest part of the railway ; the undulating foreground is dotted with Cycas trees. See 366.

352. **Clivia miniata and Moths, Natal.**—On the left is a cluster of the ripe fleshy seed-vessels. This plant is better known in gardens as *Imantophyllum miniatum*, Hook. For another fine species of this genus, see 391.

353. **Cork Trees at Cintra, near Lisbon.**—A scene in Da Castro's garden, where, according to tradition, the first orange-tree in Europe was planted. The Cork-tree is a species of Oak (*Quercus suber*, Linn.) and the cork is the bark, which is removed at intervals after the trees have attained an age of about 30 years ; the process in no way interfering with the further healthy development of the tree.

354. **White Convolvulus and Kaffirboom, painted at Durban, Natal.**—This massive *Convolvulacea* (*Ipomoea ventricosa*, Choisy) is a native of the West Indies. *Erythrina caffra* Thunb. is the botanical name of the Kaffirboom. Panel 99.

355. **Morning Glory, Natal.**—This is *Ipomoea rubro-coerulea*, Hook., a Mexican species now cultivated in many countries, and covering all the verandahs at Durban, at the time of the artist's visit.

356. **Angraecum and Urania Moth of Madagascar.**—The genus *Angraecum* numbers about 250 species, inhabiting the Mascarene Islands and Tropical and South Africa ; and their flowers vary in size from less than a quarter of an inch long in *A. parvulum*, from Mauritius, to eighteen inches in the present *A. sesquipedale*, Thouars. Indeed this has the longest spur or nectary of any known orchid, and Darwin suggests that its fertilisation is probably effected through the agency of some moth having an almost equally long proboscis.

357. **Blue Lily and large Butterfly, Natal.**—Behind are large tufts of the plant (*Agapanthus umbellatus*, L'Hérit.) as

it grows in its native haunts. There is a variety with white flowers.

358. Ordeal Plant or Tanghin and Parokeets of Madagascar.—*Cerbera Tanghin*, Hook., yields a poisonous juice which was formerly much employed in Madagascar to detect and punish crime. If the guilty or suspected person survived the ordeal his innocence was proclaimed, though the escape was usually owing to some innocuous drug having been, for a consideration, substituted for the Tanghin.

359. Looking seaward from the mouth of St. John's River, Kaffraria.—Various Aloes and the banana-like *Strelitzia augusta*, Thunb. on the rocks in the foreground. Flowers of the *Strelitzia* in 369.

360. Doum and Date Palms on the Nile above Philae, Egypt.—Among Palms the Doum (*Hyphaene thebaica*, Mart.) is remarkable for having normally a branched trunk, instead of a single trunk with a terminal crown of leaves. It has a wide range in eastern tropical and subtropical Africa, and also occurs in Arabia, and its brown fibrous fruit is eaten by the natives of Upper Egypt, though it is anything but palatable. *Phoenix dactylifera*, Linn. the Date, is essentially a Palm of the desert, flourishing where no rain falls, and yielding a nourishing food where no other is produced. Nevertheless, its roots must be able to reach subterranean waters, for as the Arabs say in their figurative language : "this king of the oases plunges its feet into water, and its head into the fire of heaven." Though cultivated in other countries it is only in the desert region of North Africa that it is a tree of the first importance to the inhabitants. Indeed in the oases it constitutes nearly the whole of the arboreous vegetation ; and where, in consequence of warfare, the Date groves have been cut down the places have been rendered permanently desolate. The varieties cultivated are almost as numerous as those of the apple ; Cosson enumerating seventy-five for the Oasis of Zibau alone. They differ in the consistence, shape, colour and ripening season of the fruit, and bear such names as Beauty of Mimon, Gazelle's Horn, Dove's Egg, Bird's Brain, Bittersweet, and Sweetness Itself.

361. Papyrus or Paper Reed growing in the Ciane, Sicily.—In ancient times the Papyrus (*Cyperus Papyrus*, Linn.) was a plant of great importance, for from its stems was prepared

the paper upon which the Egyptians wrote their books, etc. It is true that Parlatore has described the Sicilian and Syrian plant as a species (*Cyperus syriacus*) distinct from the Egyptian Papyrus; but it has not been generally admitted as such, and the differences are so trifling and minute, even if constant, as to be imperceptible to the ordinary eye. The Papyrus inhabits only the south-eastern part of Sicily, chiefly in the neighbourhood of Syracuse, where however, as Parlatore suggests, it may have been introduced from Syria.

362. **White and Yellow Everlastings (with varieties of Mantis to match) and other Natal Flowers.**—On the right the yellow-flowered *Senecio macroglossus*, DC., a climber with ivy-like leaves; the clustered wholly yellow *Helichrysum appendiculatum*, Less. with a radiate species of the same genus in the centre; on the left the lovely *Oxalis semiloba*, Sond. and a species of *Cyrtanthus* of the section *Gastronema*, behind. Similarity in colouring of flowers and the insects which visit them, serves to protect the latter from their feathered foes.

363. **Trees from the Artist's Hut at St. John's, South Africa.**—On the right the Amatungula, (*Carissa grandiflora*, E. Mey.) or auntigoulah, as corrupted by the colonists; the best native fruit of the country. Above it and on the left the Milk Tree (*Sideroxylon inerme*, Linn.) of which the Kaffirs make their clubs. See 378.

364. **View of a Table Mountain from Bishop Colenso's House, Natal.**—The Australian Gum-trees, Indian Bamboos, and other exotic plants in the garden were planted by the Bishop himself.

365. **Strelitzia and Sugar Birds, South Africa.** — The genus *Strelitzia*, of which four or five species are known, is peculiar to South Africa, and its botanical affinity is with the Banana (*Musa*) and with the traveller's tree of Madagascar (*Ravenala*). *S. augusta* (see 369) much more nearly resembles the genera named than the present, which is *S. Reginae*, Ait. and the most ornamental of them all. Its seeds are eaten by the Kaffirs. Another species (*S. juncea*, Andr.) is remarkable for the blade of the leaf being undeveloped.

366. **A Cycad in fruit in Mr. Hill's Garden, Verulam, Natal.**—Behind on the left a plant of the same. This is *Cycas circinalis*, Linn., a species having a wide range in the tropics

of the Old World, including many islands in Polynesia. A kind of sago is prepared from the large seeds, which are conveyed long distances, uninjured, by oceanic currents, a fact which may account for this plant being among the earlier ones that reach the rising coral islands. The leaf-like development of the inflorescence is singular.

367. **A Giant Kniphofia near Grahamstown.**—*Kniphofia* is a genus of the *Liliaceae* numbering about twenty known species, which inhabit Eastern Africa, from Abyssinia to the Cape, and Madagascar. The species here represented (*K. Northiae*, Baker) differs from all the others, except *K. caulescens*, in eventually forming a distinct stem below the crown of leaves, like some of the aloes.

368. **Two Flowering Shrubs of Natal and a Trogon.**— The brilliant red *Schotia speciosa*, Jacq. is related to the gorgeous Indian *Amherstia* (see 594). The fragrant white *Gardenia Thunbergia* Linn. f. was cultivated in this country more than a century ago, though it has now given way to species of more compact habit of growth.

369. **Strelitzia augusta at St. John's Kaffraria.**—Trees of the same in the background, and *Tecomaria capensis*, Spach., trailing over the vegetation on the left (see 365).

370. **A Tree Euphorbia, Natal.**—This is *E. grandidens*, Haw., very much like *E. abyssinica*, Rausch, which Bruce figures so faithfully in his "Travels" that there is no mistaking its genus, though he stoutly maintained, "in spite of all that botanists said to the contrary," that it was a true Cactus. The yellow-flowered creeper on the left is *Senecio macroglossus*, DC. represented natural size in 362.

371. **Group of Natal Flowers.** — In the top right hand corner *Loranthus natalensis*, Meissn. then clusters of the blue *Pycnostachys reticulata*, Benth. and the white and pink *Dombeya Burgessiae*, Gerard, the "Zulu Cherry," on the left. The central figure is a *Cyrtanthus* near *C. angustifolius*, Ait., with a pale purple species of *Hypoestes* on the right, a wild Gourd, (*Cephalandra palmata*, Sond.) and an *Ipomoea* entwining the vase.

372. **Undercliff and its two Fairies, with Raintree, St. John's.**—The botanical affinity of the Raintree has not been ascertained. It is a name given to various trees, notably

members of the *Leguminosae* in different parts of the world in consequence of water falling copiously from them at certain seasons ; whether the water is discharged from the glands on the footstalks of the leaves, or by insects which feed upon the leaves, still requires investigation, though the latter seems the more probable. The South African Raintree is, however, not a member of the *Leguminosae*, as it has undivided, laurel-like leaves.

373. **The "Gates" of St. John's River, Kaffraria.**—Bishop Galloway's house in the foreground.

374. **Looking up Stream from the mouth of the St. John's River, Kaffraria.**—Various Aloes, *Strelitzia augusta*, and *Mesembryanthemum* on the rocks in front.

375. **Flowers of St. John's in Pondo Basket.**—Beginning on the right at the top, there is the dark blue *Coleotrype natalensis*, C. B. Clarke, a purplish red Balsam (*Impatiens*, sp. having a long slender spur), clusters of the small white flowers of the "White Pear" (*Apodytes dimidiata*, E. Mey.) the red and black seed-vessels of which lie at the foot of the basket on the right; and a *Loranthus* with reddish flowers, which open with elasticity jerking out the stamens and the long, coiled, watch-spring-like style, which terminates the future seed-vessel. In the centre is a white *Pavetta*, and immediately over it the purple-red flowers of *Vigna vexillata*, Benth., and a solitary flower of the yellow *Sphedamnocarpus pruriens*, Planch. Returning to the right, the two pale orange flowers and narrow tendrilled leaves are those of *Littsonia modesta*, Hook., a singular *Liliacea*, followed by the more showy deeper orange *Crocosma aurea*, Planch. ; a large *Hibiscus* with purple centre, the purplish *Grewia lasiocarpa*, E. Mey. and an *Ipomoea* below. Lying in front is a branch of *Acridocarpus natalitius*, Juss. bearing flowers and large winged seed-vessels. Panel 118.

376. **Male Papaw with Flowers and Imperfect Fruit.**—Usually the male and female flowers of the Papaw (*Carica Papaya*, Linn.) are borne on separate plants, the former on long hanging branches, the latter on very short stalks, so that the fruit hangs close to the stem. (See 36.) It has been observed, however, that the same individuals, after bearing only female flowers for several seasons, bore nothing but

male flowers. Occasionally, too, as represented in the painting, female flowers, or possibly hermaphrodite flowers, are associated with the males, and thus it happens that the normally male plant bears fruit.

377. **Crinum Moorei and Honeysuckers, Bashi River, South Africa.**—This beautiful *Crinum* was introduced into the Glasnevin Botanic Garden about twenty years ago, and is now not uncommon in cultivation, and is said to be hardy in the milder parts of the kingdom.

378. **Amatungula in Flower and Fruit and Blue Ipomoea, South Africa.**—Painted at the mouth of the Kowie River. Trees of the Amatungula (*Carissa grandiflora*) are shown in 363. The *Ipomoea* is *I. mutabilis*, Edwards, a native of Mexico and the West Indies, and only a colonist in South Africa.

379. **Mouth of the St. John's River, Kaffraria, and aboriginal inhabitants.**

380. **A common Plant on sandy sea-shores in the Tropics.**—This lovely trailer (*Ipomoea biloba*, Forsk, is found on almost all sandy sea-shores in the tropics as well as in some sub-tropical regions, including many of the most remote oceanic islands. It is a most vigorous plant, its stems sometimes attaining a hundred feet in length, rooting from its joints as it lengthens, thus serving to bind the sands; and its seeds will bear long immersion in salt water without injury (See 551).

381. **The Knobwood and Flowers of Natal.**—One of the most singular of South African trees is the Knobhout or Knob-wood (*Zanthoxylum capense*, Harv.), the trunk of which is studded with massive pyramidal excrescences of the bark, which in time are easily detached and serve as playthings for children. On the trunk here depicted is a tuft of *Angraecum Saundersiae*, Bolus, and the other flower is *Ceropegia Sandersoni*, Dene., the petals of which are united by their tips forming a kind of windowed canopy over the stamens and pistil. Panel 106.

382. **The Kaffir Plum, painted in the Perie Bush, South Africa.**—Flowers and fruit of the tree (*Harpephyllum caffrum*, Bernh.) represented in 384. Panel 115.

383. **A Remnant of the Past near Verulam, Natal.**—This trio of grand old Aloes (*Aloe Bainesii*, Dyer) was about forty feet high at the time the painting was done, and the only ones in that neighbourhood, where the native vegetation is fast disappearing before cultivation. The western species, of which this is the eastern counterpart (*Aloe dichotoma*, Linn.) sometimes, it is recorded, attains a height of sixty feet with a trunk four feet in diameter. These are the only two species of *Aloe* known that grow into large branched trees.

384. **Kaffir Plumtrees overhanging St. John's River, Kaffraria.**—Observe the cord-like climbers attached to the trees, and the tufts of *Agapanthus umbellatus* on the bank. For flowers and fruit of this tree see 382.

385. **Some grotesque plants from the Karroo, South Africa.**—In front on the right the singularly-formed and coloured flowers of *Gomphocarpus grandiflorus*, Benth. & Hook. f., a member of the *Asclepiadaceae*. On the left, the globular, ribbed plant, so strongly resembling an *Echinocactus* (See 14) as to be easily mistaken for one, is *Euphorbia meloformis*, Ait. Behind, a dwarf species of *Aloe* and a yellow *Bobartia?* The species of *Aloe* are so numerous and many of them so much alike that they are scarcely distinguishable except in the living state.

386. **Aloes at Natal.**—In front is a portion of the inflorescence, natural size, of the arboreous one ; to the left is a plant of a species which does not form a trunk. It is near, if not true, *Aloe latifolia*.

387. **Aloe and Passionflower, South Africa.**—The Aloe flowers in this painting belong to the trunkless species in 386 ; and the Passionflower (*Passiflora edulis*, Sims.) is a plant of American origin cultivated and colonised in South Africa, where it is encouraged on account of its edible, purplish fruit.

388. **Various species of Hibiscus, with Tecoma and Barleria, Natal.**—The central plant with yellowish white flowers is *Hibiscus cannabinus*, Linn., with *H. surattensis*, Linn., above on the left, and *H. calycinus*, Willd. below it, and one small pale yellow flower of *H. Trionum*, Linn., amid the blue *Barleria* on the left. *Pavonia Mutisii*, H. B. & K. is the name of the pale rose flower on the left, and the orange one below it is

probably another species of the same genus. At the top on the right is the handsome scarlet-flowered *Tecomaria capensis*, Spach.

389. Cycads, Screw-pines and Bamboos, with Durban in the distance.—Cultivated in the Durban Botanic Garden, though most of the plants are natives of the country. The Cycads are chiefly species of *Zamia*, with a small plant of the endemic *Stangeria paradoxa*, T. Moore, in the foreground on the left. The last is remarkable among Cycads for its very distinct foliage resembling some large *Lomaria* among ferns. It finds a counterpart, however, in the Australian *Bowenia spectabilis*.

390. Vegetation on the St. John's River, Kaffraria.—The trees on the right, bearing white flowers, are the White Pear, see 375.

391. Clivia and Grapnel Plant, South Africa.—The grapnel plant (*Harpagophytum procumbens*, DC.) produces one of the most singular seed-vessels known. Its long claw-like appendages terminate in sharp recurved prickles, which attach themselves readily to any substances with which they may come into contact. *Clivia nobilis*, Lindl. was named in compliment to a late Duchess of Northumberland, a member of the Clive family.

392. Two climbing plants of St. John's, and Butterflies.—The purple pea-flower is apparently a species of *Dolichos*, and the yellowish green flowers are those of *Riocreuxia torulosa*, Dcne. Compare this with *Ceropegia Sandersoni*, Dcne. (381.) In the former the narrow lobes of the corolla at first cohere by their tips, but afterwards free themselves and curl back, whereas in the latter the broad corolla-lobes cohere and form a windowed permanent canopy over the stamens and pistil.

393. Part of the "Residence," St. John's, Kaffraria.—At the time of the Artist's visit the whole "Residence" consisted of a number of Pondo Huts, one of which forms a part of this painting; and the tree overhanging it is the White Pear. (See 375.)

394. Star of Bethlehem from Algiers.—This is probably one of the varieties of *Ornithogalum narbonense*, Linn., in cultivation under the name *O. grandiflorum*.

395. Buphane toxicaria and other Flowers of Grahamstown.—*Buphane toxicaria*, Herb. is the large bulb bearing a single large head of innumerable small red flowers with projecting stamens. Like the gigantic *Brunsvigia multiflora* (399) it develops leaves and flowers alternately, not coetaneously, as most plants. The specific name *toxicaria* was given to it in consequence of the venomous properties of its juice, which is, or was, used by the Bushmen to poison their arrows. Hanging from above is a species of *Zygophyllum*, and the trailing plant with reddish, daisy-like flowers is a species of *Mesembryanthemum*, concerning which genus some particulars are given in the description of 398. To the left of the big bulb is a plant having fleshy leafless stems and curiously marked brown flowers : this is *Stapelia Bufonia*, Jacq. which received its specific name in allusion to the resemblance which its flowers exhibit in colour and marking to a toad (*Bufo*). For other species of this genus see 431. The pink orchid in the left corner is a species of *Satyrium*, probably *S. longicolle*.

Special reference to the butterflies (*Diadema misippus*) in this painting is demanded, because this species offers one of the most perfect instances of mimicry known in the insect world. The brown one above is the female, and the other the male ; and the former so closely resembles *Danais chrysippus* as to be easily mistaken for it.

396. A Selection of Flowers from Table Mountain, Cape of Good Hope.—A stout fleshy ground-orchid (*Satyrium carneum*, R. Br.) with pink flowers ; a Tree Daisy (*Osmitopsis asteriscoides*, Cass.), a blue *Psoralea*, with three species of Heath (*Erica*) on the left. In South Africa there are at least 500 different species of Heath presenting the greatest diversity in the size, shape, and colours of their flowers. As might be expected, where such variety exists, no species covers large expanses like our native heaths, or our gorse.

397. A tree of the sea-shore, St. John's River, Kaffraria. —*Hibiscus tiliaceus*, Linn. (syn. *Paritium tiliaceum*, Juss.) is one of the commonest of littoral trees in tropical and subtropical countries, and it is one of the earliest arboreous inhabitants of rising coral islands. It often produces stilt-like roots from its stem, similar to the Screw Pines, which act as stays to it. For an allied West Indian species see 118.

398. The Hottentot Fig and other Succulents from the Karroo.—*Mesembryanthemum edule*, Linn., is the name of

one of the plants which yield the fruit called, " Hottentot Fig," represented hanging down on the left in this painting, with white, yellow, and pink varieties of its flowers above ; but this is probably another species. The Artist observed that the flowers open of a pure white, turn yellow the next day, and die off pink. This fruit is somewhat acid and of an agree-able flavour when divested of its outer clothing. *Mesem-bryanthemum* numbers some 300 species in South Africa with about eight or ten more widely scattered in other parts of the world ; and the African species offer great diversity in the size and shape of their almost invariably fleshy leaves, and in the colours of their flowers, which so closely resemble the flower-heads of some of the *Compositae* as to be easily mistaken unless examined ; but here the numerous narrow radiating bodies are the petals of one flower, not the corollas of so many separate flowers. The plant with thick broad leaves and a branched inflorescence of bright red flowers is a species of *Cotyledon*, perhaps one of the many forms usually regarded as varieties of *C. orbiculata*, Linn. Behind is a little piece of *Aptosimum depressum*, Burch., and the finger-like branchlets bearing small yellow flowers above, belong to a species of *Euphorbia*.

399. **Brunsvigia multiflora, near Queenstown, South Africa.** This Amaryllid is remarkable for its large bulb and inflor-escence, the latter appearing each season after the leaves have decayed and disappeared. Plants of it are scattered over the plain behind in company with the Thorn Tree, *Acacia horrida*, Willd.

400. **Social Birds and Social Herbs at Malmesbury, South Africa.**—Here is the familiar *Richardia aethiopica*, Kunth, of our windows and conservatories, growing gregariously in its native swamps, associated with the almost cosmopolitan bull-rush (*Typha latifolia*, Linn.), which is hung with the nests of a social finch. Foliage and flowers of an allied species of *Richardia* are of the natural size in 417. The dwarf, dense shrub on the right is the Krippelboom (*Leucospermum cono-carpum*, R. Br.), and beyond are Australian Gum trees, which have been planted. For flowers of the Krippelboom see 410.

401. **Vegetation of the Addo Bush with Kaffirs and their Habitations.**—Hanging from the trees in front are nests of a species of social finch different from that on the bullrushes in 400. On the right is an *Aloe*, and the gouty-stemmed

trees with purplish flowers are the Spekboom (*Portulacaria afra*, Jacq.) an arboreous *Portulacea*.

402. **Cape Colours.**—The white-flowered "Ink Plant" (*Cycnium tubatum*, Harvey) in front, with the rosy *Hibiscus pedunculatus*, Thunb., blue *Plectranthus*, a white and purple-spotted species of *Asystasia* and the little scarlet *Striga coccinea*, Benth., which sticks in the throats of incautious cattle and chokes them. At the bottom on the right is a graceful *Phyllanthus* having its small leaves in two rows and tiny white flowers hanging below them.

403. **Vegetation on the Hills near Grahamstown.**—A slender-stemmed arboreous *Euphorbia*, *Crassula coccinea*, Linn., the gouty *Erythrina caffra*, Thunb., Elephant's Foot (*Testudinaria elephantipes*, Lindl.), and bushes of *Oldenburgia arbuscula*, DC. on the hills behind. See 408.

404. **Root Parasites and Blue Blepharis, Port Elizabeth.**—As may be seen, these brilliantly coloured plants have no green leaves; and they have no need of them, because they draw their nourishment from the roots of other plants upon which they fasten as the mistletoe does on the branches of trees. They constitute a genus (*Harveya*) of *Scrophulariaceae* closely allied to *Hyobanche*. (See 436.) On the right is *Blepharis procumbens*, Pers. (*Acanthaceae*), the singular unilateral corollas of which, with the stamens attached, will stand upright when reversed, and are called "old women" by Cape children.

405. **A Medley of Flowers from Table Mountain, Cape of Good Hope.**—On the right, the scarlet *Sutherlandia frutescens*, R. Br., followed by the white balls of the minute flowers of a *Brunia?* a blue and red *Lobostemon* (*Boraginaceae*); below the *Sutherlandia* are female cones of *Leucadendron platyspermum*, R. Br., and the yellow heads of the male inflorescence of the same shrub (see 450) with a purple *Senecio* between them. Next comes a kind of "Everlasting" (*Helichrysum speciosissimum*, Willd.) having white flower-heads with a yellow centre, and a blue *Lobelia*. Partly beneath the other flowers is the great Ground-orchid, *Disa cornuta*, Sw. with dark blue and white hooded flowers and thick leaves mottled with red; and lastly the beautiful *Mimetes cucullata*, R. Br. a proteaceous shrub having whitish flowers supported by pink bracts.

406. Touch-me-not and Sugar-Birds at Tulbagh, South Africa.—In front the purple flowers and pale green leaves of *Melianthus major*, Linn., or Touch-me-not (Dutch : Truytje roer mÿ niet—literally Gertie, touch-me-not), so called because every part of the plant has a nauseous smell; behind male plants of *Leucadendron corymbosum*, Berg., in which the flowering branchlets are given off in tiers at intervals along the stems.

407. The Wool-Flower of South Africa and some others. —*Lanaria plumosa*, Ait. is the name of the densely woolly plant having small white flowers and grass-like leaves. Other conspicuous flowers in this painting are the orange *Leonotis nepetaefolia*, R. Br. (see 124), the rosy *Chironia pedunculata*, Lindl. a white Heath (*Erica* sp.) the yellow *Cassia mimosoides*, Linn., and a greenish yellow *Diosma?* Less conspicuous is a *Gomphocarpus* on the left and the bluish *Commelina nudiflora*, Linn. or Ten o'clock Flower, on the right, with foliage of an *Ochna* behind. The *Leonotis* bears the name of Kaffir Opium and has the reputation of being a good remedy against snake bites.

408. A Mountaineer from the Hills near Grahamstown.— This handsome robust Composita (*Oldenburgia arbuscula*, DC.) inhabits the sterile, stony region chiefly occupied by plants having succulent stems or leaves. (See 403.)

409. Old Dutch Vase and South African Flowers.—This painting done at Groot Post gives some idea of the astonishing wealth in variety exhibited by the bulbous plants of South Africa. In no other part of the world is there so great a concentration of species of this class of plants, and many of the species are so closely allied that it is impossible in a brief description, such as can be given here, to indicate intelligibly all those represented in this and some of the other selections. Therefore it must suffice to name those easily distinguished.

At the top, the blue *Vieusseuxia tripetaloides*, DC. and two flowers of the yellow *V. Bellendeni*, Sweet; the crimson flowers above on the right are *Antholyza* sp., and next to it is *Gladiolus orchioides*, Andr., and the large star-like rosy flower with a dark centre is *Hypoxis stellata*, Linn. f. A yellow *Babiana* hangs over on the left, and below is the pale yellow *Grielum tenuifolium*, Linn. a Rosaceous herb. On the right the pale yellow *Sparaxis grandiflora*, Ker, and the densely crowded *Ornithogalum thyrsoideum*, Jacq.

410. Krippelboom, with False Bay in the distance: South Africa.—The family, *Proteaceae*, of which the Krippelboom (*Leucospermum conocarpum*, R. Br.) is a member, is almost as largely represented in South Africa as it is in Australia, but by different genera. Among them *Protea* is remarkable for its large heads of flowers, in which the surrounding coloured bracts are the most conspicuous part ; and *Leucadendron* is singular in the male and female flowers being borne on separate individuals. See 405 and 419.

411. A View on the Kowie River, South Africa.—*Aloe*, *Zamia*, and *Strelitzia* on the right, and tree Euphorbias on the distant hills.

412. Lachenalias and Butterflies, South Africa.—*Lachenalia orchioides*, Ait., and *L. pallida*, Ait., here represented are among the less showy sisters of the brilliantly coloured *L. tricolor*, Thunb., and others in cultivation from the same country.

413. A South African Sundew and Associate.—*Drosera cistiflora*, Linn., as this Sundew is named, as far surpasses our native species in the size and colour of the flowers as our cultivated Pelargoniums do their wild ancestors in South Africa. On the other hand, the foliage is so like that of our long-leaved species as to be apparent to the most casual observer. The other plant is *Dipidax triquetra*, Baker, a member of the *Liliaceae*. See 422.

414. Fat Plants of the Addo Bush, South Africa.—Flowers of a *Cotyledon* with a tuft of the same, and *Portulacaria afra*, Jacq. (Spekboom or Elephant's Food) on the right. Among the other flowers *Haemanthus*, a tall *Aloe*, and *Schotia speciosa*, Jacq., are readily distinguishable. The Spekboom, or Fat Tree, is particularly abundant in some localities, and is one of the last resources of cattle in the dry season ; but they will not touch it when other food is to be had. See 447.

415. Honeyflowers and Honeysuckers, South Africa.—The Sugar Bush (*Protea mellifera*, Thunb.) is one of a numerous genus of South African shrubs remarkable for their large showy flower-heads. See description of 410. The slender climber (*Microloma linearis*, R. Br.) entwining it, belongs to the *Asclepiadaceae*.

416. An Old Friend and its Associates in South Africa.— The old friend is *Pelargonium peltatum*, Ait., one of the parents of the many beautiful varieties of ivy-leaved Pelar-

goniums now in cultivation, associated with the yellow *Lisso-chilus speciosus*, R. Br., and another ground orchid, *Habenaria Bonatea*, Reichb. f. In front a flowering branch of *Protea pulchella*, Andr.

417. Beauties of the Swamps at Tulbagh, South Africa.— *Watsonia rosea*, Ker, one of the handsomest of the Iris family ; *Kniphofia aloides*, Moench., and *Richardia hastata*, Hook., a near ally of the species commonly cultivated in this country.

418. The Glory of Table Mountain, Cape of Good Hope.— This showy ground orchid (*Disa grandiflora*, Linn.) grows along the streams on the top of Table Mountain, and was formerly believed to be restricted to this region, but it was discovered on the Cedar Mountains in the Clanwilliam district about ten years ago. The blue flower is another of the same genus, *Disa graminifolia*, Ker. Behind is a common fern of the region, *Todea barbara*, Moore, which is also abundant in Australia and New Zealand.

419. Not one Flower, but many in one, Van Staaden's Kloof.—As mentioned in the description of 410, there are numerous flowers in the separate inflorescences of the *Proteaceae*, surrounded by coloured leaves or bracts. This is *Protea cynaroides*, Linn., which has the largest flower heads of its genus, and it bears them when only two or three feet high. It grows on the tops of the mountains. Above is the head of a bird, its red wing feathers also showing ; and what is very extraordinary, this red will wash out with soap and water !

420. A South African Water-Plant in Flower and Fruit.— The "Water Uyentjes" (*Aponogeton distachyum*, Thunb.) is eaten as a salad at the Cape of Good Hope. As happens with many other water plants, after the flowering period the flower spikes are pulled under water, where the seed ripens ; but in order to show the ripe fruit it was necessary to bring it to the top in the painting. This water-plant is hardy, in the warmer parts, at least, of the United Kingdom, though it does not produce such fine flowers as at home.

421. Tree Aloes and Mesembryanthemums above Van Staaden's Kloof.—*Aloe saponaria*, Haw., is the stemless species, and the arboreous one is *A. africana*, Mill., or an allied species. Trailing on the ground is a species of *Mesembryanthemum ;* behind the *Aloe*, on the right, *Plum-*

bago capensis, Thunb., (see 433) and Dornboom (*Acacia horrida*, Willd.) on the left.

422. **South African Sundews and other Flowers.**—Above, a plant of the elegant and beautiful *Monsonia speciosa*, Linn. (*Geraniaceae*) with *Babiana rubro-coerulea*, Reichb. ? on the right, and *Homeria miniata*, Sweet, on the left. There are two species of Sundew ; a white variety of *Drosera cistiflora*, Linn. (see 413), and the pale purple *D. pauciflora*, Banks ; the former having long leaves like the English *D. anglica*, Huds., and the latter roundish leaves similar to those of our *D. rotundifolia*, Linn.

423. **A Medley from Groot Post, South Africa.**—The prominent orange-coloured plant is a leafless root-parasite (*Hyobanche* sp.) with *Babiana rubro-coerulea*, Ker, on the right ; on the left rose and yellow *Romulea* sp., a blue *Aristea* and *Hesperantha falcata*, Ker. Again on the right *Montbretia* sp., having variegated flowers, with a *Diascia?* (*Scrophulariaceae*) and a *Verbena?* above.

424. **View of Table Mountain, looking from Groot Post.**

425. **View from the Steps of Table Mountain through a Wood of Silver Trees.**—The Silver Tree (*Leucadendron argenteum*, R. Br.), characterises the vegetation of the slopes on the eastern side of Table Mountain, where alone it grows plentifully in a wild state. Formerly it was supposed to be restricted to Table Mountain, but it has recently been found in several localities in the Drakensteenberge, at a distance of between fifty and sixty miles. Whether it is really wild or originally planted in these places, is a little uncertain. It is readily distinguished from all its numerous congeners (see 426). Here the undergrowth consists largely of Heaths and dwarf Proteas.

426. **Foliage, Flowers, and Fruit of the South African Silver Tree.**—On the right below is a head of female flowers, and above on the left a ripe cone, from which the dry plumed perianths are wafting away the seeds. In the middle and above are heads of male flowers, in various stages of development. The large caterpillars devour the thick leathery leaves, which one would have thought too hard for them to bite. As in *Leucadendron platyspermum* (see 450), so in *L. argenteum*,

the two sexes are borne on separate trees, but there is no great dissimilarity between the male and female trees of the latter species.

427. **Antics of Ants among the Flowers.**—When painting these Proteas (*Protea mellifera*, Thunb., and another species below, the artist was not a little surprised to see the florets rising and wriggling and dancing about in a most unaccountable manner, and on investigating the cause of these movements, discovered it to be ants pushing the florets out to make room for their nests. A green beetle also inhabits the flower-heads.

428. **Pendulous Sparaxis and Long-tailed Finch in Van Staaden's Kloof.**—South Africa is the richest part of the world in Iridaceous plants, and the beautiful *Dierama pulcherrima*, Baker (better known as *Sparaxis pulcherrima*, Hook.), here represented, is certainly the most graceful and the loveliest of them all. It grows in wet situations, and as much as six feet high. There are varieties of various colours. Some botanists regard this as a variety of *Dierama pendula*, Koch, which it may be in a broad sense, though the extreme forms are very different.

429. **Flowers of the Wagenboom and a Podalyria, and Honeysuckers.**—Wagenboom or Wagon-tree (*Protea grandi-flora*, Thunb.), like many of the other so-called trees of South Africa, is of quite small dimensions; but its very hard wood is serviceable for making the felloes of wheels, etc. The *Podalyria* is *P. calyptrata*, Willd., one of a considerable genus restricted to South Africa.

430. **Water-Lily and surrounding vegetation in Van Staaden's Kloof.**—*Nymphaea stellata*, Willd., the Water-Lily in this painting, is very widely spread in Africa and India, and there are white, blue, purple, and rose varieties. The Orchid is *Disa tripetaloides*, N.E.Br. ; behind are various species of *Zamia, Euphorbia, Aloe*, and *Agapanthus*.

431. **A South African Specialty.**—Like so many other South African genera of plants, *Stapelia* presents an almost indefinite number of forms or species. In this genus the differences are in the shape of the leafless, succulent stems, and in the shape and colour, etc., of the usually strangely-marked flowers. Here are two very distinct types of the genus, one

having the petals fringed with long hairs, which the slightest
breath of air sets in motion (see 395). Not more weird
looking is the Chameleon associated with them. The flowers of
some of the species of *Stapelia*, if not of all, exhale such an
odour of carrion that flies deposit their eggs in them, and
they become infested with maggots. The white flower below
is *Turraea obtusifolia*, Hochst., a member of the *Meliaceae*.

**432. Aloes and Plumbago near Grahamstown, South
Africa.**

**433. The Blue Plumbago in contrast, Van Staaden's
Kloof.**—Blue of the particular shade of *Plumbago capen-
sis*, Thunb. is exceedingly rare in the vegetable kingdom.
The white-flowered orchid here is *Angraecum arcuatum*,
Lindl., which is small in a genus containing *A. eburneum* (see
489), to say nothing of the Madagascar *A. sesquipedale* (see
356) with flowers nearly a foot and a half long. Burchell, who
travelled many years in South Africa, and made perhaps the
finest botanical collection ever brought thence to England, is
commemorated by the scarlet *Burchellia capensis*, R. Br.,
belonging to the large family, *Rubiaceae*.

434. The South African Doornboom, and Fingo Huts.—
Many of the Acacias are formidably armed with spines, but
perhaps none more so than *Acacia horrida*, Willd., the Doorn-
boom or Thorn Tree of South Africa. Beyond the Thorn
trees and Huts is a Dutch farm, and the Perie Bush; the
scene being near King William's Town.

435. Protea and Golden-breasted Cuckoo, of South Africa.
—This magnificent *Protea* (*P. speciosa*, Linn.) grows about
as tall as a man, and is remarkable alike for its thick, red-
margined leaves, and its elegantly fringed bracts. Over a
century ago (1786) Masson sent seeds of it to Kew, and the
first plant flowered in the nursery of Grimwood and Wykes, at
Kensington, in August 1800.

436. Flowers of the Sandy Flats, near Cape Town.—A
root-parasite, *Hyobanche sanguinea*, Linn., at the bottom, on
the right, with white *Freesia Leichtlinii*, Klatt, dark purple and
yellow, *Sparaxis tricolor*, Ker, a species of *Watsonia* having
rosy flowers and very near *W. rosea* (see 417), pale pink *Gla-
diolus angustus*, Linn., and the large dull-coloured *G. grandi-
florus*, Andr., an orange-coloured orchid (*Satyrium coriifolium*,
Sw.) and a blue *Geissorhiza* ?

437. **Giant Everlasting and Protea, on the Hills near Port Elizabeth.** — *Helipterum phlomoides*, DC. is one of the most remarkable of the many kinds of "Everlasting" found in South Africa. It grows several feet high, and on the hill side in the distance looks like so many tombstones. The *Protea* is *P. formosa*, R. Br., which, like *P. speciosa* in 435, has beautifully fringed bracts.

438. **Wild Flowers of Ceres, South Africa.**—In the centre the yellow "Tea Plant," *Rafnia amplexicaulis*, Thunb., the leaves of which are commonly used either alone or with ordinary tea to make a beverage. The Heath above on the right is *Erica grandiflora*, Linn., with a *Mesembryanthemum*, a *Watsonia* and a *Gladiolus* below ; a white *Moraea* at the top, and below on the left. In front *Leucospermum nutans*, R. Br., a species of *Protea* on the left, and white and pink varieties of *Cyphia volubilis*, Willd., hanging from the vase.

439. **View on the Kowie River, with Trumpet Flower in front.**—Painted from Dr. Becker's Verandah, Port Alfred. *Tecoma Mackenii*, is the finest of the very few *Bignoniaceae* indigenous in South Africa. The bird perched thereon is *Ploceus capensis*. On the left, Tree Euphorbias, etc.

440. **Earth-nut and a Prickly Gourd, St. John's, Kaffraria.** —*Arachis hypogaea*, Linn., the Earth-nut, is one of a few plants belonging to various families, which, after flowering, wriggle their seed-vessels into the earth, where the seed ripens. It is believed to be a native of South America, though it is now found wild in many other warm countries, having escaped from cultivation. As an article of food it is of considerable importance in hot countries. The gourd (*Momordica involucrata*, E. Mey.) with yellow flowers, is a native, and the rosy *Portulaca* is probably an introduced variety of the South American, *P. grandiflora*, Hook.

441. **Green-flowered Ixia, and other Cape Singularities.**— The blue-green *Ixia viridiflora*, Lam., is the most noteworthy in this selection of flowers, painted at Ceres. There is, or was, a variety in cultivation with a greater infusion of green in the flowers. In front is a species of *Leucospermum*, and *Helipterum eximium*, DC. with flannel-like leaves and rose and crimson flower-heads, which retain their brightness for years. To the left of the *Ixia* is the singular *Pelargonium triste*, Ait., with greenish-yellow and brown flowers and fern-like leaves. The crimson flower at the top is *Ixia speciosa*, Andr., and on

the right are a pink *Watsonia*, an orange-scarlet *Cyrtanthus* and a *Helichrysum* below.

442. **View with Aloes and Euphorbias near Grahamstown.**—Painted at a Christmas picnic.

443. **South African Flowers, and Snake - headed Caterpillars.**—Behind *Begonia natalensis*, Hook., and a small fern (*Pellaea hastata*, Link.) with a blue-flowered *Disa* on the right, probably *D. venusta*. Bolus, and *Streptocarpus Rexii*, Lindl., in front. Observe the long twisted seed-vessels of the latter. The odd-looking caterpillar, when startled, draws in its head and looks like a snake, the patches of colour doing duty for eyes.

444. **View of Cadle's Hotel and the Kloof beyond, near Grahamstown.**

445. **Scene in Dr. Atherstone's Garden, Grahamstown.**—The small, flat-topped house is almost wholly concealed by creepers, a window only being discernible. Here the owner has assembled plants from all quarters of the globe, and blended them with the indigenous vegetation of the country. We see the European Lavender (*Lavandula vera*, DC.), an *Agave* and *Bougainvillea spectabilis*, Willd., from America, China Roses, and Australian Gum trees behind, with various South African Aloes and Cycads, etc.

446. **Water-loving Plants and Kingfisher, near Grahamstown,**—Floating in the water is *Limnanthemum Thunbergii*, Griseb., a member of the same family as the Gentians; in front two varieties of the tufted *Eucomis punctata*, Ait., with the rosy *Disa racemosa*, Linn. f., and a species of *Cyperus* behind.

447. **Four South African Plants.** — Scarlet *Cyrtanthus angustifolius*, Ait., variegated aroid (*Richardia albo-maculata*, Hook.), a yellow and purple *Moraea*, and Spekboom (*Portulacaria afra*, Jacq.) behind, see 414.

448. **View of the valley of Ceres, from Mitchell's Pass, "Cabbage Plant" in front.**—The plant is an *Othonna* (*Compositae*), and probably a variety of *O. amplexicaulis*, Thunb.; its popular name refers to its thick fleshy leaves not to any culinary use.

449. **South African Flowers in a wooden Kaffir Bowl.**—Above, on the right, white flowers and prickly fruit of *Gompho-*

carpus fruticosus, Ait., then the red flowers and fruits of " Anteliza " (*Antholyza aethiopica*, Linn.), and the flesh-coloured, narrow-petalled *Strophanthus divergens*, Grah., with its singular two-armed seed-vessel (see 645). Below are the scarlet *Striga coccinea*, Benth., white Ink Plant (*Cycnium adoense*, E. Mey.), and *Dalechampia capensis*, Spreng., a yellow *Hibiscus*, with purple centre, a white Jessamine, an *Aloe*, a *Pelargonium*, and *Schotia speciosa*, Jacq., in front.

450. **Looking over an expanse of Leucadendron towards Ceres and Mitchell's Pass.**—The taller plants with dark-coloured cones in the forks of the branches are the females, and the other the males of *Leucadendron platyspermum*, R. Br. In front the two sexes are represented life-size. See also 405.

451. **"Coming out" of a Cape Beauty.**—This young Ostrich turned its head from side to side to listen to voices while still half-enclosed in the shell.

452. **Flowers of Tulbagh, South Africa.** — Quaking Grass (*Briza maxima*, Linn.), a crimson *Babiana*, blue *Lapeyrousia corymbosa*, Ker, small yellow *Rochea* on the right, pale yellow *Homeria collina*, orange *Ornithogalum*, with a red locust and the curious little *Pelargonium oxalidifolium*, Pers., in front.

453. **Yellow-wood Trees and Creepers in the Perie Bush.**—The Yellow Wood, *Podocarpus Thunbergii*, Hook., is one of the largest and most valuable of South African timber-trees ; see panel of it below. On the right a Toucan is seated on a bush of *Cussonia spicata*, Thunb., a very striking *Araliacea*.

454. **Ostrich Farming at Groot Post, South Africa.**—Ostriches are stripped of their feathers twice a year, the operation, it is asserted, causing the bird little pain. Certainly no permanent injury ensues for fresh crops of feathers are produced year after year for a period the limit of which is at present unknown. The trees are Australian Gum and Wattle, with a hedge of Aloe.

455. **Red Water-Lily.**—This is the Indian *Nymphaea Lotus*, Linn. See also 818.

456. **Haemanthus and other South African Flowers.**—In front a dwarf species of *Erythrina* and *Eucomis punctata*, Ait. var., with *Haemanthus magnificus*, Herb., var. *superbus*, Baker, and above on the right, the purple brown *Tulbaghia alliacea*,

Linn., which has a strong odour like that of garlic, though the flowers are said by Burchell to be agreeably fragrant towards evening.

457. **Wild Chestnut and Climbing Plant of South Africa.** —*Calodendron capense*, Thunb., the Wild Chestnut, is one of the finest as well as one of the showiest of South African trees. It is a member of the usually small-flowered *Diosmeae*, a tribe of the *Rutaceae*, restricted to South Africa. The climber is *Cephalandra palmata*, Sond. Panel 134 is *Calodendron*.

SEYCHELLES.

458. **A Swamp Plant and Moorhen, Seychelles.** — This beautiful plant (*Hymenocallis rotata*, Herb.) is a native of the West Indies, and is now half wild at Mahé. The Moorhen is remarkable for its very large feet.

459. **Wormia and Flagellaria in the Seychelles.**—*Wormia ferruginea*, Baill. is an endemic species of a small genus represented in Madagascar, and ranging from India through the Archipelago to North Australia. Its bright red, young leaves, more than its flowers, render it conspicuous in the landscape. While young the leaf-stalks have a cup-like expansion at the base, which in the morning is full of water serving to nourish the leaf during the day ; but it shrivels up as the leaf gets older and does not need it. (See 474 and panel 147.) *Flagellaria indica*, Linn., the grass-like climber supports itself by tendrils at the tips of the leaves. It is very widely spread in the tropics of the Old World, and gives the name *Flagellariaceae*, to a very small family intermediate between Rushes and Lilies.

460. **Ipomoea and Vavangue with Mahé Harbour in the distance.**—*Vangueria edulis*, Vahl, or Vavangue, is a native of Madagascar, and now cultivated (and naturalised) in many other warm countries for the sake of its edible fruit. Observe the wasp's nest upon it. *Ipomoea palmata*, R. Br. is almost cosmopolitan in the tropics.

461. **Round Island and Ile Aride from Long Island, Seychelles.**—In the foreground from left to right, Filao

(*Casuarina equisetifolia*, Forst.), Screw-Pine (*Pandanus* sp.) and Cashew-nut (*Anacardium occidentale*, Linn.) ; the first and the last are both regarded as colonists, though they are now among the commonest of trees of the islands.

462. **Screw-Pines in Praslin, Seychelles.**—Various species of *Pandanus* or Screw-Pine constitute a prominent feature in the vegetation of the Seychelles, see 473 and 495.

463. **An Asiatic Pancratium, colonised in the Seychelles.**

464. **Palms in Mahé, Seychelles.**—Besides the cocoa-nut, which may or may not have reached these islands independently of human agency, there are eight species of Palm indigenous in the Seychelles, and six of them are found nowhere else in the world ; while the remaining two only extend to Mauritius and Bourbon. Here is the red-tinged, comparatively dwarf, *Roscheria melanochaetes*, Wendl. with *Nephrosperma Van-houtteana*, Balf. f., behind it, *Deckenia nobilis*, Wendl., on the left, *Dictyosperma alba*, Wendl., in front of it, and *Angraecum eburneum*, Thouars, below.

465. **The only Shade in Ile Aride, Seychelles.**—A partially uprooted tree of *Terminalia Catappa*, Linn., affords the only real shade in the island, and under its welcome branches all the inhabitants assemble.

466. **Smelt-Fishing at Port Victoria, Mahé, Seychelles.**

467. **Palms, Capucin Trees, etc., on the cliffs near Venn's Town, Mahé.**—The prominent Palm is *Stevensonia grandifolia*, Duncan, with Screw-Pines on the left. Behind are dead and living trees of the Capucin (*Northea seychellana*, Hook, f.) the handsome foliage of which may be better seen in 501. An epiphytic fig embraces a branchless trunk on the right. See 486.

468. **Seychelles Pitcher Plant and Bilimb Marron.**—The first (*Nepenthes Pervillei*, Blume) inhabits only the mountain region of Mahé ; while the second, though likewise peculiar to the islands, is common in woods from the sea shore to the tops of the mountains. It is *Colea pedunculata*, Baker, and it produces its clustered yellow flowers from the trunk and other branches.

469. **Veloutier Blanc and pair of Martins, Seychelles.**—*Scaevola Koenigii*, Vahl, the Veloutier Blanc of the Seychelles

is a common littoral shrub in the tropics of the Old World and Polynesia, including many of the very remote islands. It belongs to the family *Goodenoviaceae*, which, with few exceptions, is restricted to Australia. See 813.

470. **Screw-Pines, Palms, Tree-Ferns, and Cinnamon Trees on the hills of Mahé.**—*Cyathea sechellarum*, Mett., is the only tree-fern found on these islands. It is common, and in favourable situations, the trunk reaches a height of forty to fifty feet. The palms are *Roscheria melanochaetes*, Wendl., and *Stevensonia grandifolia*, Duncan. See 478.

471. **Dr. and Mrs. Hoad at home in Praslin, Seychelles.**— The hencoops and roof-caps consist of single leaves of the Double Cocoanut, and the rest of the roof of other palm leaves. In the foreground are trees of *Bombax* and Mango.

472. **Saponaire or Periwinkle and Green Frogs in Mahé.** —*Vinca rosea*, Linn., and its variety *alba*, supposed to be a native of America, is now found wild in most hot countries.

473. **Screw-Pines on the hills of Mahé, Seychelles.**—This is probably the endemic *Pandanus Hornei*, Balf. f., or there may be more than one species. *P. Hornei* branches freely and grows to a height of sixty feet, but in striking contrast to *P. sechellarum* (495), it produces few or no aerial roots.

474. **Coco de Mer Gorge in Praslin, with distant view of Mahé Silhouette and the Cousins.**—The Coco de Mer or Double Cocoanut (*Lodoicea sechellarum*, Labill.) is peculiar to the Seychelles, and only abundant in Praslin; but long previous to the discovery of the group, in 1743, its enormous nuts were found floating in distant parts of the sea, giving rise to absurd and fabulous tales concerning their origin. High prices were given for the nuts at no very distant date, when marvellous medicinal virtues were attributed to all sorts of extraordinary things. See 476 and panel 142. In front is a bush of the endemic *Wormia ferruginea* (459).

475. **Male inflorescence and Ripe Nuts of the Coco de Mer, Seychelles.**—A portion of the outer fibrous covering of the fruit has been removed showing the two-lobed nut, which usually contains only one seed, probably the largest in the vegetable kingdom.

476. **Male and Female Trees of the Coco de Mer in Praslin.**—On the right the taller male trees, which some-

times attain a height of 100 feet, but the female is always shorter. The feather-leaved palm in front may be *Deckenia*. Round Island, Felicité and a portion of La Digue are seen in the distance.

477. **Female Coco de Mer bearing Fruit covered with small Green Lizards.**—Study of perfect and imperfect nuts much reduced from the natural size.

478. **Wild Pine Apples, and Stevensonia and other Palms, Praslin.**—*Stevensonia grandifolia*, Duncan, is, or was, common in all the islands, though not found elsewhere. It is a grand Palm growing from forty to fifty feet high, but *Verschaffeltia splendida*, Wendl., of which there are some young examples on the right, equals it in other respects and surpasses it considerably in stature, rising to a height of eighty feet. This is likewise common and endemic in the Seychelles.

479. **Waterfall in the Gorge of the Coco de Mer, Praslin.** —On the left a female, and on the right a male specimen of the Coco de Mer Palm, each bearing its inflorescence. See 475.

480. **View of the South Coast of Mahé and Schools of Venn's Town, Seychelles.**—*Pandanus sechellarum*, Balf. f., sending down roots almost from the top, *Cyathea sechellarum*, Mett., and other vegetation.

481. **Moon reflected in a turtle pool, Seychelles.**—A view of St. Anne's Island from the artist's window at Mahé with an unbroken reflection of the moon in the turtle pool below, and a cocoanut palm in the foreground.

482. **Two trailing-plants with Lizard and Moth from Ile Aride, Seychelles.**—Among generally dispersed tropical plants the red and black-seeded *Abrus precatorius*, Linn., is one of the commonest; excluding such as are actually weeds of cultivation. The leafless *Sarcostemma viminale*, R. Br., here associated with it has a wide range in the Mascarene Islands and Tropical and South Africa.

483. **Emile's Palm House, Praslin, Seychelles.**—This sylvan dwelling is constructed of the Cocoanut and *Stevensonia* Palms, rigged with the leaves of the Coco de Mer, of which the small hut is entirely made. The trees in the foreground are *Albizzia Lebbek*, Benth., the Bois Noir of the Seychelles, which is widely spread in temperate and tropical Asia and

Africa, and often planted. Secured to one of the trees is a Hawkshead Tortoise, whose shell is the fortune of the fishermen of the islands.

484. **Life on the coast of Praslin, Seychelles.**—A view from among the crabs on the rocks. The vegetation on the shore consists of cocoanut, *Casuarina equisetifolia*, Forst., *Calophyllum Inophyllum* (see 494), and *Scaevola Koenigii*, with Coco de Mer starring the hills beyond.

485. **Foliage, Flowers, and Fruit of a common tree of the sea-shore, Praslin.**—A view from the rocks, with Ile Aride and a part of Curieuse in the distance. This tree (*Cordia subcordata*, Lam.) is common on the tropical shores of the Old World and throughout Polynesia, being one of the earliest of the arboreous occupants of rising coral islands. It was the principal tree, after the cocoanut, found by Darwin in the Keeling Islands, the entire vegetation of which he attributed to the agency of oceanic currents in conveying seeds thither.

486. **The highest point in Mahé with dead Capucin trees in the valley.**—A view from Venn's Town. Conspicuous in the vegetation are the white, dead trunks of the Capucin Tree (*Northea seychellana*, Hook. f.), which seems to be dying out in the islands, and as it is not known to grow elsewhere it is likely soon to become extinct. Frequent fires are probably the cause of its destruction. Interspersed is the tree fern (*Cyathea sechellarum*, Mett.) and the smooth, green patches on the slopes consist of a trailing fern.

487. **Flowers of a bush and Pitcher Plant, Mahé.**—The Pitcher plant is shown growing in a tangled mass on the huge granite boulder below; and beyond is the harbour of Mahé. We have not been able to identify the shrub with anything known to grow in the island, and it is probably an undescribed *Rubiacea*.

488. **Mandrinette and mountain home of the Pitcher Plant in the distance.**—A view from the artist's window at Mr. Estridge's house; the harbour of Mahé below. The showy shrub here represented in *Hibiscus liliiflorus*, Cav., a native of Mauritius, Rodriguez, Bourbon, and these islands.

489. **A Native Orchid and Butterflies, Mahé, Seychelles.** —*Angraecum eburneum*, Thouars, is an Orchid of a genus characteristic of the Mascarene Islands and Tropical and South Africa. See 356.

490. **Fruit grown in the Seychelles.**—An attractive and delicious fruit is the Framboisier (*Rubus rosaefolius*, Sm.) in the boat of Banana leaf, with foliage and flowers by the side. It is a native of Malaya and a colonist in the Seychelles ; and the Indian Mango and American Soursop (*Anona muricata*, L.) the fruit cut across, are both cultivated. In front is a seed of the Capucin tree, see 501.

491. **The Six-headed Cocoanut Palm of Mahé, Seychelles.** —Like the majority of Palms the cocoanut only branches in consequence of some injury to its terminal growing point. The Doum is an exception. (See 360.) The white-flowered plant is the American Vanilla, *V. planifolia*, Andr., much cultivated in the Seychelles for its aromatic seed-pods.

492. **The Clove in fruit, and view over Mahé, Seychelles.** —It is rare to see the clove tree in fruit where it is properly cultivated, because the cloves used as a condiment are the unopened flower buds. See 688.

493. **View of Round Island and a part of St. Anne's** from Quarantine Island.

494. **Foliage, Flowers, and Fruit of the Tatamaka, Praslin** —Among big trees growing on the shores of the Mascarene Islands, tropical Asia and Polynesia, the present (*Calophyllum Inophyllum* Linn.) is conspicuous alike from its commonness and its beauty. Its seeds germinate freely, it is averred, after long immersion in sea-water, when cast ashore on almost naked coral islands. Panel 141.

495. **Screw-Pines, Palms and Ferns, from path near Venn's Town, Mahé.**—The Screw Pine (*Pandanus sechellarum*, Balf. f.) on the left is the same species as that in 480, and exhibits perhaps the maximum intensity of aerial root-formation. In front, on the right, is a tuft of *Asplenium Nidus*, Linn., with the tree fern (*Cyathea sechellarum*, Mett.) and *Roscheria melanochaetes*, Wendl., behind. The feathery Palm is probably *Deckenia*, and the taller ones behind with some of the leaves changing red, *Stevensonia grandifolia*, Duncan.

496. **The Seychelles Pitcher Plant in blossom and Chamaeleon.**—Behind *Lycopodium Phlegmaria*, Linn., which is common in humid regions of all tropical countries. See 468.

497. **Native Vanilla hanging from the Wild Orange, Praslin, Seychelles.**—*Vanilla Phalaenopsis*, Reichb. f., is en-

demic in the Seychelles, and, like several other species of the genus, it is leafless. The orange on which it grows is naturalised only in these islands.

498. **A Selection of Flowers, Wild and Cultivated, with Puzzle Nut, Mahé.**—Crimson *Russelia juncea*, Zucc., from Mexico, on the right, then whitish *Moringa pterygosperma*, Gaertn., or Horse-radish Tree of tropical countries, and a yellow-brown *Strophanthus* (from Madagascar), below the last the pink flowers and open seed vessels of a *Tecoma?* and a white *Ipomoea;* in the centre, *Cerbera Tanghin*, Hook., with *Lagerstroemia indica*, Linn., on the right, and *Clerodendron Thomsonae*, Balf. (Africa) in fruit. In front of the vase a small flowering branch and a ripe seed-vessel, burst open of the "Puzzle Nut" (*Carapa moluccensis*, Lam.). This is a common tree on the muddy shores of tropical Asia, Eastern Africa, Australia, the Mascarene Islands, and Polynesia. The seed-vessel is sometimes as large as a child's head, and is packed full of seeds most unequal in size and most irregular in shape, insomuch that if once taken out it is very difficult to fit them in again. Moreover, they are covered with a very thick fibrous testa, which renders them very buoyant and impervious to water, consequently, they are carried uninjured from shore to shore by oceanic currents, hence the wide distribution of the species.

499. **A Tripod Cocoanut, Mahé, Seychelles.**—The hut is made of the plaited leaves of the cocoanut and roofed with the same in the natural state.

In an early state the ovary of the future fruit of the cocoanut is three-celled, each cell containing a single ovule ; but two of these are almost always obortive and soon obliterated, so that only one seed arrives at maturity. Occasionally, however, all three are developed, and this explains the probable origin of the tripod cocoanut in the painting.

500. **A group of Palms in Mahé, Seychelles.**—It is not evident what Palm this is, which grows near the coast—perhaps *Dictyosperma alba*, Wendl.

501. **Foliage, Flowers, and Fruit of the Capucin Tree of the Seychelles.**—For many years the seeds of the Capucin lay in our Museums ; and, although it was evident that they belonged to some member of the *Sapotaceae*, nothing was known by botanists of the tree which produced them. But

through the exertions of Mr. Estridge, the artist procured flowering specimens of the tree, which were communicated to Sir Joseph Hooker, who figured and described them, and was pleased to name the tree *Northea seychellana*. The popular name Capucin was given, doubtless, in allusion to the appearance of the seed divested of the pericarp, when it bears some resemblance to the hooded head of a monk. Panel 145.

TENERIFFE.

502. **Flowers of the Pomegranate, painted in Teneriffe.**— The Pomegranate (*Punica Granatum*, L.) is believed to be a native of North-Western India ; but, as in the case of most plants that have been cultivated from remote times, it is difficult to determine where it is really indigenous. Its fruit is valued in hot countries on account of the refreshing property it possesses.

503. **Dragon Tree at San Juan de Rambla, Teneriffe.**

504. **Group of Flowers, painted in Teneriffe.**—The cactus (*Opuntia Dillenii*, Haw.) lying in front of the vase is cultivated for its spines, which are used to fasten the bags of cochineal insects to another kind of cactus, on which the insects feed (see 522). The birds are *Agapornis pullaria*. The reddish bell-shaped flowers are those of *Canarina Campanula*, L., a plant peculiar to the Canary Islands ; and the showy violet-blue flowers are apparently those of an *Iochroma*, an American genus of *Solanaceae*.

505. **Common Aloe in Flower, Teneriffe.**—The rocky slope covered with a dense thicket of the same plant, (*Aloe vera*, L.) which is a native of South Africa. Aloes or Bitter Aloes is the dried juice of this and other species of the genus (see 528).

506. **Dragon Tree at Orotava, Teneriffe.**—This is the largest descendent of the famous tree of which a short history is given under 511.

507. **Cluster of Air-roots of a Dragon Tree, Teneriffe.**— These thick air-roots gradually grow downwards and cover the whole trunk which has been gashed and hacked by the collectors of Dragon's Blood.

508. **A Cactus-like Plant growing close to the sea in Teneriffe.** — This singular shrub (*Euphorbia canariensis*, Linn.) forms a characteristic feature of the vegetation of the lower zone in the Canaries.

509. **Houseleek and Canary-birds in Teneriffe.**—Several kinds of Houseleek (*Sempervivum*) are very common on roofs and rocks and other dry situations, in the Canaries. *Serinus canarius* is the scientific name of the canary-bird.

510. **View of the Peak from the bridge of Icod, Teneriffe.** —Bananas and Date Palms in the foreground.

511. **Dragon Tree in the Garden of Mr. Smith, Teneriffe.** —The Dragon Tree, or more correctly the Dragon's Blood Tree (*Dracaena Draco*, L.), is a native of Teneriffe, and is one of the most celebrated trees in the annals of natural history, for until within a few years ago there stood at Orotava a gigantic specimen of it that had scarcely increased in size since it was first described by the navigators of the early part of the fifteenth century. This tree was about seventy-five feet high, and its trunk about seventy-eight feet in girth, and quite hollow for a long time preceding the destruction of the tree by a storm in 1867. It was formerly supposed by Humboldt and others that this tree lived to a very great age; but from what is now known of its rapid growth when young, it seems likely that the trunk attains its full size in a much shorter period even than the tree lives after this has taken place. Very little, if any, of the concrete resinous juice is now used in this country; the Dragon's Blood of commerce being the produce of a palm (*Calamus* sp.). See 506.

512. **View of the Peak of Teneriffe.**—Cacti (*Opuntia*) and other succulent plants in the foreground; the candelabrum-like inflorescence on the right belongs to the American Aloe (*Agave americana*, L.).

513. **View of Sitio del Pardo, Orotava, Teneriffe.**—The succulent plants on the rocks in the foreground belong to the genera *Kleinia*, *Aloe*, *Euphorbia*, *Opuntia*, &c. Plants having thick, fleshy stems or leaves constitute a predominating feature in the vegetation of the coast region of Teneriffe.

514. **View of Puerto de Orotava, Teneriffe, from the Sitio del Pardo.**—Top of a Date Palm (*Phoenix dactylifera*, L.) in the foreground. The Date Palm, though cultivated in Southern Europe and Western Asia, is really more at home

in North Africa, where it affords the principal food of a large population. It is the Palm of the Oases, and supplies not only food for man and beast, but, like many other members of the same family, a variety of other useful articles. This and the still more valuable Cocoanut Palm have plume-like leaves, contrasting with the fan-shaped leaves of many others. The male and female flowers of the Date Palm are borne on separate trees, so that under cultivation this palm should be propagated by offsets. By this means the preponderance of female or date-bearing trees is ensured and the variety is kept pure—for there are many varieties. The trees grow from sixty to eighty feet high, and live to a great age, producing a large crop of fruit every year. It is wild, though doubtfully indigenous, in some of the Canary Islands, and grows in some parts in company with *Pinus canariensis.* See 360.

515. A View in the Botanic Garden, Teneriffe.

516. Abyssinian Ensete in a garden in Teneriffe.—*Musa Ensete*, Gmel., is the most ornamental of the genus, but its fruit is not edible. It was first discovered by Bruce more than a century ago ; and seeds of it were sent to Kew in 1853 by Walter Plowden, British Consul at Massowa. Like the Banana, it flowers only once, but, unlike that plant, it is several years before it flowers.

517. Study of Olives, painted in Italy.—The Olive (*Olea europaea*, L.), is a tree of very slow growth, and is usually small ; but it attains a great age, and some of the very old trees have trunks of enormous girth. It has been cultivated in the countries bordering the Mediterranean from time immemorial, and the oil obtained from the fruit is there an important article of food, besides being extensively used in cooking other articles, whilst in this country it is only eaten with salads, preserved sardines, and such things, though large quantities are used in the arts and manufactures. Panel 156.

518. Dracunculus canariensis and Cineraria in Flower, Teneriffe.

519. A Species of Bugloss, Teneriffe.—*Echium simplex*, DC.), a stately tree-like herb about six feet high.

520. Orange Flowers and Fruits, painted in Teneriffe.—The Orange (*Citrus Aurantium*, Risso) is cultivated in many parts of the South of Europe, and in other countries bordering the Mediterranean Sea. Formerly a very large proportion of

those eaten in England came from the Azores. Two hundred shiploads, it is stated, were annually exported from the Island of St. Michael alone ; but of late years the orange trade has declined, and pineapples are now largely grown in their place. Under favourable conditions orange trees are exceedingly productive. Wallace mentions one in St. Michael's that bore 20,000 fruits in one crop. It is supposed that the orange, lemon, citron, &c., were all originally brought from tropical Asia. Panel 160 is Lemon-tree wood.

521. **Scene in Mr. Smith's Garden, Teneriffe.**—An arbour covered with the Cherokee Rose (527), and *Bougainvillea* (108) creeping over Cypress and Myrtle trees.

522. **View in the Cochineal Gardens at Santa Cruz, Teneriffe.**—Women taking off the rags in which the newly hatched insects (*Coccus cacti*) are pinned to the Cactus plants (*Opuntia coccinellifera*, Steud.). After being left a few days the insects attach themselves to the plants, and no longer need the rags. The Cochineal insect is reared in large quantities in Brazil, Mexico, and the Canary Islands, for the sake of its crimson dye.

523. **Dragon Tree in a garden at Santa Cruz, Teneriffe.**—The thick protuberances below the point where the branches are given off are air-roots ; they are represented natural size in 507. See the description of 511.

524. **View of Icod, Teneriffe.**—Reeds (*Arundo Donax*, L.) on the high ground to the left, and Cochineal Gardens below.

525. **Old Manor of Castro, Teneriffe.**—Tree-heath (*Erica arborea*, L.) and Cinerarias (*Cineraria cruenta*, L.) in blossom. This is the wild parent of the many coloured varieties of Cineraria grown in greenhouses in this country.

526. **The Canary Islands Pine at Icod, Teneriffe.**—The vegetation of the Canary Islands presents some strange anomalies, not the least interesting of which is the pine (*Pinus canariensis*, Ch. Smith) associated with the Date palm.

527. **Cherokee Rose with the Peak of Teneriffe in the distance.**—The Cherokee Rose (*R. laevigata*, Michx.) although very common in the South-eastern States of North America is only a colonist there ; its native country being China. Associated with it here is the pink semi-double Damask Rose.

528. Aloe and Cochineal Cactus in Flower, Teneriffe.— *Aloe vera* L. and *A. barbadensis*, Mill. and Cochineal Cactus, *Opuntia coccinellifera*, Steud.

BORNEO AND SINGAPORE.

529. Foliage and Flowers of Medinilla magnifica.—A native of Manilla, and perhaps the most gorgeous of all the numerous *Melastomaceae* ; cultivated at Singapore.

530. The Tapang-Tree, Sarawak, Borneo. — The smooth cylindrical trunks of this tree (*Koompassia excelsa*, Taub.) often rise to a height of 100 feet without a branch, yet the Dyaks climb them in quest of the honeycomb that the bees hang on the branches. They climb these trees at night, building a bamboo ladder as they go up by driving pegs in above their heads and tying the other end of the pegs to long slender bamboos, placed one over the other, and lashed together with pieces of bark. In this way they reach the top in a few hours and obtain large quantities of wax, which forms one of the principal sources of the revenue of the country.

531. Flowers of Tacca and bristly Fruit of the Rambutan. —The long thread-like organs of *Tacca cristata*, Jack, are bracts which proceed from below the flowers. A favourite fruit in the Malay Archipelago is the Rambutan or Ramboostan (*Nephelium lappaceum*, Linn.). It bears the same relation to the Chinese Litchi, as the apple does to the pear.

532. The Breadfruit, painted at Singapore.—The Breadfruit, *Artocarpus incisa*, Linn., is a tree of moderate size, a native of the South Sea Islands, where its fruit forms the chief food of the inhabitants, answering in use and taste to our bread. A cloth is made from the fibre of the young trees; canoes from the trunks, and a kind of glue from the sap. Fruit of the best varieties contain no seeds, and these varieties are propagated by suckers. The Breadfruit is now cultivated in many countries, including the West Indies, whither it was introduced four years after the first attempt in 1789 by Lieut. Bligh, of the ship "Bounty," whose crew mutinied after he had shipped his cargo of plants. Pitcairn island, in the South Pacific, is the home of the descendants of the mutinous crew. The larger Butterflies are *Papilio polytes* ; the white one is a *Pieris*.

533. Flowers and Fruit of the Cananga, Singapore.—The highly-scented petals of *Cananga odorata*, Hook. f. et Thoms., are much loved by the native ladies of the Malay Islands. They are used in the manufacture of Florida Water and of the Ilang-ilang of the Philippine Islands.

534. Orchid and Ferns of Sarawak, Borneo.—The Orchid is *Eria ornata*, Lindl., and the ferns are *Polypodium Phymatodes* and *P. drynaria*.

535. View of the Maharajah of Johore's House from Major McNair's Garden, Singapore.—Durian (*Durio zibethinus*, L.), and Traveller's Tree (*Ravenala madagascariensis*, Sonn.) in the foreground : a small " Red Areca," *Cyrtostachys Lakka*, Becc., a little back, and an old Norfolk Island Pine (*Araucaria excelsa*, R. Br.) in the distance to the height of the house. See 543.

536. Flowers and Fruit of the Cocoa Tree, painted at Singapore.—The Cocoa (*Theobroma Cacao*, Linn.) is a small tree, usually under twenty feet high, producing its flowers and fruit on the main stem and older branches. It is a native of tropical America, and now cultivated in many other parts of the world. There are several other species of the genus, and it is probable that some of them yield a portion of the cocoa and chocolate of commerce. The common cocoa tree is usually cultivated in the East under the shade of the tall Coral trees (*Erythrina indica*) and attains its full height and bearing in about eight years. Each fruit contains a large number of seeds packed in a delicious pulp. The fern is *Drymoglossum piloselloides*.

537. Fruit of Sandoricum and Green Gaper, Borneo.—This fruit (*Sandoricum indicum*, Cav.) has an agreeable subacid flavour, and it is eaten in large quantities by the natives. The pulp mixed with rice and fermented furnishes an intoxicating drink. *Calyptomena rafflesii* is the name of the bird.

538. Flowers of Sarawak, Borneo.—The large inflorescence with orange-red leaf-like bracts is *Hosea Lobbiana*, Ridley. Above, on the right, is a small white Passion-flower (*Passiflora foetida*, L.), and on the left flowers of probably some species of *Tabernaemontana*. Below is *Anisophyllea trapezoidalis*, Baill.

539. Malay Houses and Creek.—A view from the Istana, Sarawak, Borneo, with Areca Palm and old tree covered with epiphytes in the foreground.

540. **Moonlight View from the Istana, Sarawak, Borneo.**

541. **View of the Hill of Tegora, Borneo.**—Tall trunks of trees left standing here and there, showing the character of the forest before the quicksilver mines tempted civilised men to come and destroy it.

542. **View of Matang, Borneo.**—An Epiphyte (*Ficus*) twined around one of the trees in the foreground. These stranglers often survive after their victims (the trees upon which they germinated and commenced life having rotted away), standing like gigantic lattice-work shafts, crowned with a tuft of green leaves. See description of 781. The large grass is possibly *Miscanthus sinensis*, Anderss.

543. **View of Kuching and River, Sarawak, Borneo.**—The plant with Banana-like foliage on the left is the Madagascar Traveller's Tree (*Ravenala madagascariensis*, Sonn.). It belongs to the same natural family as the Banana ; but instead of yielding food it affords water to the thirsty traveller. The water is stored in the sheathing bases of the leaves, and it is obtained by tapping. Behind the Traveller's Tree are some Cocoanut Palms ; in the water in front *Nipa fruticans*, Wurmb., with bamboo on the right. See description of 589. The Water-snake is *Tropidonotus piscator*.

544. **Flowers and Fruit of the Carambola and Butterflies, Singapore.**—The Carambola (*Averrhoa Carambola*, L.) is a small evergreen tree, and, like its only congener, the Bilimbi (152), a native of some parts of tropical Asia; it is often cultivated for its fruit, which makes excellent tarts. It will also take out stains. The Bilimbi has rather larger flowers, produced on the main stem. *Amblypodia* is the genus to which the Butterflies belong.

545. **Forest Scene, Matang, Sarawak, Borneo.**—Buttressed tree and Orang-utan.

546. **Old Boat-house and Riverside Vegetation, Sarawak.**—Trunk of Cocoanut Palm, Areca and Sago Palms, both in fruit, Nipa, &c.

547. **View of the River from the Rajah's Garden, Sarawak.**—*Crinum augustum*, Roxb., *Costus speciosus*, Sm., Bamboos (*Dendrocalamus*), Durian, Mango trees, &c., in the foreground.

548. **Walk under Palms, with a glimpse of the River at Sarawak.**

549. **Foliage, Flowers, and Fruit of a Swamp Shrub of Borneo.**—A species of *Wormia*.

550. **Durian Fruit from a large tree, Sarawak.** — The Durian (*Durio zibethinus*, L.) is regarded as the king of fruits by the Malays, and most persons agree that it has a very delicious flavour; but it likewise has a very unpleasant smell, which few Europeans overcome. The custard-like pulp in which the large seeds are embedded is the part eaten fresh, while the outer covering is boiled down and used as a wash for the skin. The seeds are pounded into flour, and also used as Vegetable Ivory. For a portrait of the tree see 535.

551. **A Sand-binding Plant of Tropical Shores.**—*Ipomoea biloba*, Forsk. or Goat's-foot is a very common and widely-diffused plant on sandy sea-shores in the tropics. See 380.

552. **Flowers and Fruit of the Pomelo, a branch of Hennah, and Flying Lizard, Sarawak.**—Hennah (*Lawsonia inermis*, Linn.) yields a dye much used by Eastern ladies to dye their hair, eyelids, finger nails, &c. The Pomelo is a variety of Shaddock (*Citrus decumana*, Linn.). The Lizard's name is *Draco viridis*.

553. **The Istana, from the Slanting Bridge, Sarawak.**—*Gardenia, Crinum Northianum*, Baker, *Nipa fruticans*, Betel-nut Palms and Bamboos (*Dendrocalamus*) in the foreground.

554. **Group of Tree Ferns around the spring at Matang, Sarawak.**

555. **A Bornean Pitcher Plant, Sarawak.**—The green inside of the pitchers, with two darker green spots or eyes just under the lid, is a noteworthy character of this species of *Nepenthes*, which is probably an undescribed one. The species of *Nepenthes* are scattered from North India and China to Ceylon, Madagascar, and through the Malayan Archipelago to North Australia; but it is only in Borneo and the Malay Peninsula that the species are numerous, and form a feature in the vegetation. About 40 species are known. The pitchers, which are appendages of the leaves, should not be confounded with the flowers. See description of 556.

556. **Foliage, Pitchers and Flowers of a Bornean Pitcher Plant, and an Orchid.** — The flowers of most species of

Nepenthes are less showy than the pitchers. They are uni-sexual; the males and females being in separate spikes and perhaps always on different plants. In this species (*Nepenthes Phyllamphora*, Willd.) the male flowers are purple-brown, with a central column of stamens terminating in a yellow knob. The orchid is apparently *Vanda Hookeriana*, Rchb. f.

557. **View of Matang and River, Sarawak, Borneo.**—Palms (*Arenga saccharifera*, Labill., &c.) and Mangosteens in the foreground. Toddy, or Palm Wine, an intoxicating drink, is made from the *Arenga* and sugar is obtained by boiling and evaporation of the sap of this palm. A good tree will yield 100 pints of sap in twenty-four hours. Ropes and oakum for caulking are made from the fibre at the base of its leaves. Foliage and fruit of the Mangosteen are represented in 577.

558. **Lake of Ajmere, North-West India.**

559. **Flowers of a Jasmine and a Pink Begonia, Borneo.** —This is *Jasminum gracillimum*, Hook. f., a comparatively recent addition to our gardens, and one of the most desirable of an exquisite genus.

560. **Flowers of a Dogwood and an Indigo from the Himalayas.**—The flowers of the Dogwood (*Cornus capitata*, Wall.) are quite small and many crowded together, each head being subtended by four coloured bracts, that look very much like petals. This shrub bears an edible fruit not unlike that of the strawberry-tree (*Arbutus Unedo*, L.). *Indigofera* is the botanical name of the Indigo genus, which is very numerous in species.

561. **A new Pitcher Plant from the limestone mountains of Sarawak, Borneo.**—This, *Nepenthes Northiana*, Hook. f., has one of the largest pitchers of any known species. In consequence of seeing this painting, Messrs. Veitch sent a collector all the way to Borneo on purpose to get the species, and he succeeded in bringing home living plants of it.

562. **Honeysucker at work, Sarawak, Borneo.**—*Stachytarpheta mutabilis*, Vahl. The genus is numerous in species, all of them native of America, but this species is now common in the tropics of the Old World. *Nectarinia* is the genus of the Honeysucker.

563. **A Mangrove Swamp in Sarawak, Borneo.**—Various trees and shrubs, belonging to different natural families, that constitute the vegetation of the tidal swamps of warm countries,

are called Mangroves ; but the *Rhizophoraceae* a small family
are all, or nearly all, maritime, and specially entitled to the
name. The tree represented here is one of the commoner ones
(*Bruguiera gymnorrhiza*, Lam.). Each branch bears a cluster
of leaves and flowers at the tip ; and each flower produces one
seed. But the most remarkable thing in the economy of this
and other Mangroves is the provision for their reproduction
from seed. Instead of the fruit falling or the seed falling from
the fruit or seed-vessel when ripe, as most seeds do, the seed
germinates in the seed-vessel while it is still attached to the
mother-plant; its root growing out at the top, as shown of the
natural size in the front of the picture. This root either goes
on growing until it reaches the mud, or getting too heavy, the
young plant drops from the mother-plant and sticks in the mud,
where it soon unfolds its first leaves, and becomes established as
an independent plant. In this way the Mangroves cover miles
and miles of muddy swamp with a dense thicket of vegetation,
gradually extending seaward and reclaiming more land.

564. **View from Matang over the Great Swamp,
Sarawak, Borneo.**—Shadow of the hills at sunset.

565. **Palawan Trees, Sarawak, Borneo.**—This tree (*Tristania
Whiteana*, Griff.) is easily recognised in the landscape, as it
sheds its bark like an Arbutus, leaving the trunk a deep red.

566. **View from the Istana, Sarawak, Borneo.**— Ducu or
Dookhau fruit (*Lansium domesticum*, Jack.) in front.

567. **Sago Palms in flower, with a glimpse of the river at
Sarawak, Borneo.**—The word *Sagus* is said to be derived from
Sagu, which in the language of the Papuan race signifies
bread, and is given to the Palm *Metroxylon Sagu*, Rottb., from
which the greater part of the sago of commerce is obtained.
Sago itself is obtained from the soft inner portion of the
trunk, and is extracted by pounding and washing. Refer to
the description of 610.

568. **View down the river at Sarawak, Borneo.**—Boat-
house and Palms (*Areca Catechu*, L.) in the foreground.

569. **Pitcher Plants with Fern behind, Sarawak, Borneo.**—
Nepenthes gracilis, Korth. The pitchers on young plants
usually differ very much in shape and colouring from those
of adult plants. The fern is *Gleichenia linearis*.

570. **Other Species of Pitcher Plants from Sarawak,
Borneo.**—*Nepenthes Rafflesiana*, Jack., one of the most

ornamental of the genus, originally introduced into Kew Gardens from Singapore in 1845. The one below is *N. ampullacea*, Jack.

571. **A Clump of Screw Pine and Palm with a glimpse of the river, Sarawak.**—A strong fibre is obtained from the leaves of some of the Screw pines ; and sugar bags are made of the leaves of *Pandanus utilis*, Bory, a Mauritian species. The Palm conspicuous from its red stem is *Cyrtostachys* Lakka, Blume ; The Screw Pine is *P. Kaida*, Kurz.

572. **Leaf Insect.** — See description of 676. *Phyllium siccifolium.*

573. **Mouth of the Kuching River, Sarawak.**

574. **A climber in flower and fruit, Sarawak.** — The flowers, although green in colour, are very sweet-scented. It is an *Artabotrys (Anonaceae).*

575. **Foliage and Fruit of a Forest Tree of Java.**—*Amoora Aphanamixis*, Schult., a member of the *Meliaceae.*

576. **Group of Wild Palms, Sarawak, Borneo.** — *Areca Catechu*, L. (Betel) in flower, *Arenga saccharifera*, Labill. in fruit. Observe also Taro (*Colocasia esculenta*).

577. **Flowers and Fruit of the Mangosteen, and Singapore Monkey.**—The Mangosteen (*Garcinia Mangostana*, Linn.) is a native of Malacca, and it is esteemed by many as the best of all tropical fruit. The white arils are juicy like the grape, the pink rind is apt to leave a stain on anything it touches. See 557.

578. **Bitter wood in flower and fruit, painted at Sarawak.** —This is *Quassia amara*, L., a tropical American tree, cultivated in various parts of the world for its medicinal properties. " Quassia chips " are the product of this tree.

579. **Tree covered with Epiphytes, and a Palawan tree, Sarawak.**—See 565.

580. **View of Singapore, from Dr. Little's garden.**—A red-stemmed Palm (*Cyrtostachys Lakka*, Becc.) and Wine Palm (*Caryota mitis*, Lour.) in the foreground. For further particulars the reader is referred to the description of 670. Observe the Honolulu creeper, *Antigonon leptopus*, Hook. & Arn.

581. **Flowers and Butterflies of Sarawak, Borneo.** — *Mussaenda macrophylla*, Wall., is the plant on which the Butterflies (*Ornithoptera priamus*) are painted, though they are from Amboina. The flowers of the *Mussaenda* are very curious, having small orange-yellow corollas, and one of the calyx lobes of one of every three of the outer flowers of the cluster grown out into a white leaf-like organ. The blood-red blossoms of the *Clerodendron* are used by the Dyaks for dressing the heads and trophies brought home from battle. A second species of *Clerodendron* is represented in fruit.

582. **Flowers and Fruit of the Doctors' Tree, Sarawak, Borneo.**—This climber (*Rourea* sp.) is a member of the *Connaraceae*, a small family allied to the *Leguminosae*.

583. **Areca, or Betel-Nut Palm, Singapore.**—This palm (*Areca Catechu*, L.) is extensively cultivated in tropical Asia for its seeds, which are cut in slices and rolled in the leaves of species of *Piper* and chewed with lime. See 310.

584. **The Quicksilver Mountain of Tegora, Sarawak, by moonlight.**

585. **Scorpion Orchid, cultivated at Singapore.**—It is the *Arachnanthe moschifera*, Blume, a native of the Malayan archipelago ; also recorded from Japan, where, however, it is only cultivated. The central back petal, representing the tail of the scorpion, is musk-scented, and when this is removed the flowers are scentless.

586. **Two cultivated Plants, painted at Singapore.**—The central plant, having long leaves, purple beneath, and a curious inflorescence enclosed in two bracts resembling a bivalve shell, and on that account sometimes called the Oyster Plant, is *Rhoeo discolor*, Hance, and the lily-like flowers in front are those of *Zephyranthes rosea*, Lindl. Behind and above may be seen the delicate foliage and rosy balls of minute flowers of one of the Sensitive Plants (*Mimosa pudica*, L.), a common weed in hot countries.

587. **Foliage, Flowers, and Seed-vessels of a Peruvian Bark Tree.**—There are several species of the genus *Cinchona* yielding bark of different qualities, and they are all natives of Peru, Bolivia, and the adjoining countries in South America, where, however, they have become very scarce in the accessible districts ; but the English in the mountains of India, Ceylon, and Jamaica, and the Dutch in the mountains

of Java, have for many years successfully cultivated the most valuable kinds. Several different alkaloid substances are extracted from Peruvian bark, including quinine, the bi-sulphate of which is the "quinine" or "sulphate of quinine" of the druggists—one of the most reliable remedies in cases of malarial fever. This is a variety of *Cinchona Calisaya*, Wedd.

588. **Group of Cultivated Flowers.** — In the foreground *Dendrobium primulinum*, Lindl. and *Combretum grandiflorum*, G. Don., with a passion-flower (*Passiflora laurifolia*, Linn.), the white-flowered *Bauhinia variegata*, Linn., a *Crinum*, and *Ixora coccinea*, L., &c., in the jar. Observe the drooping yellow flowers of *Gmelina Hystrix*, Kurz, and the purple-flowered *Asystasia coromandeliana*, Nees.

589. **Nipa Palm, Borneo.**—Inflorescence of the natural size in front, with a portion of a leaf behind, and the growing plant in fruit in the distance. This somewhat anomalous-looking Palm (*Nipa fruticans*, Wurmb.) is very common in the muddy estuaries of rivers and in tidal swamps in eastern tropical Asia; and it is the most valuable of all growing things to the Dyaks of Borneo. Their huts are framed and floored with its leaf-stalks, roofed and matted with its leaves; from its juices they extract sugar and make a kind of wine and from its young leaves cigarette papers. The seeds are solitary in the nuts, which are clustered in huge balls as large as a man's head. The seeds, it is recorded, lie dormant in the fruit several years before germination, when the fruit becomes detached from the plant and is floated off by the tide to establish itself on some other mud bank. This plant only grows where mangroves flourish. Its tall feathery leaves are from fifteen to thirty feet high.

590. **Malayan Moth Orchid and an American Climber.**— *Phalaenopsis amabilis*, Blume, is one of the most distinct types of showy orchids. It is here associated with the beautifully variegated foliage of *Haemaria discolor*, Lindl. The climber (*Antigonon leptopus*, Hook. & Arn.), a native of Central America, belongs to the same family as the common Knotgrass.

591. **Road Making in the Tegora Forest, Sarawak, Borneo.**

592. **Two Climbing Shrubs, painted at Singapore.**— *Quisqualis indica*, L., with red and white flowers, and *Thunbergia erecta*, T. Anders.

593. **Orchids of Sarawak, Borneo.**—*Dendrobium superbum*, Rchb. f., having purple flowers with a darker lip; and *Calanthe vestita*, Wall., white and orange.

594. **Foliage and Flowers of the Burmese Thaw-ka or Soka, painted at Singapore.**—*Amherstia nobilis*, Wall., has perhaps the most magnificent flowers of any member of the large family, *Leguminosae*, to which it belongs. The Burmese call it *Thaw-ka* or *Soka*, and handfuls of the flowers are offered before the images of Buddha. It is only known in temple and other gardens.

595. **Bornean Orchids.**—In the lower left corner, *Cypripedium Hookerae.* Rchb. f., with spotted leaves, and above it, *C. Lowii*, Lindl., with a white-flowered *Sarcochilus Calceolus*, Lindl. on the right, and a *Sarcanthus*.

596. **Flowers and Fruit of Barringtonia, Borneo.**—*Barringtonia speciosa*, Forst., is a tree of the Myrtle order, common on the sea-shore of the Malayan, Mascarene, and Polynesian Islands. A kind of lamp oil is expressed from the seeds, and mixed with bait it is used to stupefy fish in order to facilitate their capture. The butterfly is *Diadema bolina*.

597. **Foliage and Fruit of the Gourka or Goraka of India.**—This tree (*Garcinia dulcis*, Roxb.), yields an inferior quality of gamboge. The fruit is hidden beneath the dense screen of foliage, and can only be seen by lifting it aside.

598. **Stagshorn Fern, and the Young Rajah of Sarawak, with Chinese Attendant.**—This remarkable fern (*Platycerium grande*, J. Sm.), is of a prodigious size and bears two kinds of fronds, fertile and sterile, the former being pendent and divided into narrow segments.

599. **A cultivated Crinum, painted in Borneo.**—*Crinum augustum*, Roxb., a native of Mauritius and Seychelles, and one of the handsomest of this fine genus of *Amaryllidaceae*. Entire plants are represented in 547.

600. **Foliage and Flowers of a Tropical American Shrub and Honeysuckers.**—*Solandra grandiflora*, Sw., resembling *Datura arborea*, L., and a member of the same family, namely *Solanceae*.

601. **Flowers and Young Fruits of the Pinanga malaiana, Scheff.**

602. **A Bornean Crinum.**—This plant (*Crinum Northianum*, Baker), is common enough in Borneo, yet it was not previously known to botanists.

Around the doorway, beginning on the left, are *Cissus discolor*, Blume, from Borneo, *Hoya coriacea*, Blume, and *H. imperialis*, Lindl., from Malaya, the Indian *Vanda coerulea*, Griff., *Camellia theifera*, Griff., India and China, *Luculia gratissima*, Sw., India, *Trachelospermum jasminoides*, from China and Japan, and the Japanese creeper, *Vitis inconstans*, Miq., on the right post.

On the left panel of the door is a festoon of *Stephanotis floribunda*, Brongn., a native of Madagascar, commonly cultivated in this country for bridal bouquets, &c. ; and on the right is the beautiful New Zealand *Clianthus puniceus*, Banks and Sol., whose only congener is represented in 718. It is remarkable as one of the very few leguminous plants native of New Zealand.

603. **Specimens of the Coquito Palm of Chile, in Camden Park, New South Wales.**—The palms were planted by Sir W. Macarthur, and were fifty years old when painted. The Coquito Palm (*Jubaea spectabilis*, H. B. K.), which is the most southerly representative of the family in America, is remarkable for its stout trunk. In Chili a sweet syrup called *Miel de Palma*, or Palm-honey, is prepared from the sap, which is or was, much esteemed for domestic use as sugar. See 8.

BORNEO AND JAVA.

604. **Foliage of the Gutta Percha.**—All the true gutta percha imported from Singapore and the Malay Islands is the inspissated latex of this tree (*Dichopsis Gutta*, Benth.) ; many allied species afford a similar but inferior product.

605. **Foliage, Flowers, and Fruit of the Sapodilla Plum.** —*Achras Sapota*, L., a native of tropical America, is now cultivated in other parts of the world for its excellent fruit, which tastes like a medlar. The latex of this tree is used in America in the manufacture of chewing-gum.

606. **View near Garoet, Java, Wild Bananas and Coffee Bushes in Front.**—For flowers and fruit of Coffee see 153.

607. **River Scene at Sarawak, Borneo, when the tide is getting low.**—A boat-builder's house surrounded with Palms, Bananas, and Breadfruit trees. On the water a cocoanut shell, full of burning oil, which is supposed to be carrying off the Bad Spirit from some sick-house to the sea.

608. **The Avocado or Alligator Pear.**—*Persea gratissima*, Gært. f., is a member of the Laurel family, native of tropical America, where, as well as in other countries, it is commonly cultivated. Though strangers do not at first relish the fruit, it is highly esteemed, especially in the West Indies and America, where it is usually eaten as a savoury with pepper and salt. It has a firm yellow pulp, possessing a nut-like taste ; hence it has been called Midshipman's Butter. Oil is obtained from the pulp by expression, and used in soap-making ; and the seeds yield an indelible black juice used as marking ink. The gigantic moth is *Tropaea selene*. Painted in Java.

609. **Tea Gathering in Mr. Hölle's Plantation at Garoet, Java.**—The volcano of Goentoen in the distance. In the right foreground Coffee bushes, a Cypress, and some trees of *Canarium commune*, L.

610. **A Tailor's Shop in the Botanic Garden, Buitenzorg, shaded by Sago Palms and Bananas.**—The Sago Palm (*Metroxylon Sagu*, Rottb.) attains a height of about thirty feet in fifteen years, and then sends up a large terminal inflorescence. Before this appears the tree is cut down and the skin removed and the inner part prepared by scraping and much washing for export or home use. Wallace says that one tree will supply a man with a whole year's food. Look at 567.

611. **Foliage, Flowers, and Fruit of Vanilla albida.**—Several species of this genus are cultivated for the fruit or seed-vessel, which is used to scent and flavour delicate sweet-meats and beverages. It is worthy of note that the genus *Vanilla* is one of the very few genera of Orchids inhabiting tropical regions that are represented by indigenous species both in America and the Old World. See 491.

612. **Cobweb Bridge in Borneo, made by the Dyaks with Rattans and Bamboos.**—Only one of the latter is provided for

foot hold, but it is so cleverly fastened that even Europeans in shoes can cross it, if not too giddy from the swinging motion. Rattans are the slender tough stems of various species of *Calamus*, climbing palms which abound in the Malayan region.

613. **Foliage, Flowers, and Fruit of the Pepper plant.**— The pepper plant (*Piper nigrum*, L.) is a native of S. India. White and black pepper are from the same plant. Whole black pepper is the ripe fruit untouched, and white pepper is the same thing with the outer skin of the fruit removed.

614. **The Turong, or Pigeon Orchid in Borneo, and a purple-brown Cymbidium.**—The former (*Dendrobium crumenatum*, Lindl.) comes into blossom simultaneously on all the plants about every nine weeks, and the trees and roofs on which it grows seem on those days to be covered with snow, which on the morrow all melts away. Forbes alludes to its behaving in the same way in Sumatra. The *Cymbidium* is *C. Finlaysonianum*, Lindl.

615. **Collection of Fruits, painted at Lisbon.**—Unfamiliar to most English people is the long purple Aubergine or Egg-plant (*Solanum esculentum*, Dun.), as well as the large red Pimenta or Red Pepper, a variety of Capsicum.

616. **Group of Bornean Plants.**—At the bottom on the left is the singular Aroid (*Gamogyne Burbidgei*, N. E. Br.) with rosy crimson spathes; above, *Labisia pothosina*, N. E. Br., and a *Psychotria*, bearing blue berries, with the clustered yellow fruit of *Polyalthia macropoda*, King, and below the beautiful variegated foliage of *Piper porphyrophyllum*, N. E. Br.

617. **Foliage and Fruit of the Kenari and Butterfly, Java.**—The nuts of the Kenari or Java Almonds (*Canarium commune*, Linn.) are so hard that only the Black Cockatoo can crack them; and this he ingeniously manages, according to Wallace, by first stuffing one of the leaves into his large beak, for the purpose of steadying the nut. Kenari timber is most valuable. The Butterfly is a *Pieris*.

618. **Houses and Bridges of the Malays at Sarawak, Borneo.**

619. **View of the Salak Volcano, Java, from Buitenzorg.** —Like most of the volcanoes in Java, it is clothed with the richest forest up to the very edge of the crater, interrupted

here and there only by patches of Cinchona, Coffee, and Tobacco cultivation, and lower down by terraces of Rice and Indian Corn. In the immediate foreground are Cocoanut Palms, Bananas, Bamboos, and Mango trees; and the same trees, associated with the Bread-fruit and Sago Palms, border the river.

620. **The Great Square of Malang, Java.**—The trees are a kind of Fig (*Ficus Benjamina*, L.), with bullock carts beneath their shade.

621. **The Papandayang Volcano, Java, seen from Mr. Hölle's tea plantations.**—A rich plain intervening, watered from the hot springs.

622. **Another View of Papandayang, with Jak fruit Tree in the foreground.**

623. **The Soembing Volcano, Java.**—In front a plantation of Teak trees, and the artist's home for ten days, seen from the top of the Boro Bodoer. See the description of 636.

624. **Curious Plants from the Forest of Matang, Sarawak, Borneo.**—On the left, attached to a trunk, are the bladder-like leaves of *Dischidia Collyris*, Wall. (*Asclepiadaceae*); and the red ribbon-like bodies bearing numerous small flowers are the inflorescences of *Pterisanthes polita*, M. Laws., a climbing shrub, in floral structure closely allied to the Grape Vine. The little plant in flower at the bottom on the right is *Didymocarpus reticosus*, Clarke, associated with coloured-leaved Begonias and other plants. Below are young leaves of *Lygodium scandens*.

625. **Foliage and Flowers of a tree commonly cultivated in warm countries.**—*Sesbania grandiflora*, Pers., var. *coccinea*, may be a native of the Malayan Archipelago and North Australia. The tender leaves, flowers, and young pods are all eaten by the natives of Malaya in their curries, and the very bitter bark is used as a tonic. There is a variety having white flowers.

626. **Palms in the Botanic Garden at Rio Janeiro.** The Organ Mountains appear in the back ground.

627. **Blue-flowered Climber and a common Swamp Plant of Sarawak, Borneo.**—The Burmese *Thunbergia grandiflora*, Roxb., and a species of *Fagraea*, belonging to the *Loganiaceae*.

628. **Wild Flowers of Sarawak, Borneo.**—In the centre the handsome *Coelogyne asperata*, Lindl., with the young inflorescences of a plant of the ginger family behind ; Pitchers of a species of *Nepenthes*,and the small purple-flowered *Dendrobium secundum*, Wall., lying in front.

629. **India-rubber trees at Buitenzorg, Java.**—For some particulars respecting this tree (*Ficus elastica*, Roxb.) the reader is referred to the description of 260. It is a native of Assam in North India, and is remarkable for the large buttresses it forms.

630. **Village of Mat Houses, near Garoet, Java.**—Observe that the houses are raised on piles above the ground, so that the air can circulate beneath the floors.

631. **Flowers and Fruit of the Jamboa Boll, Java.**—The fruit is sweet, like a pear, and is the product of a species of *Eugenia* of the section *Jambosa*.

632. **Young Leaves and Flowers and Fruit of Cotton tree.**—The seeds of *Eriodendron anfractuosum*, DC., are densely clothed with silky-white hair (Kapok), which is used to stuff pillows, &c.; in Java the trees themselves are used as telegraph posts, as the branches grow so conveniently at right-angles to the trunk that they do not interfere with the wires.

633. **Rice Harvest, near Bandong, Java.**—The working buffaloes, though very savage towards men, get fond of the boys who drive them and habitually sit on their backs, and have been known to fight wild beasts in their defence.

Rice (*Oryza sativa*, L.) is now very generally cultivated in warm countries, and it is the staple food of a larger number of the human race than any other grain. In some parts of India and China it is almost the only food of millions of people.

634. **Foliage, Fruit, and Flowers of a Rose-apple, Java.**—Fruit edible. This is probably a variety of *Eugenia aquea*, Burm. f.

635. **Tea-drying in Mr. Hölle's establishment, Java.**

636. **The Volcanoes of Merapi and Merbaboe, Java, from the top of Boro Bodoer.**—The rich plain at their feet covered with morning mist ; the tops of the Cocoanut groves alone showing above it, and indicating the position of the numerous native villages. In the foreground are some of the 400 life-

size statues of Buddha, amidst their shattered dagobas, which adorn the wonderful pyramid and its seven steps or terraces. They contain the whole history of the holy man, illustrated in the finest bas-relief, and if stretched out would measure three miles in length. The building was commenced apparently in the fifth or sixth century, and may have been in progress 200 years before it was completed.

637. **Plants of Sarawak.**—On the left the bold, longitudinally-ribbed foliage of a *Melastomacea* with a vine in fruit, the name of which we have not determined ; and the small cluster of scarlet flowers belongs to a species of *Globba*, perhaps to *G. atrosanguinea*, Teijsm. & Binn.

638. **Foliage and Fruit of Sterculia parviflora.**—The lower seed-vessels ripe and open, exposing the seeds to view. Each cluster of seed-vessels is the product of a single flower. See 281.

JAPAN AND JAVA.

639. **Japanese Flowers.**—*Forsythia viridissima*, Lindl. (yellow), *Azalea, Camellia*, and *Paeonia Moutan*, Sims. The variegated foliage at the top is of *Cleyera Fortunei*, Hook. f., a shrub belonging to the same family as the Camellia.

640. **Foliage, Flowers, and Fruit of Eugenia, Sarawak, Borneo.** Flowers of *E. grandis*, Wight, fruit of *E. aquea*, Burm. f.

641. **Japanese Chrysanthemums,** cultivated in this country.

642. **Rice Drying** on the sea-shore near Yokohama, Japan.

643. **Gate of the Temple of Kobe, Japan, and Wistaria.** —*Wistaria chinensis*, Sieb. et Zucc., trained over the gateway, and a noble Camphor Tree (*Cinnamomum Camphora*, Nees) behind it.

644. **A Clearing in the Forest of Tji Boddas, Java,** with bank of Tree Ferns.

645. **Two Flowering Shrubs of Java.**—*Strophanthus dichotomus*, DC., and *Lagerstroemia indica*, L. The five-tailed

corollas of the first are singular, as well as its large seed-vessel, which consists of two carpels spread out horizontally; and the wavy-petalled, rosy flowers of the latter are not unfamiliar in the greenhouses of this country.

646. **The Gader Volcano, Java, from Sindang Laya.**—A young *Casuarina*, and *Datura arborea* in the foreground with an *Erythrina* in flower and a *Furcraea* poling on the left.

647. **View from the Artist's Window at Buitenzorg, Java.**—Cocoanut Palms, Bananas, Breadfruit trees, and Coffee bushes. *Clerodendron paniculatum*, Linn., in flower on the left.

648. **Roadside View from Sindang Laya, Java.**—A Durian tree (*Durio zibethinus*, DC.) may be seen on the left.

649. **Village of Tosari, Java, 6000 feet above the level of the sea.**—*Casuarina* trees, and the smoke of the Volcano Smiroe rising above the hill. Here are the gardens which supply all the European vegetables to the towns below.

650. **Zedoary, a Climbing Plant and Mantises, Java.**—The corolla of the climbing *Ceropegia* is remarkable in having the narrow ends of the lobes united at the tips. Zedoary root (*Curcuma Zedoaria*, Rosc.) is used medicinally.

651. **Garden of the Nishihongwange Temple, Kioto, Japan.**—Cycads (*Cycas revoluta*, Thunb.) and various dwarf plants on a rockery.

652. **Entrance to the Temple at Kobe, Japan.**—In the foreground on the right is the Sacred Horse, an albino with blue eyes and a pink nose, and hoofs turned up from want of exercise. He is fed by the true believers with beans, which are kept ready in saucers near him; and a piece of money is left in their place. He is always kept tied up in readiness, in case the god come earthward and want a ride. Near him is a stuffed horse-skin, so that even if he died the god would not be horseless. On the left in the middle distance is an old Tallow tree (*Stillingia sebifera*, Sieb. et Zucc.) with tufts of a Sumach upon it.

653. **The Hottomi Temple at Kioto, Japan.**—A Pine tree trained as an espalier in front, and autumn tints in the background.

654. **Temple over the Great Bell of Chion-in, Kioto, Japan.**—This bell is eighteen feet in diameter.

655. **Interior of Chion-in Temple, Kioto, Japan.**

656. **Small Temple of Maruyama at Kioto, Japan.**— *Cryptomeria japonica*, Don, and bamboos in the background. The form of devotion practised at this temple consists in running round it one hundred times, and dropping a piece of wood into a box each time the worshipper passes it.

657. **View of the City of Kioto, Japan, in the morning mist.**—Taken from outside of the Artist's paper window. In the foreground, on the right, is the top of a pine tree, clipped and trained so as to resemble a bank of turf from where the artist sat.

658. **Distant View of Mount Fujiyama, Japan, and Wistaria.**—This beautiful, hardy, climbing shrub *Wistaria chinensis*, DC., is a native of China and Japan, and was introduced into this country about the year 1816. The original plant was nearly killed through being kept in a hot-house.

659. **Japanese Flowers, painted from plants cultivated in this country.**—On the left is *Aucuba japonica*, Thunb., bearing the familiar mottled leaves and a cluster of the red berries ; a group of single and semi-double varieties of *Camellia japonica*, L., and the charming *Cydonia japonica*, Thunb., on the right. The female *Aucuba* has been cultivated in England for more than a century, but it is only since the introduction of the male plants, in the year 1861, by Mr. Fortune, that berries have been seen.

660. **Foliage and Flowers of an Indian climbing Evergreen Shrub.**—At first sight this reminds one of the Himalayan *Rhododendron Griffithianum*, Wight. It is *Beaumontia grandiflora*, Wall., belonging to the *Apocynaceae*, and climbs to the tops of the highest trees.

661. **Study of Japanese Chrysanthemums and Dwarfed Pine.**—The Japanese delight in dwarfing normally big trees ; and they have brought the art to such a degree of perfection that they can keep them down to the size of the one represented to a very considerable age. In this condition they are perfect miniatures of trees, bearing all the knots and markings of their age.

662. **Young pitchers and ripe seed-vessels of a Pitcher Plant of Java.**

663. Pawan Durfur.—Temple crushed by a large Cotton tree, Java.

664. Java Flowers.—*Agalmyla staminea*, Blume, with an Orchid and the trailing Campanulacea (*Pratia egoniaefolia*, Lindl.) in front.

665. Banyan Trees at Buitenzorg, Java.—Roots descend from the branches of this tree (*Ficus bengalensis*, L.), on all sides, and after penetrating the ground they enlarge and grow into stems three or four feet or more in girth. In this way a tree spreads and spreads until it forms a little forest in itself. See 293 and 677.

666. Palms in the Botanic Garden, Buitenzorg, Java.—In the centre are two small ones, having huge fan-shaped leaves. These are the famous Double Cocoanut, or Coco de Mer (*Lodoicea sechellarum*, Lab.), and they were then thirty years old, though they had not yet begun to form a trunk, see 474–477.

667. Cascade at Tji Boddas, Java.—Tree Ferns and *Amomum* plants in the foreground.

668. View from Malang, Java.—Mat Houses, and a large Tree in the foreground.

669. Japanese Persimmon or Kaki Fruit.—Several varieties of this fruit (*Diospyros Kaki*, Linn f.) are cultivated both in China and Japan ; and some of them have been imported, and are now cultivated in the South of Europe. In flavour they resemble a plum, and they are eaten fresh or sun-dried.

670. The Talipot Palm in Flower and Fruit, and Wine Palm in flower at Buitenzorg, Java.—Under 284 will be found an account of the mode of flowering of the Talipot Palm (*Corypha Gebanga*, Blume) ; and that of the Wine Palm (*Caryota urens*, Linn.) is equally curious. When the tree has attained a certain age, and a height of forty to sixty feet, it throws out a large cluster of flowers from the axil of the topmost leaf, and this is succeeded by cluster after cluster, alternately male and female, each one lower than the one before it, until the lowest leaf-axil is reached, when the exhausted tree dies.

671. Foliage of a Cinnamon and Atlas Moth.—The pea-like flower is *Clitoria Ternatea*, Linn. Observe the Caterpillar and Chrysalis of the Moth (*Attacus* sp.).

672. A Javan Rhododendron and Ipomoea.—The genus *Rhododendron* has a wide range in the Old World, from the Alps of Europe to China and Japan, and southward to Java, Borneo, &c. ; but the greatest development of the genus is in the mountains of N. India and China, where also the finest species grow. A few species inhabit North America. The plant in the picture is *Rhododendron javanicum*, Benn. The *Ipomoea* received its specific name *bona-nox*, " good-night, " in allusion to its opening its flowers in the evening. It is generally spread in the tropics.

673. Leaf and Inflorescence of a Gigantic Aroid, Java.—*Amorphophallus campanulatus*, Blume, is a singular and striking object. Previous to the bursting of the spathe containing the spadix, which takes place suddenly about sunrise, there is an accumulation of heat therein. When it opens it exhales an offensive odour that is quite overpowering, and so much resembles that of carrion that flies cover the club of the spadix with their eggs.

674. Hindu Idols and Frangipani Trees at Singosari, Java. *Plumeria acutifolia*, Poir.

675. Inflorescence of a Plant of the Ginger Family from Java.—The flowers are in dense clusters, which proceed from the trailing, partly underground stem ; and the ripe seed-vessels are sweet and juicy like grapes. It is probably a species of *Amomum*. The plant is represented in 667.

676. Leaf-Insects and Stick-Insects.—The singular forms assumed by these insects have suggested the names leaf-insect, stick-insect, &c., and these names are most appropriate, for the insects so closely resemble the twigs and leaves of the plants on which they live, that they seem to form part of them. These adaptations, or resemblances between the insects and the plants they feed on, serve to guard the insects against extermination by their enemies. " It is thus, " says the eminent traveller and naturalist, Mr. Bates, " that from the *Phasma* type have been " produced the narrow, green or yellow, wingless *Bacilli*, with " their habit of stretching out rigidly their elongated limbs " when clinging to a plant, so as to assume the appearance of a " slender stem—the flattened and rugged-lobed, mossy-looking " *Prisopi* and *Creoxyli*, which, when the wings are folded, " cannot be distinguished from a piece of lichen-covered bark— " the flattened *Phyllium*, which, as everyone knows, cannot " be distinguished from a leaf of the tree on which it crawls

" —and so forth, the adaptation of general form carrying with
" it modification of limbs and appendages." The *Phasmidae*
are numerous, some 600 species having been described, and they
are widely dispersed in warm countries.

677. **Old Banyan Trees at Buitenzorg, Java.** — See the
description of *Ficus bengalensis*, L. 293.

678. **Bamboos and Cocoanut Palm.**—Carrion Crows watching
Malays in a Butchery, Java.

679. **The Ardjuno Volcano from Tosari, Java.** — Tree
Ferns and Casuarinas in the foreground.

680. **View from the Bridge of Magelang, Java.**—Men re-
moving a Mat House, with vegetation of Palms, Bananas, and
Fruit Trees.

681. **Climbing Aroid and Nest of White Sparrows, Java.**
—*Rhaphidophora* sp. and *Padda orizivora*.

682. **Group of Palms, Botanic Garden, Buitenzorg, Java.**

683. **Foliage, Flowers, and Fruit of a Malayan Tree.** —
This is *Saraca declinata*, Miq., a member of the *Leguminosae*.

684. **Foliage, Flowers, and Fruit of the Sacred Lotus in
Java.**—The roots and seeds of *Nelumbium speciosum*, Willd.,
were eaten by the Egyptians in the time of Herodotus, as they
are at the present time in India ; but it long ago disappeared
from Egypt—how long ago, it is impossible to say. Its petals
are astringent. The fruit, however, is the most remarkable
part of this plant. A number of separate carpels, each con-
taining a single seed, are immersed in the funnel-shaped
receptacle ; and when ripe they are loose in the sockets, so
that if the fruit be shaken they make a noise like a rattle.
Further particulars respecting this interesting plant are given
in the description of 294. It flowers freely every season in
these gardens.

685. **Idols and Temples at Brambanang, Java.**

686. **Volcanoes from Temangong, with Sugar Palms in the
foreground, Java.**—The trunk of this palm (*Arenga
saccharifera*, Lab.) when dead is hollow, and furnishes
very durable underground water-pipes. The black fibre
obtained from the leafsheaths and used as cordage is

noted for its power of resisting wet. Finally, the sap yields toddy and sugar.

687. **Foliage and Fruit of a small Screw Pine, Java.**

688. **Foliage and Flowers of the Clove, Fruit of the Mango, and Hindoo God of Wisdom.**—The cloves of commerce are the unopened flower-buds, and the tree that produces them (*Eugenia caryophyllata*, Thunb.) is a native of the Moluccas, though now cultivated in the West Indies and other parts of the world. For further particulars respecting the Mango (*Mangifera indica*, L.), see description of 309.

689. **Mat Houses, Bandong, Java.**—Palms and *Datura arborea*, L., in the left foreground.

690. **The Mosque of Bandong, Java.**—The large trees are *Pterocarpus indicus*, Willd., commonly planted for shade in Java.

691. **Statue of Buddha.**—From the Great Pyramid of Boro Bodo, Java. *Poinsettia* and *Iris* behind it.

692. **Ripe Fruit of Screw Pine, and sprig of Sandal Wood.**—*Pandanus tectorius*, Sol. No. 571 shows the habit of growth of the Screw Pine. Consult the description of 246.

693. **Gardener's Cottage, Buitenzorg Botanic Garden, Java.**—It is hung with Bird Cages and shaded by trees covered with Rattan or Climbing Palms (*Calamus* sp.).

694. **Banyan Tree at Passu Gulah, near Diocio, Java.**—A prisoner was formerly chained to the stone table for many years and employed his time rolling the two big stones around.

695. **Foliage and Flowers of a Forest Tree of Java.**—*Fagraea auriculata*, Jack, is the name of the tree ; and the bird (*Megalaema* sp.) is probably not a native of Java, though it was bought and painted there !

696. **Banana, American Aloe, and Cypress, in a Garden, Java.**—This Banana, *Musa coccinea*, Roxb., does not bear an edible fruit. *Agave americana*, Linn., the American Aloe, is wholly different from the true Aloes of South Africa. See 383, 386, etc.

697. **Group of Wild Flowers of Java, from Tosari.**—These flowers were from an elevation of 6000 feet. The

most noteworthy flower in the group is the fine large Forget-me-not in the centre. Two of the plants in front on the left, the *Physalis* and *Datura* (long, purple flower), are common now in nearly all warm countries. The yellowish-flowered *Hydrangea*, in front of the young Fern-fronds indicates some relationship with the vegetation of Japan. Other genera represented are *Impatiens, Melastoma ?* and *Crotalaria* ; and the small blue peaflower hanging in front is *Parochetus communis*, Hamilt. Note the young frond of a fern still rolled up.

698. **Two Swamp Plants of Java in Flower.**—The snow-white flowers of the *Costus speciosus*, Sm., like those of most of its allies, are very fugitive, but the red bracts from which they spring are more durable. *Cassia alata*, Linn., belongs to a genus numerous in species, generally diffused in warm countries, and nearly all of them, like the present, have yellow flowers; but *C. nodosa* (332) is a noteworthy exception. Other species are represented in 33 and 336.

699. **Blauwater, Pasoeroewan, Java.**—An old Hindu Tank, whose Temple has disappeared ; but its sacred monkeys are pensioned and petted by the Dutch Government.

700. **Foliage and Fruit of the Tamarind and Flowers and Fruit of the Papaw in Java.**—The Tamarind (*Tamarindus indica*, Linn.) is a large timber-tree, native of tropical Africa and Australia, and is commonly planted for shade. Its pods contain a soft, acid pulp within the brown shell, which is very refreshing preserved in syrup. It is also used medicinally. For a portrait of the tree itself, see 279. The Papaw (*Carica Papaya*, L.), a native of Tropical America, is now common in most hot countries ; the fruit is usually eaten raw. It likewise possesses the rare and remarkable property of making fresh meat tender in a few hours. Paintings of the tree may be seen in 36 and 91.

701. **View of the Village of Tosari, Java.**—The Ardjuno Volcano seen across the rich Plain. The tall slender trees in the foreground are *Casuarina equisetifolia*, Forst.

702. **Flowers and Fruit of the Palmyra, and the Palm seen through a window, Java.**—It is recorded that the parts of this Palm (*Borassus flabelliformis*, L.) are applied to such a number of purposes that a poem in the Tamil language

although enumerating 801 uses, does not exhaust the catalogue. The fruit has a thick coating of fibrous pulp, which is roasted and eaten, or made into a jelly, which somewhat resembles that of the currant. It is noteworthy that the young seedlings of this Palm are used as an article of food. They are cultivated for the markets and either eaten in a fresh state, or after being dried in the sun ; and sometimes they are made into a very nutritious kind of meal. The Palmyra is very widely dispersed in tropical Asia and commonly cultivated, growing from sixty to seventy, and occasionally to a hundred, feet high. Unlike the Talipot, the Wine Palm and some others, the Palmyra flowers season after season.

703. **Small Hindu Temple of Kidel, Java.**—Bananas, Bamboos, and Palms in the background.

704. **Tree Fern in the Preanger Mountains, Java.**

705. **Palmyra Palms in Flood-time.**—This Palm commonly grows in low tracts of land that are inundated during the rains. For further information, see description of 702, in which the flowers and fruit are represented.

706. **Flowers of Roselle.**—This is *Hibiscus Sabdariffa*, Linn., an annual plant commonly cultivated in hot countries. Tarts and jellies are made from the fleshy calyx and capsule freed from the seeds. A drink prepared from the same parts in the West Indies is called Sorrel-drink, and the plant Red Sorrel. The leaves are used in salads.

707. **Palmyra Palms and Epiphytal Trees in Flood-time, Java.**—See 702.

AUSTRALIA AND NEW ZEALAND.

708. **A New Caledonian Plant, Hibiscus Cooperi.**

709. **View from the Botanic Gardens, Hobart Town, Tasmania.**—Grass-Trees (*Xanthorrhoea* sp.) and an Oyster Bay Pine (*Frenela rhomboidea*, Endl. var. *tasmanica*) in the foreground.

710. **View over the Blue Mountains towards the Sea, New South Wales.**—Flowers, seed-vessels, and young shoots, of *Syncarpia laurifolia*, Tenore, a tree of the same beyond on the left, and a Kangaroo Rat in the foreground.

711. Berry-bearing Tasmanian Shrubs.—In front the foliage and inflorescence of *Richea dracophylla*, R. Br., which reminds one rather of the Pine Apple than the beautiful genus *Epacris*, to which, however, it is closely allied. The dark-purple berries are those of *Notelaea ligustrina*, Vent., a shrub of the same family as the Olive. The berries vary, it is stated, from white to purple into every shade of pink or red. Above on the left, is a spray of the beautiful blue berries of *Billardiera longiflora*, Labill. The clustered white fruit on the right is of *Gaultheria hispida*, R. Br., a common mountain shrub in Tasmania. In this the fleshy part is the calyx, and the pink lines are the inner margins of the lobes. Between the clusters of *Gaultheria* is a branch of *Aristotelia peduncularis*, Hook. f., furnished with rosy cherry-like fruit. The acorn-like bodies above, on the right, appear to be a kind of gall on *Doryphora Sassafras*, Endl.

712. A New Zealand Dracophyllum.—This remarkable genus is spread over New Zealand, Australia (especially Western), and New Caledonia: and the present species (*D. Traversii*, Hook. f.) as well as most of the others, has all the appearance of an endogenous plant rather than an *Epacridea*. The same remark applies to *Richea*, represented in 711.

713. View of Lake Wakatipe, New Zealand.—New Zealand Flax (*Phormium tenax*, Forst.) in the foreground. This is the most useful plant in the islands. Half-a-pint of honey juice can be obtained from the flowers of a single plant; a gum is exuded where the leaves are broken away from the stem, which is much used and even eaten by the Maoris; and the dried flower-stalks contain a pith which, when ignited, keeps glowing like tinder, and is carried about by the Maoris as slow matches. On the fresh-cut leaves the Maoris draw and write with a sharp-edged shell; and split or cut into strips they serve as rope or string, which is again plaited into baskets, plates and dishes, nets and sails, and woven into garments. About half the leaves are plucked each year without injury to the plants. Although the fibre of the New Zealand Flax is very strong and easily obtained in large quantities, it has until recently been little used by manufacturers, on account of the difficulty and expense attending the separation of the fibre from the gum resin secreted by the plant. It is one of the commonest and most persistent of plants in the islands, growing equally well from sea-level up to an altitude of 5000 feet.

714. View of the Otira Gorge, New Zealand.—Conspicuous in the vegetation of the foreground are the white plumes of the Toe Toe Reed (*Arundo conspicua*, Forst.), and on the rocks, trees of *Dracophyllum Traversii*, Hook. f. (see 712), and one of *Metrosideros lucida*, Menzies ; the latter projects from the rocks across the scene. Quite in front is a plant of the large white-flowered, peltate-leaved *Ranunculus Lyallii*, Hook. f., the finest species of the genus. On account of the form of its leaves it is called Water Lily by New Zealand shepherds. The nearest allies of this plant inhabit the uplands of South Africa. On the rocks behind are some tufts of the " Kid-glove " or " Leather " plant (*Celmisia coriacea*, Hook. f.), so named on account of the white felt that clothes the leaves. The tree at the top on the right with light-green foliage is *Dacrydium Colensoi*, Hook., an ally of the Cypresses of the northern hemisphere.

715. View in the Forest on Mount Wellington, Tasmania.— The large tree with dark foliage in the centre is a species of Beech-birch of the colonists (*Nothofagus Cunninghamii*); and the light-green trees, one on each side, are the Celery-topped Pine (*Phyllocladus rhomboidalis*, Rich.) and Sassafras (*Dory-phora Sassafras*, Endl.). In front are some Tree-Ferns (*Dicksonia antarctica*, Labill.), and *Richea dracophylla*, R. Br.

716. Illawarra, New South Wales.—Paper-bark Tree (*Melaleuca Leucadendron*, Linn.), and other species of the same genus ; and a pink-tipped spray of *Callistemon salignus*, DC. Compare the latter with the gorgeous *C. speciosus*, 776.

717. Castle Hill Station, with Beech Forest, New Zealand.

718. The Australian Parrot Flower.—This brilliantly coloured flower, also called Sturt's Pea or Glory Pea (*Clianthus Dampieri*, A. Cunn.), if not very common, has a wide range, occurring in New South Wales, South Australia, and also on the north-west coast. It is noteworthy as being one of the few plants brought home by Dampier on his second voyage at the beginning of the eighteenth century. A second species, painted on one of the panels of the door opposite is a native of New Zealand.

719. Ripe cone of a Cycad, Illawarra, New South Wales.— The beauty of the richly-coloured seeds of this Cycad

(*Macrozamia spiralis*, Miq.), is only seen after the cones begin to break up.

720. Foliage and Flowers of the Blue Gum, and Diamond Birds, Tasmania.—The Blue Gum (*Eucalyptus Globulus*, Labill.) grows to a large size, occasionally exceeding 300 feet; it inhabits Tasmania and Victoria. The very different foliage on the right at the bottom represents the juvenile condition. It is worthy of remark that the Gum Trees, though among the largest trees in the world, have very small or even minute seeds. It has been computed that an ounce of sifted seed of *E. Globulus* contains 10,000 fertile grains. The birds belong to the *Plocidae*.

721. New Zealand Flowers and Fruit.—The spherical plant in the foreground is a small specimen of the "Vegetable Sheep" (*Raoulia eximia*, Hook.f.). It inhabits the mountains, growing as large and looking so much like a recumbent sheep at a little distance that shepherds have often been drawn to the top of the stony mountains to find only a clump of this *Composita* instead of a stray sheep. Behind the *Raoulia* are some fronds of the singular fern *Trichomanes reniforme*, Forst., which is peculiar to New Zealand. The prickly leaves hanging from the vase are those of the southern Bramble (*Rubus australis*, Forst.), which bears a yellowish, austere fruit; and the yellow berries are the edible fruit of the Karaka (*Corynocarpus laevigata*, Forst.), an outlying member of the *Anacardiaceae*, having large laurel-like leaves. On the left are some hanging spikes of a blue *Veronica*, and another species, probably *V. speciosa*, R. Cunn., is represented above on the right, whilst the centre is filled with the clustered crimson flowers of *Metrosideros tomentosa*, A. Cunn., contrasting with the white-flowered *Plagianthus Lyallii*, Hook. f.

722. Group of Nikau Palms, with a background of the Kawa Kawa, New Zealand.—The Nikau Palm, *Rhopalostylis sapida*, Wendl. & Drude (syn., *Areca sapida*, Soland.) is the most southern member of the order, and one of the least graceful; it is also the only one indigenous in New Zealand. On the right is one bearing flowers and young fruit. *Piper excelsum*, Forst., the Kawa Kawa, is an outlier of its large genus, which also occurs in New South Wales and in Southern Polynesia. It is noteworthy that no species of the *Piperaceae* inhabits Tasmania, Southern, or Western Australia.

723. **View of Mount Earnshaw from the Island in Lake Wakatipe, New Zealand.** — The trees in the foreground having dense tufts of narrow leaves at the ends of the branches, and large clusters of dirty-white flowers, belong to the Liliaceous genus *Cordyline*. They are called cabbage-trees by the Colonists, and a durable fibre is obtained from their leaves, but it is not so tough as that of *Phormium*. On the right is a plant of the curious *Panax longissimum*, with long deflexed leaves. The tufted plants in the foreground, one of which has a flower-stem, belong to the Umbelliferous genus *Aciphylla*, of which there are several species. They are called "spear-grass" and "Wild Spaniard," as their hard, sharp-pointed leaves form thickets impenetrable to man and beast. Mount Earnshaw is 9000 feet high.

724. **Fishbone Tree and the Parson Bird of New Zealand.** —The plant on the left, having long, deflexed, coarsely-toothed leaves, giving it the appearance of a wrecked umbrella, is the juvenile condition of *Panax crassifolium*, Planch. & Dcne., which was formerly supposed to be a distinct species, and described under the name of *P. longissimum*. As may be seen, the flowering branches bear leaves having three or five radiating leaflets. As great, though not so marked, a difference exists between the leaves of the young or sterile branches and those of the flowering branches of the common Ivy, a member of the same family. *Prosthemadera Novae-zealandiae* is the name of the bird.

725. **Blue Gum Trees, Silver Wattle, and Sassafras on the Huon Road, Tasmania.**--Both living and dead trees of the Blue Gum (*Eucalyptus Globulus*, Labill.) associated with *Acacia dealbata*, Link, and *Doryphora Sassafras*, Endl.

726. **Flowers and Foliage of the Silver Wattle, Queensland.** —This tree (*Acacia dealbata*, Link) yields an excellent gum, and when in flower it scents the whole country with its sweetness. Behind is the farm of Greenlands ; and on the left a Eucalyptus tree hung with parasites, with a long train of sheep raising a cloud of dust.

727. **View at Illawarra, New South Wales.** — Palms (*Livistona australis*, Mart.) in the foreground.

728. **She Oak Trees on the Bendamere River, Queensland, and Companion Birds.**--She Oak is the colonial name of one or more species of *Casuarina*, a genus which finds its maximum

development in Australia, where there are about twenty species spread all over the country. This is probably *C. quadrivalvis*. Other species bear the names He Oak, Swamp Oak, &c.; yet they have no near affinity with the true oaks. Various explanations of the origin of She Oak are given, the most probable being from shiok, a native name.

729. **A selection of West Australian Flowers.**—The bluish-green plant in the lower left corner is the Salt Bush, apparently a species of *Atriplex*, which covers thousands of miles of barren country, and will keep the sheep alive the first two years, until it is replaced by grass. Above are the showy yellow flowers of *Lambertia echinata*, R. Br., and the wing-branched *Acacia alata*, R. Br. Hanging across the middle is the so-called Jasmine, probably an *Apocynea*; and the thick bluish-green leaves and small clusters of pale lilac flowers belong to a species of *Hakea*, whose woody seed-vessel is shown on the right below. Conspicuous on the right are the orange-red flowers of *Beaufortia decussata*, encircling the straight branches, on which the small leaves are arranged in four rows.

730. **A Selection of Flowers from Mount Wellington, Tasmania.**—In the foreground on the left are the clustered red and bluish berries of *Cyathodes glauca*, Labill., the rosy flowers of a *Pimelea*, the lilac flowers of a *Prostanthera*, and behind these the small spicate flowers of *Bellendena montana* R. Br., the red berries of *Lissanthe strigosa*, R. Br., and the Tasmanian Ivy (*Panax Gunnii*, Hook. f.) bearing terminal clusters of black berries. Above, a branch of *Eucalyptus cordata*, Labill., bearing seed-vessels; to the right a cluster of Tasmanian Lilac (*Prostanthera lasianthos*, Labill.), followed by the large white flowers and ample ruddy foliage of *Anopterus glandulosus*, Labill., and the crimson flowers of *Telopea truncata*, R. Br.; the lobed leaves behind the *Anopterus* are those of the Celery-topped Pine (*Phyllocladus rhomboidalis*, Rich.). Hanging in front, the showy blue-fruited *Billardiera longiflora*, Labill., and the white-fruited variety of *Drymophila cyanocarpa?* with two or three native Cherries (*Exocarpus cupressiformis*, Labill.) at the bottom.

731. **Entrance to the Otira Gorge, New Zealand.**

732. **Palms and Ferns, a scene in the Botanic Garden, Queensland.**—On the left are *Asplenium Nidus*, L., with large undivided fronds, and *Platycerium grande*, J. Sm.; behind them the arboreous *Alsophila australis*, R. Br. In the foreground is a slender miniature Palm (*Bacularia monostachya*,

F. Muell.) with coral-red fruit ; and in the middle distance, on the right, an example of the Asiatic *Caryota urens*, L., remarkable for its compoundly divided leaves.

733. View of the "Organ Pipes," Mount Wellington, Tasmania.—These are basaltic columns, such as are found in many other parts of the world.

734. Australian Sandal Wood with Mistletoe and Emu Wren, West Australia.—In this case the leaves of the parasite (*Loranthus pendulus*, Sieb.) and the nurse plants (*Fusanus spicatus*, R. Br.) are so much alike as not to be easily distinguishable. *Malurus malacurus* is the name of the wren.

735. Australian Bears and Australian Pears.—The Wooden Pear represented in this picture is one of the western species (*Xylomelum occidentale*, R. Br.), which differs from the common Eastern one (see 739) among other things in having wavy, coarsely-toothed leaves. The pears or seed-vessels are quite woody and very hard ; and split down the middle when ripe, to release the two winged seeds. The Native Bear or Koala (*Phascolarctos cinereus*) inhabits Eastern Australia, from Moreton Bay to Port Phillip. It is a nocturnal animal, usually selecting the slanting fork of a Gum Tree for its sleeping place during the day; and it feeds on the leaves and young shoots of the Gum Tree at night. Like the Kangaroo, it is a Marsupial or pouched mammal, and when its young are old enough it takes them out of its pouch and carries them on its back. It is quite arboreal in its habits, and the division of its five claws into two groups enables it to grasp the branches in such a way that it can go head downwards as well as upwards. The painting was done from a young pet in Victoria.

736. The Bottle Tree of Queensland.—Beyond, a grass fire through which the artist and her companions had to gallop. The Bottle Tree (*Sterculia rupestris*, Benth.) received its name on account of its singularly swollen trunk. It was first discovered by Sir T. Mitchell on one of his expeditions into the interior of Queensland.

737. Gum Trees, Grass-trees, and Wattles in a Queensland Forest.—These belong to the genera *Eucalyptus*, *Xanthorrhoea*, and *Acacia* respectively ; the last in flower.

738. View in the Brisbane Botanic Garden.—A Moreton Bay Pine (*Araucaria Cunninghami*, Ait.) in the foreground, and an American *Tacsonia* in front.

739. **Flowers and Seed-vessels of the Port Jackson Wooden Pear, New South Wales.**—Like the fruits or seed-vessels of so many Australian shrubs and trees, the Wooden Pear (*Xylomelum pyriforme*, Knight) is very hard and woody. Each fruit contains only two seeds, and these are furnished with a light, delicate wing, whereby the wind often bears them a long distance.

740. **West Australian Flowers.** — " Kangaroo Feet " (*Anigozanthus*), of which five species are depicted, are peculiar to West Australia, and are remarkable for the uncommon hues of their very hairy flowers. *A. Manglesii*, Don, the tall one behind, with green and crimson flowers, is one of the most striking. Quite behind is a tuft of the Smoke Plant (*Conospermum triplinervium*, R. Br.), which often fills the damp hollows, presenting the appearance of a real mist hovering over the ground. The foreground is carpeted with a creeping plant, which we have not recognised, of two varieties, white and red. See 776.

741. **Scene in a West Australian Forest.**—Large trees of the Black Butt and Red Gum (*Eucalyptus calophylla*), with undergrowth of Grass-trees (*Xanthorrhoea*), *Banksia*, *Kingia*, *Macrozamia Fraseri*, Miq., &c. The Grass trees are commonly called Black Boys, a human specimen of which is placed by the side of one to show the likeness. In the left foreground are some very fine old examples of the *Kingia australis*, R. Br.

742. **Wild Flowers of Victoria and New South Wales.**— At the back, two or three species of *Stylidium*, a large and curious genus almost entirely Australian, upwards of eighty species being known. They are remarkable for the great irritability to touch exhibited by the central organ (column) of the flower. On the right is a yellow and purple orchid (*Diuris* sp.). The yellow-flowered *Composita* with a dark centre is the Cape Weed (*Cryptostemma calendulacea*, R. Br.), which in a few years has covered every meadow in Victoria; and the hanging *Papilionacea* is *Platylobium triangulare*, R. Br.; *Epacris longiflora*, Cav., lies in the foreground, with a species of *Grevillea* on the right.

743. **Brisbane Botanic Gardens.**—Palms in the foreground and avenue of Araucarias behind. The two tall palms are a species of *Ptychosperma*; the dwarf one behind, *Areca Northiana*, Hill; with *Kentia minor*, F. Muell., on the right.

744. **West Australian Plants.** — *Cephalotus follicularis* Labill., and various species of Sundew (*Drosera*) in the foreground, with *Conostylis* sp. (clustered yellow flowers), *Bulbine* sp. ? (racemose yellow flowers), and a blue-flowered *Lobelia*, behind on the left; and *Cheiranthera filifolia*, Turcz., hanging above on the right. The most remarkable plant in this group is the pitcher-bearing *Cephalotus*, which is only found in West Australia. It has no affinity to the climbing Pitcher Plants (*Nepenthes*), but is allied to the northern genus *Saxifraga*.

745. **Evening Glow over "The Range."** — Seen through Red Gums at Harlaxton, Queensland.

746. **Foliage of a Gum Tree and Flowers of Tecoma, with Flying Opossums.** —Aided by the membrane between their legs, these little creatures (*Belideus flaviventris*) have been known to leap forty yards from an elevation of thirty feet on one side of a river to the foot of a tree on the other side. The Gum Tree is *Eucalyptus amygdalina*, Labill., which bears the names, White Gum, Red Gum, Stringy Bark, and Peppermint-tree in different localities. *Tecoma australis*, R. Br. ranges from Victoria to Cape York.

747. **Tree Ferns in Victoria, with a nest of the Lyre Bird.** —Standing a yard above the ground is the nest of this beautiful bird (*Menura superba*) amongst the old fern fronds, with a perch in front for the parents to rest on and feed their one offspring till it gets so big that it entirely fills the nest and is supposed to be strong enough to forage for itself and protect its elegant but inconvenient tail from injury.

748. **" Possum up a Gum Tree."** —The Opossum feeds on the leaves of *Eucalyptus paniculata*, Sm., and *Loranthus aurantiacus*, A. Cunn., which is parasitic on the former, and closely mimics it in its foliage. The pretty little animal was pulled out of a hole in the tree, and a few hours afterwards he had become so tame that he took milk out of a teaspoon.

749. **Two Australian Shrubs, with Sydney Harbour below.** —The climber with pinnate leaves is *Tecoma australis*, R. Br., and the other a species of *Callistemon*, probably *C. lanceolatus*, DC.

750. **Wild Flowers of Albany, West Australia.** — In the foreground, among others, are : *Anthocercis viscosa*, R. Br., the

large white flower; *Thysanotus* sp., purple flowers with fringed petals; *Leschenaultia biloba*, Lindl., deep blue flowers; behind, *Burtonia conferta*, DC. Hanging in front of the vase, *Kennedya coccinea*, Ment., with the elegant blue *Sollya heterophylla*, Lindl., on the right; and the white and pale pink inflorescence above, somewhat like a Maltese cross, is the umbelliferous *Xanthosia rotundifolia*, DC., intermixed with *Pimelea rosea*, R. Br. Above these, a species of *Petrophila*, and the pink, hop-like inflorescence of the liliaceous *Johnsonia lupulina*, R. Br. Behind and to the right several species of *Stylidium*, with the dark purple-brown *Tetratheca filiformis*, Benth., in front.

751. **Foliage, Flowers, and Seed-vessels of a rare West Australian Shrub.**—This is *Eucalyptus macrocarpa*, Hook. and a portrait of the one remaining specimen of this species near Newcastle is represented behind. Although this has the largest flowers of the 140 or more species of the genus, succeeded by the largest seed-vessels, or fruit, it is only a shrub from six to ten feet high, and has been nearly extirpated by sheep in the districts where it is known to grow. The bud, with the cap or calyptrum falling away, shows well one of the essential characters of the genus, and that which suggested the generic name. This cap consists, it is assumed, of the petals grown together. In the background are some Raspberry-jam trees (*Acacia* sp.) so called from the sweet scent of their valuable wood. On receiving a telegram that this *Eucalyptus* was in flower the artist drove out a distance of sixty miles in one day, painted it the next, and returned on the third day.

752. **View near Brighton, Victoria.**—Looking through a hedge of Ti Shrub (*Leptospermum* spp.) with a caterpillar's nest of the leaves above on the left. The small-leaved species on the right is probably *L. scoparium*, Forst., and the other *L. laevigatum*, F. Muell. The early colonists used the leaves of these shrubs as a substitute for tea.

753. **Various species of Acacia and other shrubs, good for binding the sandy shore at Fremantle, West Australia.** —A branch of *Acacia Cyclops*, A. Cunn., bearing flowers and pods in front. Observe the brilliantly-coloured funicle encircling the seeds.

754. **View of Melbourne, from the Botanic Gardens.**—The miniature trees in flower in the foreground are a species of *Cordyline* indigenous in Australia.

755. **West Australian Sand-loving Plants.**—The soil in this district is so very sandy that, with the exception of a few big stones, the whole country might be run through an hour-glass. In the foreground are the feathery ball-like inflorescences of *Trichinium Manglesii*, Lindl., associated with a richly-coloured *Grevillea;* above, on the right, foliage and flowers of *Grevillea bipinnatifida*, R. Br. ; to the left of the centre a plant of *Isotoma Browni*, G. Don, a member of the *Lobeliaceae*, regarded as poisonous to sheep; the blue-flowered *Byblis gigantea*, Lindl., one of the Sundew family; and the elegant everlasting *Helipterum rubellum*, Benth. The singular reptile in the background is called the " Devil."

756. **Forest Scene in West Australia.**—Foreground of Grass Tree (*Xanthorrhoea*); on the right, a species of *Kingia* probably distinct from *K. australis*, in the middle ; and a Cycad (probably *Macrozamia Fraseri*, Miq.) on the left, with a species of *Banksia* just behind.

757. **West Australian Vegetation.**—The shrub in front, having the leaves crowded at intervals along the branches, and thread-like racemes of small flowers, is *Leucopogon verticillatus*, R. Br., with the massive foliage and seed-vessels of *Eucalyptus calophylla*, R. Br., behind ; and the slender *Agonis flexuosa*, Schauer, with small flowers in clusters along the branches, hangs on the right.

758. **Fernshaw, Victoria.**—The white Gum Tree in the middle distance was measured by Baron Mueller, and found to be 365 feet high ; the Tree Fern in the foreground was forty feet high.

759. **Wild Flowers of the Blue Mountains, New South Wales.**—Conspicuous in this selection is the star-like white inflorescence of *Actinotus Helianthi*, Labill., an umbelliferous plant simulating a *Composita*. Lying in the left foreground are the dark blue flowers of a *Patersonia;* and on the right, rosy flowers of a pinnate-leaved *Boronia*. Other genera represented are : *Pimelea, Diuris, Eriostemon, Epacris, Correa, Kennedya, Daviesia, Helichrysum, Lambertia, Styphelia,* and *Tetratheca*.

760. **White Gum Trees and Palms, Illawarra, New South Wales.**—The lofty pinnate-leaved Palm is *Archonto phoenix Cunninghamii*, Wendl. & Drude, better known in gardens in this country under the name *Seaforthia elegans*. One of these

has its crown far away up in the tall Gum tree, and its very slender stem is probably not less than 150 feet high. In the left foreground is a group of the handsome fan-leaved *Livistona australis*, Mart.

761. Musk Tree and background of Evergreen ' Beech,' Victoria.—The Musk Tree (*Olearia argophylla*, F. Muell.), is an arboreous *Composita*, whose ample foliage forms a striking feature in the vegetation of some parts of New South Wales, Victoria, and Tasmania. The Antarctic ' beeches' belonging to the genus *Nothofagus* have sometimes been considered to belong to the Northern genus *Fagus*. The Southern species differ very much in aspect from the true beeches of the North, having small, usually evergreen leaves. There are ' beeches' in South-east Australia, Tasmania, New Zealand, and Fuegia. This Evergreen ' Beech,' *Nothofagus Cunninghamii*, Hook., is a large Forest tree attaining a height of 200 feet, and a girth of forty feet in the trunk. It is the Myrtle Tree of the colonists.

762. West Australian Vegetation.—' Jarrah ' (*Eucalyptus marginata*, Sm.) ; the handsome red-flowered *Grevillea Banksii*, R. Br. ; and Cockatoo (*Cacatua* sp.)

763. View, looking out of the Bunya Forest at the summit, Queensland.—The tops of some Bunyas (*Araucaria Bidwillii*, Hook.) to be seen in the middle distance, on the right.

764. Study of the West Australian Flame-tree or Fire-tree.—It is here associated with various species of *Banksia* and *Hakea*, and Grass Trees (*Xanthorrhoea*) on the right, looking over the Swan River valley towards the sea. *Nuytsia floribunda*, R. Br., the Flame-tree, is very remarkable in many respects. It belongs to the same family as the Mistletoe, a family numerous in species ; most of those inhabiting warm countries have brilliantly-coloured flowers, and all of them, excepting this and *Atkinsonia ligustrina*, F. Muell., a native of the Blue Mountains, in New South Wales, strictly parasitical on the branches of other trees. Although *Nuytsia floribunda* is terrestrial, and has all the aspect of an independent tree, it is supposed that it may be parasitical on the roots of some other tree or shrub, because all attempts to rear seedlings have been unsuccessful. Its trunk is soft like pith, yet it has a massive appearance. Its gorgeous flowers are more brilliant than

flames, for they are undimmed by smoke. They are painted natural size in 766.

765. **Sandal Wood and Opossum Mouse, West Australia.** —The Opossum Mouse is the smallest of all the marsupials. It is an herbivorous animal, living in tree ferns, and of nocturnal habits. Its prehensile tail is in constant use. The artist had three alive in London for some time. They are most gentle, and when placed in the hand they become quite flat like bats. The original *Antechinus flavipes*, as the name indicates, had yellow feet, but this has pink feet. *Fusanus spicatus*, R. Br., is the largest of several kinds of Sandal wood inhabiting Australia.

766. **Flowers of the Flame-tree and yellow and black twiner, West Australia.** — In the distance Flame-trees, *Nuytsia floribunda*, R. Br. (see description of 764). *Kennedya nigricans*, Lindl., is remarkable for the very dark purple, almost black, of its flowers.

767. **Study of the Bunya-Bunya.**—This noble Conifer, *Araucaria Bidwillii*, Hook., is perhaps the most valuable food-tree indigenous in Australia, and only grows on one semi-circle of hills, within 100 miles in stretch, between the Brisbane and Burnett rivers, Queensland. The larger of the older trees are nearly 200 feet high, with a circumference of trunk of about twenty-five feet ; and the horizontal markings on the pillar-like trunks make them very conspicuous amongst other trees. But what is most remarkable about these trees is that they are the only hereditary property any of the aborigines are known to possess. Each tribe has its own group of trees, and each family a certain tree or trees ; and any interference with these rights leads to conflict. The larger cones are a foot long and nine inches in diameter ; and they are full of edible nuts (seeds) as large as chestnuts. Every third year there is an unusually large crop, when the natives assemble from all parts to collect it. By an Act of the Colonial Government the Bunya-Bunya is strictly preserved for the use and sustenance of the aborigines. Look at 763, 771, 773.

768. **Our Camp on the Bunya Mountains, Queensland.**

769. **White Gum and Stringy-bark Trees, New South Wales.**—The bark of the latter (*Eucalyptus obliqua*, L'Hér.) comes off in large slabs, and is used in making wigwams and roofs ; and the natives also use it when they wish to cross a

river. They strip off a large concave piece and stop up the ends with mud, so as to keep the water out; thus forming a rude canoe in which they paddle themselves over with a piece of wood, leaving it to rot or float away.

770. **View from Collaroy, New South Wales, looking towards the Liverpool Downs.**—The plain is dotted with Gum trees and the river bordered with Casuarinas, with blue and crimson Parrots (*Aprosmictus erythropterus*) in the branches of the Peppermint (*Eucalyptus piperita*, Sm. ?) in front.

771. **Nest of the Coachman's Whip Bird, in a Bunya-Bunya, Queensland.**—The trees, *Araucaria Bidwillii*, Hook., were full of these hanging nests of the *Psophodes crepitans*, made of the freshest green moss, and ornamented with the feathers of the common red and blue parrots.

772. **West Australian Vegetation.**—Flowers and fruiting cones in various stages of development, of *Banksia coccinea*. R. Br.; and flowers of a climbing Papilionacea (*Gompholobium polymorphum*, R. Br.), with a distant view of King George's Sound.

773. **View in the Bunya-Bunya Forest, Queensland, and Kangaroos.**—The tall trees having slender spreading branches, leafy only at the tips, are the Bunya-Bunya, *Araucaria Bidwillii*, Hook. See description of 767. The Kangaroos belong to a family of mammals peculiar to Australasia and America. They bring forth their young before they are fully developed; and for some time after their birth the young are carried by the mother in a pouch beneath the abdomen, where they are attached to the teats. There are many different species of Kangaroo in Australia. They move by jumps on their hind feet, and can travel very fast.

774. **A Natural Fernery in Victoria.**

775. **A West Australian Banksia.** — Flower-spikes of *Banksia attenuata*, R. Br., in various stages of development. The narrow grey spike in front is the youngest, having in this condition the appearance and texture of wool-work; above, in an oblique position, is one a little further advanced, and just below this is one with the flowers fully expanded. In the lower corner is an old spike bearing a few seed-vessels, from which it may be seen that only a very small number of the

numerous flowers are fertile. *B. attenuata* is a tree of about forty feet high, restricted to West Australia.

776. Flowers of a West Australian Shrub and Kangaroo Feet.—*Anigozanthus flavida*, Red., is the name of the herb. The genus *Callistemon* comprises about ten species scattered nearly all over Australia, but *C. speciosus*, DC., the one here depicted, is the finest. It inhabits King George's Sound and the neighbouring districts. On the left side of the picture is a branch bearing seed-vessels. See 740.

777. Trees near Fernshaw, Victoria.—The tall trees are *Eucalyptus amygdalina*, Labill., most of them more than 300 feet high. Several trees of this species that have been measured were more than 400 feet high; and the tallest measured was said to be 471 feet high. In the foreground is an evergreen, Beech, (*Nothofagus Cunninghamii*) and Tree Ferns (*Dicksonia antarctica*).

778. Australian Spear Lily and an Acacia.—There are two species of *Doryanthes*, the present *D. Palmeri*, Hill, and *D. excelsa*, which has a globose infloresence. They both inhabit Eastern Australia. See 844 in the gallery above. *Acacia armata*, R. Br., ranges from New South Wales to King George's Sound in the West.

779. An Old Currajong Tree, New South Wales.—The aborigines make their fishing lines from the bark of the Currajong (*Hibiscus heterophyllus*, Vent.), and the soft, spongy trunks are formed into canoes.

780. Branch of a Grevillea, and a View on the Swan River, West Australia.—The branch bears both flowers and seed-vessels, and is probably *Grevillea leucopteris*, Meissn. Behind is a bush of the same, and a Red Gum Tree hung with a species of *Loranthus*.

781. Poison Tree strangled by a Fig, Queensland.—The central figure of this picture represents the skeleton-like trunk of a Fig Tree, which has nearly strangled the Poison Tree (*Laportea moroides*, Wedd.), in a fork of whose branches it started life as a seedling epiphyte. It soon grew apace, and sent down many roots to the earth, where they obtained food and grew in size, enclosing and crushing the trunk of the nurse-tree. Behind are some large pillar-like trunks of *Araucaria Bidwillii*, Hook., whilst the graceful Seaforthia (*Archonto phoenix Cunninghamii*, Wendl. & Drude), Tree

Ferns and *Callitris* share the foreground. Under the *Callitris* is a nest of the Bush Turkey.

782. **Karri Gums, near the Warren River, West Australia.** —Casuarinas and Emus in the foreground. The Karri Gum trees (*Eucalyptus diversicolor*, F. Muell.) are among the tallest trees in the world. Baron Mueller states that he has seen many of them that approached 400 feet in height. One of those painted has a monstrous ring of warts around the trunk, reminding one of the columns of Milan Cathedral, the trunks being as white and polished as the pillars themselves. See 777.

783. **View in the Botanic Garden, Brisbane, Queensland.**— Flowers of the Large Water Lily (*Nymphaea gigantea*, Hook.) with Screw Pines (*Pandanus* sp.) and a species of *Aralia* in the background. This Water Lily is peculiar to Australia.

784. **West Australian Shrubs.** — Foliage and flowers of *Banksia grandis*, Willd., with a blue-flowered species of *Comesperma* (perhaps *C. volubile*, Labill.) climbing over it. This is one of the noblest of the genus *Banksia*, which numbers nearly fifty species—all Australian, and chiefly Western.

785. **Flowers of the Waratah, of New South Wales.**— This is *Telopea speciosissima*, R. Br., the most gorgeous of all the Australian *Proteaceae*, and now almost restricted to the Blue Mountains. It is a shrub from six to eight feet high. A plant is seen in the background, and the yellow flowers of an *Acacia* above it.

786. **Gum Trees and Tree Ferns, Victoria.**—This Gum is the *Eucalyptus amygdalina*, Labill., one of the loftiest of the numerous kinds of Gum trees. See 777.

787. **A Bush Fire at Sunset, Queensland.**—Vast areas of country are devastated by periodical fires.

788. **Fig-tree Village, and its Big Godfather, Illawarra.**

789. **Flowers and Seed-vessels of a West Australian Gum Tree and Honeysuckers.**—This (*Eucalyptus ficifolia*, F. Muell.) is perhaps the most beautiful of all the Gum Trees. It is a small tree nearly allied to *E. calophylla*, R. Br. (see 757), but the latter has white flowers.

790. **Foliage, Flowers, and Fruit of a Queensland Tree, and Black Cockatoo.**—*Macadamia ternifolia*, F. Muell.,

belongs to the *Proteaceae*, and is closely allied to *Helicia*, which extends northward to India, China, and Japan. This bird (*Calyptorhynchus banksii*) alone has a beak strong enough to crack the nuts of the *Macadamia*.

791. **West Australian Shrubby Vegetation.** — Various species of *Hakea* ; a flower-bearing branch of *Eucalyptus tetraptera*, Turcz., at the top on the right ; and a purple-flowered Malvacea (*Hibiscus Huegelii?*). The genus *Hakea* is peculiar to Australia, and comprises nearly one hundred species, spread over the whole country, but most numerous in the west. That on the left, having conch-like leaves, is *H. cucullata*, R. Br. ; and that on the right, with flat spatulate leaves and remarkably curved seed-vessels, is *H. cyclocarpa*, Lindl.

792. **Plant and Animal Life at Mudgee, New South Wales.**—White Gum Trees and Casuarina, in the centre, with Platypus (*Ornithorhynchus paradoxus*) in the water and Native Bear (*Phascolarctos cinereus*) in a fork of the Gum Tree on the left.

793. **Foliage, Flowers, and Seed-vessel of the Opium Poppy.**—This plant (*Papaver somniferum*, L.) has been cultivated in Eastern countries from the most remote time for the sake of the inspissated juice, called opium ; it is largely grown in Asia Minor, Persia, India, and China. Morphia, one of the alkaloids extracted from opium, is a valuable drug.

VARIOUS.

794. **Temple at Almorah, Kumaon, North-west India.**— A Yucca in flower on the left.

795. **A Ruined Mosque at Champaneer.**—Near Baroda, Western India.

796. **Kattiawar from the road up to Pallitana, Western India.**

797. Street in Ajmere, and Gate of the Daghar Mosque. —Benevolence to Bulls and Birds by Hindus.

798. Lake of Islands, Oodipore, Guzerat, Western India.

799. Palace of Deeg, Bhurtpore, India. — Deeg lies a little north-west of Agra, and the palace buildings are said to be unsurpassed in India for elegance of design and perfection of workmanship, except by the Taj Mahal of Agra.

800. View of Pushkar or Pokur, North-west India.—Pokur, or Holy Pokur as it has been called, is about five miles from Ajmere, and is remarkable for the large number of shrines and cenotaphs in the vicinity.

801. Another view at Pushkar.

802. Three Volcanoes, from Tremangong, Java.

803. The Preanger Mountains, Java.

804. The Kluet Volcano, from Ngantang, Java.—In the foreground Natives showing respect to the Regent and Collector.

805. The Soembrin Volcano, from Magellang, Java.

806. Elephant Gate and Neem Tree at Chittore, India.—Chittor or Chittogurh in the North-West, on the River Birneh, is the ancient fortified capital of Rajpootana, formerly of great importance, and containing some fine architectural monuments, now in a state of decay.

807. The House-builder Caterpillar, on a flowering shrub, Brazil.—This industrious creature weaves together sticks and leaves and makes itself a perfect covering, in and out of which it can move its head quickly at the slightest alarm or interruption of its usual occupation of eating every young twig and leaf within its reach. It hangs its house to the branches by temporary ropes, and takes care to secure itself by a fresh one elsewhere before it breaks the old ones and jerks itself to new feeding-ground. After three weeks of such wandering, it goes into the usual sleep of a chrysalis and awakes a most dowdy moth, the female having absolutely no wings.

808. A Brazilian Epiphytal Orchid.—*Sophronitis coccinea*, Rchb. f.

809. View at Morro Velho, Brazil.—A Yucca and the candelabrum-like American Aloe (*Agave americana*, L.) in

flower in the foreground. This should not be confounded with any of the species of the genus *Aloe* (see 505 and 528), all of which are natives of the Old World, and chiefly of South Africa.

810. **Another Brazilian Orchid.** — This is *Sophronitis grandiflora*, Lindl., which is cultivated in this country.

811. **Glimpse in a Glen at Gongo, Brazil.**—The dark flowers in the background are those of a *Melostomacea* (*Pleroma*), see 69 ; and the yellow ones belong to an *Aspilia* (see 44).

812. **Gate of Mariamma Temple, Japan.**

813. **Plants of the Sandy-shore at Port Alfred, South Africa.**—The shrub with shining leaves and white flowers is *Scaevola Koenigii* (see 469) ; the hoary plant with yellow flowers, *Microstephium niveum*, Less., with *Statice scabra*, Thunb., below and a species of *Salicornia* to the left.

814. **View in the Garden of Acclimatisation, Teneriffe.**— The plant with yellow flowers in the left corner is a species of *Sonchus*, behind which rise the crimson spikes of an *Aloe* ; and at the back is a fine American *Wigandia*, with broad leaves and large clusters of blue flowers. In front of the cypress, on the right, is an American *Yucca* in blossom.

815. **Barranca de Castro, Teneriffe.**—Tree Heather, Laurels, Goats, and Shepherds in blankets and topboots.

816. **Study of Chinese Bananas and Bamboos, Teneriffe.**— The Banana is essentially a tropical type of the vegetable kingdom, and a glance around this gallery will give an idea of how widely spread it now is in warm countries, and what a striking object its noble foliage is in almost every scene and landscape. There are other species of the genus, notably *M. Sapientum*, L., described under 120. The young fruit of this, *Musa chinensis*, Sweet, is represented in 225.

817. **View at Peradeniya, Ceylon.**—Bamboos and Jak-fruit tree in the foreground. See 333.

818. **Red Water Lily of Southern India.**—This is the *Nymphaea Lotus*, L. (*N. rubra*, Roxb.), and was painted at Cochin.

819. **View from Kalutara, Ceylon.**—Casuarina and Cocoanut Trees.

820. **Spring Gardens, Jamaica, with its Cocoanut Palms.**

821. **View near Tijuca, Brazil, Granite Boulders in the foreground.**—The plants in the foreground are overrun by a species of Dodder (*Cuscuta americana*, L.) from which an orange dye is obtained. A similar parasitical plant often preys on clover in this country.

822. **Noonday View in the Organ Mountains, Brazil, from Barara.**

823. **View of the Sugarloaf Mountain from the Aqueduct Road, Rio Janeiro.**—A Sloth feeding on a Trumpet Tree (*Cecropia peltata*, L.) in the foreground. The Trumpet Tree is so called because its hollow branches are used by the natives of South America to make musical instruments.

824. **View from the Sierra of Theresopolis, Brazil.**

825. **View of the Corcovado Mountain, near Rio de Janerio, Brazil.**—The vegetation comprises Bamboo, Royal Palms (*Oreodoxa regia*, H.B.K.), &c.

826. **Hot Baths of Cauquenas, Chili.**—Small Bamboos in the foreground.

827. **View in the Salinas, Chili.**—The principal plants on the rocks are the yellow and blue Puyas and the *Cereus* represented natural size in Nos. 23, 26, and 19.

828. **View of the Bell Mountain of Quillota, Chili, with colonised Cardoons in the foreground.**—Among emigrant plants none has perhaps taken almost sole possession of such vast areas as the European Cardoon (*Cynara Cardunculus*, Linn.) which is the wild parent of the Jerusalem Artichoke. Both in Chili and east of the Andes in temperate South America it has spread with prodigious rapidity. Writing in 1824 St. Hilaire states that of all introduced plants in the plains of La Plata and Uruguay, the Cardoon was the most redoubtable. Previous to the war these extensive plains teemed with cattle, which were fond of the young leaves of this plant and thus kept it in check, but the enormous herds of cattle were exterminated and subsequently the Cardoon grew undisturbed and soon covered immense tracts with an impenetrable thicket of vegetation some six to eight feet high.

829. **One of the Volcanoes of the Cordilleras, from Poplar Avenue, San Gabriel, Chili.**—On the left is a cottage, and on the right a large oven, as they are commonly constructed in Chili.

830. **Vegetation on a stream at Chanleon, Chili.**—*Lomaria procera*, Spr., in front with *Gunnera scabra*, Ruiz. et Pav., and *Fabiana imbricata*, Ruiz. et Pav., on the right; *Araucaria imbricata*, Pavon, behind; on the left, yellow *Buddleia globosa*, Lam., *Proustia pyrifolia*, Lag., and a gigantic sedge, *Cyperus* sp.; the crimson flower below is *Ourisia coccinea*.

831. **Wild Flowers and Fruits of the Salinas, Chili.**—*Echinocactus* sp. in fruit, above it *Ephedra andina*, Poepp., in fruit, and a sprig of a white variety of the same in front, with the globular, green flower heads of *Eryngium paniculatum*, Cav. The others are crimson *Mutisia rosea*, Poepp., green *Quillaja saponaria*, (see 12), white *Dolia tomentosa*, Lindl., (syn. *Alibrexia tomentosa*, Miers), rosy *Proustia pyrifolia*, Lag., which climbs to the tops of the highest trees and grows so rapidly as to have suggested the name Pié de dia, that is, Foot-a-day; and *Oxalis carnosa*, Molin., having flowers exactly primrose in colour.

832. **Distant View of Santiago, Chili, from Apoquindo.**—Acacia bushes in the foreground.

————————

The paintings in the recesses between the windows in the gallery above were painted from plants cultivated in this country. Except where otherwise stated, they are represented natural size.

833. **Abyssinian Aloe.**—*Aloe abyssinica*, Lam. was discovered by the celebrated traveller Bruce, who sent seeds of it to Paris about the year 1777, and it seems to have been in cultivation ever since. The genus *Aloe* is spread all over Africa, and the species are especially numerous in the south. One species is common in India. See 505 and 528.

834. **Strelitzia, a South African Plant.**—See 365.

835. **A climbing Plant of Old Calabar.** — *Aristolochia Goldieana*, Hook. f. is one of the most singular of the many species of its genus, having the largest flowers of any yet known. It is a native of western tropical Africa, and living plants or seeds of it were sent to this country about the year 1866 by the Rev. W. C. Thomson, at whose request it was named in memory of his fellow-labourer, the Rev. Hugh Goldie. The genus *Aristolochia* is represented in all tropical and most temperate regions. See 32.

836. **A Brazilian Columnar Cactus.**—Upwards of a thousand species of *Cactaceae* are known, nearly all of them inhabiting

America, and ranging from Chili and Buenos Ayres in the south to about 50° N. lat., their greatest concentration being in Mexico. They vary in stature from an inch or two, as in some species of *Mamillaria*, to sixty feet, as in *Cereus giganteus* (see 185). The present species (*Cereus caerulescens*, Salm.) flowered at Kew, for the first time in Europe, in 1842. With the exception of one or two species of *Rhipsalis*, which have not the habit of the ordinary cactus-type, all the *Cacti* found wild in the Old World are believed to have descended from plants introduced from America. In some parts of South Africa and in Queensland, where they find a congenial climate, they are spreading very rapidly, and are becoming a nuisance to farmers.

837. **A Colombian Aroid.**—After a long reign, the brilliant *Anthurium Scherzerianum* has now to compete with its still more beautiful ally *Anthurium Andraeanum*, Linden, here represented. It appears to have been first discovered by Dr. José Triana, a native of Colombia; but to Mr. E. André, after whom it is named, belongs the honour of having brought the first living plants to Europe, in 1877.

On the panels of the door are paintings of the purple *Cobaea scandens*, Cav., a native of Mexico; and *Tacsonia mollissima*, H.B.K., from the Andes of South America.

838. **Adam's Needle or Yucca, about half natural size.**—*Yucca gloriosa*, L. is a very old inhabitant of English gardens, having been cultivated during the latter half of the sixteenth century by Gerard and Parkinson. It is a native of the south-eastern States of North America.

839. **A Garden Variety of Indian Shot.**—This is *Canna Ehemannii*, Hort., a hybrid between the tropical American *C. iridiflora* and another species.

840. **An Orchid of Tropical Asia.**—This handsome orchid, (*Vanda suavis*, Lindl.), has been cultivated in England since 1848. The allied *V. tricolor*, Hook. differs chiefly in the colour of the flowers.

841. **A Japanese Lily.**—*Lilium auratum*, Lindl. is said to be one of the commonest wild flowers in some parts of Japan. Yet, in spite of its beauty, it was not introduced alive in this country till the year 1861. The late John Gould Veitch had the good fortune to introduce it. True lilies are found nearly all round the north temperate zone.

842. **A Japanese Magnolia.**—This showy spring-flowering hardy shrub (*Magnolia obovata*, Thunb.) has been

cultivated in English gardens ever since 1796, and is recorded as having first flowered in the collection of the Duke of Portland.

843. **A New Zealand Tree Fern.**—A reduced representation of a fine specimen of *Cyathea medullaris*, Swartz, growing in the Winter Garden hard by. It is the Black Fern of the colonists and, in its native country, it forms a stout trunk from twelve to forty feet high.

844. **Australian Spear Lily.**—About one quarter natural size, painted from a plant that flowered in these gardens in the spring of 1882. See 778.

845. **A species of Ornithogalum.**

846. **A South African Sedge.**—This is *Restio subverticillata*, Linn., one out of about eighty species of *Restio* native of South Africa. The *Restiaceae* are almost exclusively restricted to South Africa and Australia, only one being found in South America and one in Cochinchina.

847. **The Papyrus.**—See 361.

848. **A Species of Watsonia.**—This is allied to *W. rosea*. (See 417.)

The floral design on the door frame is composed of a selection of mostly familiar flowers from both hemispheres, remarkable either for their large size or brilliant colouring, or both ; and painted partly from the artist's own studies and partly from coloured illustrations in the "Botanical Magazine" and other publications. On the right are North and South American flowers ; on the left Old World. Nearly all of the latter are hardy in English gardens, and almost all of them natives of the north temperate regions, from Western Europe to Japan. This gorgeous array recalls the divine admonition : "Consider the lilies of the field, how they grow," etc. The artist's initials, intertwined with Ivy (*Hedera Helix*, Linn.), surmount the two hemispheres, the respective positions of which were determined by the arrangement of the paintings in the gallery. Proceeding from right to left, and thence down the side, the flowers are: Red and White May (*Crataegus Oxyacantha*, Linn., vars.), Europe ; Common Lilac (*Syringa vulgaris*, Linn.), Europe ; Guelder Rose (*Viburnum Opulus*, Linn.), Europe ; Bluebell or Wild Hyacinth (*Scilla nutans*, Sm., syn. *Hyacinthus non-scriptus*, Linn.), Europe ; *Cistus ladaniferus*, Linn., Portugal ; the South African *Ixia flexuosa ; Dielytra*

spectabilis, DC., China ; Tree Paeonies (*Paeonia Moutan*, Sims), China ; Oriental Poppy (*Papaver orientale*, Linn.), Asia Minor ; White - flowered Caper (*Capparis spinosa*, Linn.), Mediterranean region ; Blue and White Iris (*Iris germanica*, Linn.) and various Tulips, South of Europe ; Hop (*Humulus Lupulus*, Linn.), Europe ; Brown chequered Fritillary (*Fritillaria latifolia*, Willd.), Caucasus ; *Narcissus poeticus*, Linn., and other species, Europe ; Canterbury Bell (*Campanula Medium*, Linn.), Central Europe ; Crown Imperial (*Fritillaria imperialis*, Linn.), Asia Minor ; A Chinese Lily (*Lilium Brownii*, Miellez) ; A Persian Iris (*Iris persica*, Linn.) ; A Japanese Lily (*Lilium elegans*, Thunb.) ; Stock (*Matthiola*), South of Europe ; Wallflower (*Cheiranthus Cheiri*, Linn.), Europe ; Mignonette (*Reseda odorata*, Linn.), Asia Minor, Egypt ; Common Flax (*Linum usitatissimum*, Linn.), Europe ; Blue Hydrangea (*Hydrangea Hortensia*, DC.), Japan, with the Dog Rose (*Rosa canina*, Linn.) and Sweet Briar (*Rosa rubiginosa*, Linn.), Europe.

Returning to the top the American flowers on the right are : the Pinxter Flower (*Azalea nudiflora*, Linn.), Eastern United States ; *Rhododendron catawbiense*, Michx., Virginia and Carolina ; Virginia Cowslip (*Mertensia virginica*, DC.), Virginia to Tennessee ; a white-flowered Chilian Cactus ; *Fuchsia*, South America ; *Cereus speciosissimus*, DC., Mexico ; varieties of *Dahlia variabilis*, Desf., Mexico ; *Dahlia imperialis*, Roezl., Mexico ; *Datura sanguinea*, Ruiz. et Pav., Mexico to Peru ; *Aster grandiflorus*, Linn., Virginia to Georgia ; North American Allspice (*Calycanthus laevigatus*, Willd.), Eastern States ; *Cobaea scandens*, Cav., Mexico ; Turk's Cap Lily (*Lilium superbum*, Linn.), Canada to Carolina ; *Ceanothus pallidus*, Lindl., N. America ; Spiderwort (*Tradescantia virginica*, Linn.), North America ; Californian Lily (*Lilium Washingtonianum*, Kell.), California to British Columbia ; Cardinal-flower (*Lobelia cardinalis*, Linn.), South-eastern States of North America ; Blue Salvia (*Salvia patens*, Cav.), Mexico ; Tiger-flower (*Tigridia Pavonia*, Ker.), Mexico ; Large Magnolia (*Magnolia grandiflora*, Linn.), South-eastern States of North America ; the Potato (*Solanum tuberosum*, Linn.), South America, and rose, white and crimson varieties of the Chilian *Lapageria rosea*, Ruiz. et Pav. The Humming-bird (*Docimaster ensiferus*) below the *Datura*, has the largest beak of all the humming-birds.

CATALOGUE OF THE WOODS

FORMING THE

PANELLED WAINSCOT BELOW THE PAINTINGS.*

1. **Avellano** (*Guevina avellana*, Mol.), Chili.—A small tree of the family *Proteaceae*, peculiar to Chili, and bearing an edible nut.

2. **Lleuqui** (*Podocarpus andina*, Pœpp.). Peru and Chili.— A small tree of the same family as the Pines of the northern hemisphere. The fleshy fruit is of an agreeable flavour and eagerly eaten by children.

3. **Canelo** (*Drimys chilensis*). Chili.—An evergreen tree ranging from the Andes of Peru to the Straits of Magellan.

4. **Rauli** (*Nothofagus procera*, Pœpp. et Endl.). Chili.— A kind of 'beech' of small dimensions, chiefly employed in making casks.

5. **Common Yew** (*Taxus baccata*, L.). North temperate zone.

6. **Cipres** (*Libocedrus chilensis*, Endl.). Chili.—A small tree having a soft wood used for inside work in building.

7. **Radal** or **Nogal** (*Lomatia obliqua*, R. Br.). Chili.—A tree eight to ten feet high, with a hard lustrous wood, used for making pullies, oars, mallets, and a variety of small articles.

8. **Lingue** (*Persea Lingue*, Nees). Chili.—A member of the Laurel family, attaining a height of sixty to ninety feet. The wood is of good quality and much esteemed for ship-building.

9. **Nogal** (*Lomatia obliqua*, R. Br.). Chili.

* It has been impossible to determine the names of a considerable number of the woods, including all of the Bornean. The numbers at the end of the descriptions are those of the pictures in which the trees or parts of them are represented.

10. **Pehuen** or **Piñon** (*Araucaria imbricata*, Pav.). Chili.

11. **Temu** (*Eugenia Temu*, Hook.). Chili.—A small tree of the Myrtle order.

12. **Palo Santo** (*Porlieria hygrometrica*, Ruiz et Pav.). Chili.—A small tree with a very hard, durable wood, valued also for its reputed medicinal properties.

13. **Letré** (*Rhus caustica*, Hook. et Arn.). Chili.—A small evergreen tree. See painting 12.

14. **Maniu** (*Saxegothaea conspicua*, Lindl.). Chili.—A small evergreen tree allied to the Cypress.

15. **Letterwood** (*Brosimum Aubletii*, Pœpp. et Endl.). Peru, Guiana, and Brazil.—A very fine specimen of this beautiful wood, which is also called Snake-wood and Leopard-wood in allusion to the markings. It is only the heart-wood that is thus highly coloured and elegantly marked ; and this can only be had in narrow strips. This tree is a member of the *Artocarpaceae*, or Bread Fruit family, and another species of the genus, *B. Galactodendron*, is the famous Cow-tree of South America, which yields a milk said to be of as good a quality as cows' milk.

16. **Yacca** (*Podocarpus coriaceus*, Rich.). West Indies.— A moderate-sized tree inhabiting the mountains of Jamaica, Trinidad, etc.

17. **Purple Heart** (*Copaifera pubiflora*, Benth.). Guiana and Brazil.—A member of the *Leguminosae* and one of the numerous hard, durable woods in which Guiana abounds.

18. **Locust Wood** (*Hymenaea Courbaril*, L. ?). Tropical America.—Also one of the *Leguminosae*, if correctly identified.

19. **Tulip Wood** (*Physocalymma scaberrimum*, Pohl.). Brazil.—A handsome specimen of this wood, which is much used for inlaying costly furniture, for turnery, etc. This tree is a member of the *Lythraceae*.

20. **Zebra Wood** (*Omphalobium Lamberti*, DC. ?). Guiana.

21. **Purple Heart** (*Copaifera pubiflora*, Benth.). Guiana and Brazil.

22. **Locust Wood** (*Hymenaea Courbaril*, L. ?). Tropical America.

23. **Wadaduri** or **Monkey Pot** (*Lecythis grandiflora*, Aubl.). Guiana.

24. **Rosewood** (*Dalbergia* sp.). Brazil.—One of several kinds of wood called Rosewood by furniture and cabinet makers. This is a member of the *Leguminosae*.

25. **Jamaica Satinwood** (*Zanthoxylum* sp.). West Indies.

26. **West Indian Cedar** (*Cedrela odorata*, L.). West Indies.—*Cedrela* is a Meliaceous genus represented by valuable arboreous species in America, India, and Australia. They should not be confounded with the true Cedars, which are cone-bearing trees, inhabiting temperate regions.

27. **Locust Wood** (*Hymenaea Courbaril*, L. ?). Guiana.

28, 29, 30. Unnamed.

31. **Bull - Wood** (possibly *Pinus cubensis*, Griseb.). Bahamas.

32. **Purple Heart** (*Copaifera pubiflora*, Benth.). Guiana and Brazil.

33. **Locust Wood** (*Hymenaea Courbaril*, L.). Guiana.

34. Undetermined wood from Guiana.

35. **Purple Heart** (*Copaifera pubiflora*, Benth).

36. **Pencil Cedar** (*Juniperus bermudiana*, L.). Bermudas.—It is noteworthy that this, the only forest tree in the remote cluster of islets known as the Bermudas, has been preserved by the inhabitants during the period of nearly three centuries that they have been settled. The familiar Red Cedar (*J. virginiana*, L.) is closely related to it.

37. **Purple Heart** (*Copaifera pubiflora*, Benth.). Guiana and Brazil.

38. **" Chossie Cherry."** United States.

39. **Ash Burr** (*Fraxinus americana*, L.). Eastern North America.—The White Ash of the Americans, and a large forest tree.

40. **Curled Ash** (*Fraxinus* sp.). United States.

41. **Whitewood** (*Liriodendron tulipifera*, L.). Eastern North America.—This is the Tulip Tree, of which there are good examples in these Gardens.

42. Black Cherry (*Prunus serotina*, Ehrh.). Eastern North America.—A large tree, furnishing a valuable wood for the cabinet maker.

43. Plain Grey Walnut or **Butternut** (*Juglans cinerea*, L.). Eastern North America.—A tree thirty to fifty feet high.

44. Figured Birch (*Betula lenta*, L.). Eastern North America.—This tree, which is rather large, bears the names Cherry Birch, Sweet Birch, and Black Birch, and it yields a valuable timber.

45. Bird's-eye or **Sugar Maple** (*Acer saccharum*, Marsh). Eastern North America.—A large and very handsome tree, sometimes called Rock Maple.

46. North American Satinwood (*Zanthoxylum floridum*, Nutt.).—A small tree only found in Florida.

47. Californian Dogwood (*Cornus Nuttallii*, Audb.). Western North America, from Monterey northward, to the Fraser River.—A small tree, though it occasionally attains a height of seventy feet. Wood very hard. See picture 190.

48. Black Cherry (*Prunus serotina*, Ehrh.). Eastern North America.

49. Figured Pitch Pine (*Pinus rigida*, Mill.). Eastern North America, from Maine and New York southward.—One of the commoner species, thirty to seventy feet high.

50. Maple Veneer (*Acer rubrum*, L. ?). North America.

51. Black Walnut (*Juglans nigra*, L.). North America chiefly in the Central States.—A large handsome tree, very different in habit of growth from the common Walnut. There are some fair-sized specimens in these Gardens.

52. Bird's-eye or **Sugar Maple** (*Acer saccharum*, Marsh). Eastern North America.

53. Plain Maple (*Acer macrophyllum*, Pursh.). Western North America, from Santa Barbara, in California, to the Fraser River, in British Columbia. Tree fifty to ninety feet high. The white hard wood takes a good polish.

54. Plain Grey Walnut or **Butternut** (*Juglans cinerea*, L.). Eastern North America.

55. Curled Ash (*Fraxinus* sp.). Eastern North America.

56. **Laurel Burr** (possibly the wood of *Umbellularia californica*, Nutt.). Western North America.

57. **Figured Black Walnut** (*Juglans nigra*, L.). Eastern North America.

58. **White Oak** (*Quercus alba*, L.). Eastern North America. —A large tree yielding a valuable timber.

59. **Figured Maple** (*Acer macrophyllum*, Pursh.). Western North America.

60. **Yellow Birch** (*Betula lutea*, Michx. f.). Eastern North America, New England to Lake Superior and Northward.— Sometimes called Gray Birch. Wood said to be whiter and less valuable than that of the Cherry Birch.

61. **Douglas Fir** (*Pseudotsuga Douglasii*, Carr.). Western North America, throughout the coast ranges and in the Sierra Nevada, up to 6000 or 8000 feet, and also northward near the coast, attaining its largest size in Oregon.—This is one of the handsomest of coniferous trees, growing from 200 to more than 300 feet high, with a trunk 8 to 15 feet in diameter. The flagstaff on the mound close by is of this species.

62. Unknown. East North America.

63. **Red Cedar** (*Juniperus virginiana*, L.). North America, from Florida to Hudson's Bay, varying according to latitude from a bush to a tree ninety feet high.

64. **Yellow Cypress** (*Cupressus nootkatensis*, Lamb.). Columbia River to Alaska.—Commonly cultivated in this country under the name of *Thuyopsis borealis*.

65. **Manzanita** (*Arctostaphylos Manzanita*, Parry). Western North America, from Oregon southward into the mountains of Mexico.—A shrub ranging from a few inches at alpine elevations to eight or ten feet in the most favourable localities. The short trunk rarely exceeds a foot in diameter.

66. **Yellow Pine** (*Pinus ponderosa*, Dougl.). Western North America, from California to Oregon and northward.— One of the taller pines, reaching 200 to 300 feet in height, with a trunk twelve to fifteen feet in diameter. Painting 195.

67. **Black Walnut Burr** (*Juglans nigra*, L.). Eastern North America.

68. Redwood (*Sequoia sempervirens*, Endl.). Western North America.—For particulars of this gigantic tree consult the description of the picture 204.

69. Live Oak (*Quercus chrysolepis*, Liebm.). California.— This is described as one of the more conspicuous and beautiful oaks of the Coast Ranges and the Sierra Nevada, throughout the length of the State. The trunk is frequently three to five feet in diameter, and one has been found twenty-eight feet in circumference.

70. Redwood (*Sequoia sempervirens*, Endl.). Western North America.

71. Mountain Laurel (*Umbellularia californica*, Nutt.). Western North America.—A handsome shrub or tree, ranging from San Diego in California to Douglas County, Oregon. In the more southern localities it rarely exceeds twenty feet in height, while northward it is a fine tree 100 feet high or more, with a trunk four to six feet in diameter. The timber is very valuable and much used for ornamental wainscoting and furnishing. This is the only *Lauracea* in Western North America. All the forest in this region increases in size from South to North following the increase of moisture.

72. Wellingtonia or **Big Tree** (*Sequoia gigantea*, Lindl. & Gord.). Western North America. See description of the picture 154.

73. Sugar Pine (*Pinus Lambertiana*, Dougl.). Western North America, throughout California and northward to the Columbia River.—A lofty tree, 150 to 300 feet high, with a trunk ten to twenty feet in diameter. It is stated in the *Botany of California* that the exudation of the partially burned tree loses its resinous qualities and acquires a sweetness similar to that of sugar or manna, for which it is sometimes used; hence the name Sugar Pine.

74. Indian Sandal Wood (*Santalum album*, L.). Mysore, Canara, Ceylon.—A small tree.

75. Buroon (*Crataeva religiosa*, Forst., var. *Roxburghii*, Hook. f.). India.—A common tree having a soft tough wood used for carving.

76. **Trincomalee Wood** (*Berrya Ammonilla*, Roxb.). Ceylon.—This is considered one of the most useful timber trees of Ceylon.

77. **Paloo Wood** (*Mimusops indica*, A.DC.). Ceylon.—Used for ordinary building purposes. No. 301 is a painting of another species of the genus.

78. **Nauladi-mara** (*Vitex altissima*, L.). Ceylon, South India.

79. **Suriya** (*Thespesia populnea*, Corr.).—A very widely-dispersed tree in tropical countries. It is of medium size, and the wood is greatly esteemed for boat-building, as it is almost indestructible under water. For cabinet making it is also in demand, and gunstocks were formerly made from it in Ceylon. Painting 256.

80. **Kakkar** (*Pistacia integerrima*, Stewart). North-west India.—Brandis states that the heart-wood of mature trees is the best and handsomest wood of the North-west Himalaya for carving furniture, and all kinds of ornamental work. A tree of forty or more feet in height, with a trunk eight to nine or sometimes twelve to fifteen feet in girth.

81. **Ceylon Satin-wood** (*Chloroxylon Swietenia*, DC.). South India, Ceylon.—In point of size and durability, Drury states this is by far the first of the timber trees of Ceylon. At Peradeniya a bridge of a single arch 205 feet in span, chiefly constructed of Satin-wood, crosses the Mahawalliganga river.

82. **Cocoanut** (*Cocos nucifera*, L.). Tropics.—See the descriptions of the paintings 156, 229, and 251. The wood is used for ornaments and fancy articles, and is commonly called Porcupine-wood.

83. **Tamarind** (*Tamarindus indica*, L.). — Cultivated throughout India, though probably not an indigenous tree. It is believed to be indigenous in tropical Africa and North Australia. The timber is highly prized for turnery. Paintings 279 and 700.

84. **Wine Palm** (*Caryota urens*, L.). Tropical Asia.—This is described at length, painting 670.

85. *Magnolia* sp.—India.

86. **Gutta Percha** (*Dichopsis Gutta*, Benth.). Indian Archipelago.—Gutta Percha came into use about the year 1845,

and the tree has entirely disappeared from the Island of Singapore, where it was formerly common. Happily it exists in Borneo and other countries.

87. **Cocoanut** (*Cocos nucifera*, L.)—Consult the descriptions of paintings 156 and 229.

88. **Tamanu** (*Calophyllum Inophyllum*, L.)—Tropical Asia, Painting 494.

89. **Surija-mara** (*Albizzia Lebbek*, Benth.). Tropical Asia, &c.—This tree is cultivated in nearly all tropical countries on account of its ornamental appearance. It is one of the trees of the avenues of Cairo. Painting 330.

90. **White Bark.** *South Africa.

91. **Coast Stinkwood.** South Africa.

92. **Onderbosch, Rooi Pear** (*Trichocladus crinitus*, Pers.). South Africa.—The branches and twigs of this shrub are used at the Cape on account of their toughness and elasticity. It is commonly employed for firewood.

93. **Coast Iron-wood, Assegai** or **Umpompote** (*Curtisia faginea*, Ait.). South Africa.

94. *Albizzia* sp. South Africa.

95. **Bawdyne.** South Africa.

96. **Bush Willow.** South Africa.

97. **Black bark, Zwartbast** (*Royena lucida*, Thunb.). South Africa.—This wood is hard and tough, and when polished it is well adapted for furniture, tools, screws, &c., but is chiefly used for wagon work.

98. **Milkwood, Masetole** (*Sideroxylon* sp.). South Africa.

99. **Kaffirboom** (*Erythrina Caffra*, Thunb.). South Africa.— This "giant of the forests" grows 50 or 60 feet high, and three to four feet in diameter. Its wood is soft and very light, and has been used for canoes, troughs, and instead of cork in the construction of fishing-nets. It is also employed for making shingles, which when tarred make very durable, good roofing. Painting 354.

* Many of the popular and native names of these South African woods are quite local, and the botanical affinities cannot be determined without leaves and flowers.

100. **Flatcrown** (*Albizzia fastigiata*). South Africa.—A smallish tree of the Natal coast and the tropics. Prized in Natal as a wagon wood for naves.

101. **Wild Fuchsia** (*Halleria lucida*). South Africa.—A small tree with hard and not durable timber.

102. **Umzlewood.** South Africa.

103. **Red Milkwood** (*Mimusops Caffra*, Sonder). South Africa.

104. **Waterwood** (*Eugenia cordata*). Natal.

105. **Essenhout** or **Cape Ash** (*Ekebergia capenis*, Sparrm.). South Africa.—Wood used for beams, planks, all kinds of wagon-work, and in the manufacture of tools, implements, &c.

106. **Knobthorn, Knopjes-doorn, Paardepram** (*Zanthoxylum capense*).—The bark of the trunk of this little tree is studded with numerous large, conical protuberances ; its height is from 8 to 10 feet. The wood is hard and close, and is used for yokes, axles, tools, &c. Painting 381.

107. **Essenhout.** See 105.

108. **White Milkwood** (*Sideroxylon inerme*, L.). South Africa.

109. **Bitter Almond.** South Africa.—A large tree of the mountains of Natal.

110. **African Oak.** South Africa.

111. **Red Milkwood.** South Africa. See 103.

112. **Assegai** (*Curtisia faginea*, Ait.). South Africa.—This tree grows to a height of from twenty to forty feet; its wood is highly prized, being tough and close-grained. It makes the best wagon spokes.

113. **Chakas Wood** or **Cape Teak** (*Strychnos Atherstonei*, Harvey). South Africa.

114. **Umhuyea.** South Africa.

115. **Kaffir Plum.** South Africa. Painting 382.

116. **Silver tree, Witteboom** (*Leucadendron argenteum*, R. Br.). South Africa.—This handsome tree has a very limited area. Its wood is soft and spongy, and is used occasionally for boxes, &c., but more commonly for fuel. Painting 425.

117. **Umdabage** (*Apodytes dimidiata*, E. Meyer). South Africa.—Perhaps White Pear.

118. **White Pear.** South Africa.—Painting 375.

119. **Umnovnove.** South Africa.

120. **Long Thorn.** South Africa.

121. **Currant.** South Africa.

122. **Thorn.** South Africa.

123. **Umsimbiti** (*Millettia caffra*, Meissn.). South Africa.

124. **Silver tree.** See panel 116.

125. **Stinkhout** or **Stinkwood** (*Oreodaphne bullata*, Nees). South Africa.—The wood of this beautiful tree smells very disagreeably when cut. It is not too hard and very durable, and resembles Walnut. It is used extensively for wagons and cabinet maker's work. At the River Knysna, where it attains a considerable size, it has been employed even in ship-building.

126. **Bastard Yellow Wood.** *Podocarpus elongatus.* South Africa.

127. **Waterboom.** Natal. See 104.

128. **Nieshout** or **Sneezewood** (*Pteroxylon utile*, Eckl. & Zeyh.). South Africa.—A tree from twenty to sixty feet in height, with a handsome, strong, durable wood. It is one of the most durable woods known, in any situation. For this reason it makes the best fencing posts in South Africa. Its popular name refers to the fact of its producing violent sneezing when sawn or otherwise worked. It is also said to ignite easily, even when green.

129. **Milkwood** (*Sideroxylon* sp.). South Africa.

130. **Castrina.** South Africa.

131. **Low Mimosa.** South Africa.

132. **Stinkwood.** See panel 125.

133. **Saffraan, Saffronwood** (*Elaeodendron croceum*, DC.). South Africa.—A small tree with whitish bark, which is covered all over with a resinous crust of a gamboge yellow colour. The wood is fine-grained, hard, close, and tough, and is sometimes employed as a second-rate wagon wood. The bark is good for tanning and dyeing.

134. **Wild Kastanie, Wild Chestnut** (*Calodendron capense*, Thunb.). South Africa.—A tree from twenty to thirty feet high. The wood is soft and white, and little used except for rural utensils, yokes, poles, &c.

135. **Cabbage Wood** (*Cussonia* sp.). South Africa.

136. **Waterboom.** South Africa. See 127.

137. **Badamier** (*Terminalia Catappa*, Linn.). Seychelles.— A tree 60 to 80 feet high, forming two-thirds of the woody vegetation in Felicité and Marie Anne Isles.

138. **Bois de Rose** (*Thespesia populnea*, Carr). Seychelles.

139. **Banoir Blanc, Bois d'ébène blanc** (*Diospyros chrysophyllus*, Poir.). Mauritius.—A small tree with glabrous very zig-zag slender branchlets.

140. **Bois Chauve souris** (*Ochrosia borbonica*, Gmel.). Seychelles.—A tree 20 to 40 feet high, which is found in all these Islands principally on the shores.

141. **Bois Tatamaka** (*Calophyllum Inophyllum*, Linn.). Seychelles.—This tall tree is common in tropical Asia and Polynesia, also Madagascar, Bourbon and Comoros, but not in continental Africa ; it is common likewise in forests of the sea shore in Mauritius. Painting 494.

142. **Coco de Mer,** or **Double Cocoanut** (*Lodoicea sechellarum*, Labill.). Seychelles. Paintings 474–477.

143. **Bois cassant** or **Mapon** (*Pisonia calpidia*, Steud.).— A low erect tree, with a corky bark. It is endemic in the mountain woods of the Pouce Range, &c., Mauritius.

144. **Latanier feuillé** (*Stevensonia grandifolia*, Duncan). Seychelles.—This palm grows to a height of from 40 to 50 feet. It is common in all the Seychelles Islands.

145. **Capucin** (*Northea seychellana*, Hook. f.). Seychelles. —Painting 501.

146. **Bois tortue** (*Morinda citrifolia*, L.). Seychelles.

147. **Bois rouge, bois marré blanc** (*Wormia ferruginea*, Baill.). Seychelles.—This tree, 30 to 40 feet high, is endemic in the native woods of the Seychelles. Painting 459.

148. **Cedre** (*Casuarina equisetifolia*, Forst.).—A native of the Malay Archipelago, now widely spread through the tropics of the Old World, and one of the commonest trees in Mauritius and Seychelles. It is thirty to fifty feet high, with a straight trunk.

149. **Bois Porcher** (*Thespesia populnea*, Carr.). Seychelles. —A small tree growing in moist places near the sea-coast, and very widely dispersed in similar situations.

150. **Bois Blanc** (*Hernandia ovigera*, Linn.).—A small tree, now become rare, in the Seychelles. It is found in the damp forests of Trois Ilots and Grandport, Mauritius.

151. **Bois noir** (*Albizzia Lebbek*, Benth.) is spread through the tropics of the Old World, and is naturalised throughout Mauritius, Rodriguez, and the Seychelles, both in the plains and on the hills. It was brought from Bengal by Corsigny in 1767. Painting 330.

152. **Manglier** (*Carapa moluccensis*, Lam.).—This is a common tree on muddy shores from East Tropical Africa to Australia. It has been gathered in the Seychelles at St. Anne's Bay, Praslin. Painting 498.

153. **Bois de Natte** (*Imbricaria maxima*, Poir.).—A tree found in the thick woods of the interior, Mauritius, and also Bourbon.

154. **Common Ash** (*Fraxinus excelsior*, L.). Europe and Western Asia.—This very tough wood is largely employed by wheelwrights and coopers.

155. **Bois Sandal** (*Carissa sechellensis*, Baker). Seychelles. —This tree is rare, and now known only in Silhouette, but it is said to have once been common in the northern forests of Mahé.

156. **Olive** (*Olea europaea*, L.). Mediterranean Region.— The Olive is usually a small, tortuously branched tree, though occasionally the short trunk attains a great size; and the wood is employed in making wheels and other articles in which hardness and durability are essential. Painting 517.

157. **Thuya-wood** (*Tetraclinis articulata*, Mast.). North Africa.—This hard fragrant wood is very durable, and it is extensively used in the construction of mosques and other buildings. It is also used in turnery. Painting 781.

158. **Turkey Oak** (*Quercus Cerris*, L.). South and Central Europe and Asia Minor.—A handsome tree of more rapid growth than the common Oak. There are some fine examples of it in these Gardens.

159. **Common Walnut** (*Juglans regia*, L.). Europe and Asia, though perhaps introduced into the former country.— Furniture and gun-stocks are the most familiar uses of this wood.

160. **Lemon** (*Citrus Limonum*, Risso).—A small tree, native of tropical Asia, cultivated in many other countries.

161. **Cedar of Lebanon** (*Cedrus Libani*, Loud.). Mount Lebanon, Syria, and Asia Minor.—There are three very closely allied species or forms of true Cedar, namely, the Atlas, the Deodar, and the present one. They all produce good timber in their native countries, but the wood of the Cedar of Lebanon and the Atlas Cedar grown in this country is comparatively soft and spongy.

162. **Babul** (*Acacia arabica*, Willd.). Tropical and sub-tropical Asia and Africa.—A small tree valuable not alone for its hard wood, but also for its gum. Indeed almost every part of it is useful.

163. **Dawata-gass** (*Carallia integerrima*, DC.). Tropical Asia and Australia.—This is a member of the Mangrove family (*Rhizophoraceae*). Timber described as rather brittle but very ornamental, with broad medullary rays, which show on a vertical section like undulating broad irregular bands, giving the wood a beautiful mottled appearance.

164. **Cocoanut** (*Cocos nucifera*, L.).

165. **Indian Sandal-wood** (*Santalum album*, L.). India.— See panel 74 and picture 319.

166. **Champak** (*Michelia Champaca*, L.).

167. **Coromandel Wood** (*Diospyros quaesita*, Thwaites). South India and Ceylon.—This is a kind of ebony.

168. *Hopea odorata*, Roxb. Burma.

169. **Nadoong** (*Pericopsis Mooniana*, Thwaites). Ceylon.

170. **Babul** (*Acacia arabica*, L.). — See description of panel 162.

171. **Tamarind** (*Tamarindus indica*, L.).—See description of panel 83.

172. **Red Sanders** (*Pterocarpus santalinus*, Linn. f.). India.—A tree of the Western Peninsula.

173. **Nadoong** (*Pericopsis Mooniana*, Thwaites). Ceylon.

174 to 187. **Bornean Woods,** which we have no means of identifying.

188. **Ceylon Satin-wood** (*Chloroxylon Swietenia*, DC.).— See the description of panel 81.

189. **Ran.** India.

190. **Albizzia moluccana*. Java.

191. *Cassia florida.* Java.

192. *Urostigma altissimum.* Java.

193. *Cyanodaphne cuneata.* Java.

194. *Dillenia speciosa.* Java.

195. *Arenga saccharifera.* Java.

196. *Firmiana colorata.* Java.

197. *Anthocephalus indicus.* Java.

198. **Lamban.** Java.

199. *Ficus crenulata.* Java.

200. *Dillenia aurea.* Java.

201. **Renjoeng.** Java.

202. **Djaketra.** Java.

203. *Cissus pergamacea.* Java.

204. *Mangifera macrocarpa.* Java.

205. *Eugenia acutata.* Java.

206. *Areca Catechu.* Java.

* The trivial and scientific names of the Java woods were all appended to them when the collection was received, and have not been compared with authentic specimens.

207. *Garcinia dioica.* Java.

208. *Memecylon appendiculatum.* Borneo.

209. **Kawoean.** Java.

210. **Haremeng** (*Sterculia* sp.). Java.

211. *Diospyros ebenum.* Java.

212. *Xerospermum Noronheanum.* Java.

213. **Kamareta.** Java.

214. *Endiandra rubescens.* Java.

215. Undetermined. New Zealand.

216. **Keaki** (*Zelkova acuminata*, Plauch). Japan.—A large tree allied to the Elms. The timber is valuable.

217. *Dracophyllum Traversii.* New Zealand.

218 and 219. Unnamed.

220. **Totara** (*Podocarpus Totara*, A. Cunn.). New Zealand. —"The most valuable timber of New Zealand."

221. Undetermined.

222. **Matai or Black Rue** (*Podocarpus spicata*, R. Br.). New Zealand.—Also a valuable timber. A tree eighty or more feet high.

223. **Kauri** (*Dammara australis*, Lamb.). New Zealand.— This Conifer is, perhaps, the tallest tree in the island, rising to a height of 120 feet, with a trunk sometimes ten feet in diameter.

224. **Rata** (*Metrosideros robusta*, A. Cunn.). New Zealand.— A tree of the Myrtle family, fifty to sixty feet high, furnishing a hard close-grained timber. See the pictures 714 and 721 for other species of the genus.

225. Undetermined. Tasmania.

226. Undetermined. Tasmania.

227. **Sassafras** (*Atherosperma moschata*, Labill.). Common in Tasmania, rare in Victoria.—It is a large tree commonly associated with ' Beech ' in Tasmanian forests.

228 and 229. **Myrtle** or "**Beech**" (*Nothofagus Cunninghamii*, Hook.). Tasmania and Victoria.—Common in the former country and constituting the greater part of the forest in some parts of the mountainous districts. Paintings 715 and 761.

230. **Mottled Kauri** (*Agathis australis*, Salisb.). New Zealand.—See panel 223.

231. Undetermined. Tasmania.

232. **Celery-topped Pine** (*Phyllocladus rhomboidalis*, Rich.). Tasmania.—A slender tree sometimes sixty feet high, but reduced to a shrub high up in the mountains. Paintings 715 and 730.

233. *Athrotaxis cupressoides*, Don. Tasmania.—A tree of twenty to forty feet, with a relatively thick trunk, sometimes as much as fifteen feet in girth.

234. **Blackwood** (*Acacia melanoxylon*, R. Br.) Australia.

235. **Huon Pine** (*Dacrydium Franklinii*, Hook. f.). Tasmania.—A tree sixty to eighty, or sometimes as much as 100 feet high.

236. **Australian Red Cedar** (*Cedrela Toona*, Roxb.). Queensland and New South Wales.—A handsome tree, apparently not specifically different from the Indian *C. Toona*. The most valuable timber in all Australia.

237. **She Oak** (*Casuarina Fraseriana*, Miq.). West Australia.—This genus is a prominent feature in Australian vegetation, but most of the species are small or only medium size trees. Paintings 701, 728, and 792.

238. **Raspberry Jam** or **Myall** (*Acacia acuminata*, Benth.). West Australia.—A tree of medium size, whose wood is said to smell like raspberry jam.

239. **Australian Sandal-wood** (*Fusanus spicatus*, R. Br.). West Australia.—A tree about thirty feet high, represented in paintings 734 and 765.

240. **Raspberry Jam** or **Myall** (*Acacia acuminata*, Benth.). —Same as panel 238.

241. **She Oak** (*Casuarina Fraseriana*, Miq.).—Same as panel 237.

242. **Tuart** or **Tooart** (*Eucalyptus gomphocephala*, DC.). West Australia. This is one of the medium-size gum trees ; its greatest known height being 120 feet, but it is usually much smaller.

243. **Jarrah** or **Mahogany** (*Eucalyptus marginata*, Sm.). West Australia.—This forms the principal forests of South-western Australia, rising exceptionally to a height of about 150 feet, good-size trees averaging 100 feet. For further information respecting the species of this genus, consult the descriptions of the paintings 746, 751, and 782.

244. *Frenela*, sp. ? West Australia.

245. **Red Gum** (*Eucalyptus calophylla*, R. Br.). West Australia.—This is one of the handsomest of the genus. See painting 757.

246. **She Oak** (*Casuarina Fraseriana*, Miq.).—Same as panel 237.

INDEX.

(The Numbers refer to the Paintings.)

THE WORLD

SHEWING THE COUNTRIES VISITED BY
MISS NORTH (RED), AND OTHER FLORAS
PARTIALLY ILLUSTRATED IN THE
COLLECTION (GREEN).

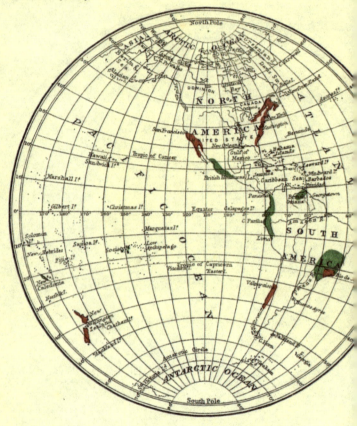